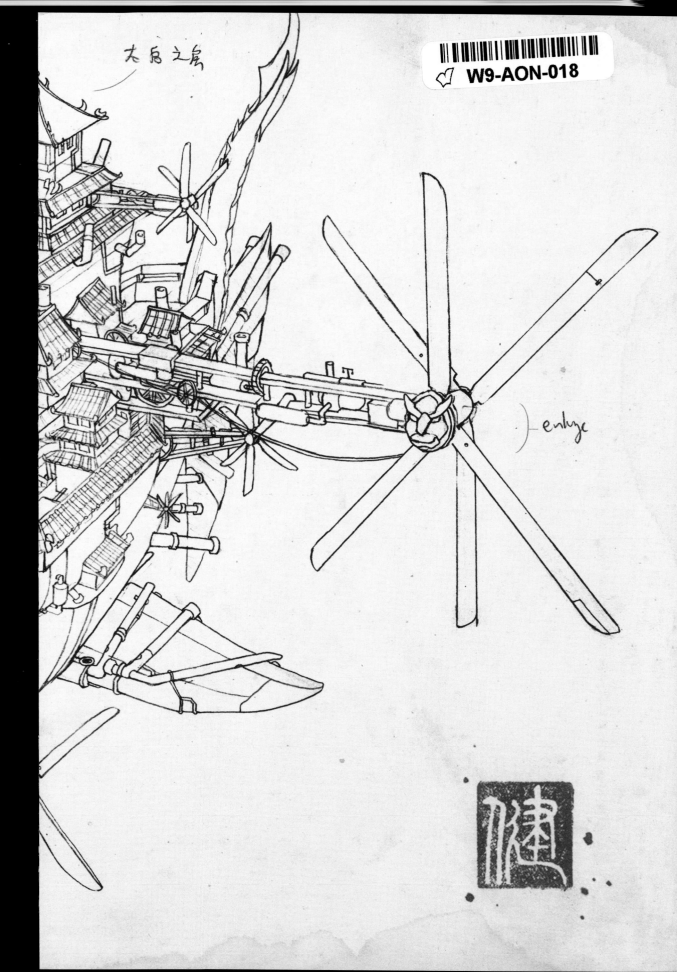

太后之岛

enlye

THE STEAMPUNK BIBLE

THE
STEAMPUNK
BIBLE

An Illustrated Guide to the
World of Imaginary Airships, Corsets and Goggles,
Mad Scientists, and Strange Literature

JEFF VANDERMEER
WITH S. J. CHAMBERS

Contributions from Desirina Boskovich, Libby Bulloff,
G. D. Falksen, Rick Klaw, Jess Nevins, Jake von Slatt, Bruce Sterling,
and Catherynne M. Valente

ABRAMS IMAGE — NEW YORK

S. J. Chambers would like to dedicate this book to Josh Johnson, Aleks Sennwald, and her parents Joseph and Sonja Chambers.

Jeff VanderMeer would like to dedicate this book to Ann VanderMeer, Leslie Anne Henkel, Matt Staggs, Jake von Slatt, and his long-suffering agent, Howard Morhaim.

EDITOR: Caitlin Kenney
DESIGNER: Galen Smith
PRODUCTION MANAGER: Alison Gervais

Library of Congress Cataloging-in-Publication Data

VanderMeer, Jeff.
 The steampunk bible : an illustrated guide to the world of imaginary airships, corsets and goggles, mad scientists, and strange literature / by Jeff VanderMeer with S. J. Chambers.
 p. cm.
 Includes bibliographical references and index.
 ISBN 978-0-8109-8958-0 (alk. paper)
 1. Steampunk fiction--History and criticism--Handbooks, manuals, etc. 2. Steampunk culture--Handbooks, manuals, etc. I. Chambers, S. J. II. Title.
 PN3448.S73V36 2011
 809.3'8766--dc22

 2010032900

Printed and bound in the U.S.A.

10 9 8 7

Abrams Image books are available at special discounts when purchased in quantity for premiums and promotions as well as fundraising or educational use. Special editions can also be created to specification. For details, contact specialsales@abramsbooks.com or the address below.

THE ART OF BOOKS SINCE 1949

115 West 18th Street
New York, NY 10011
www.abramsbooks.com

Contents

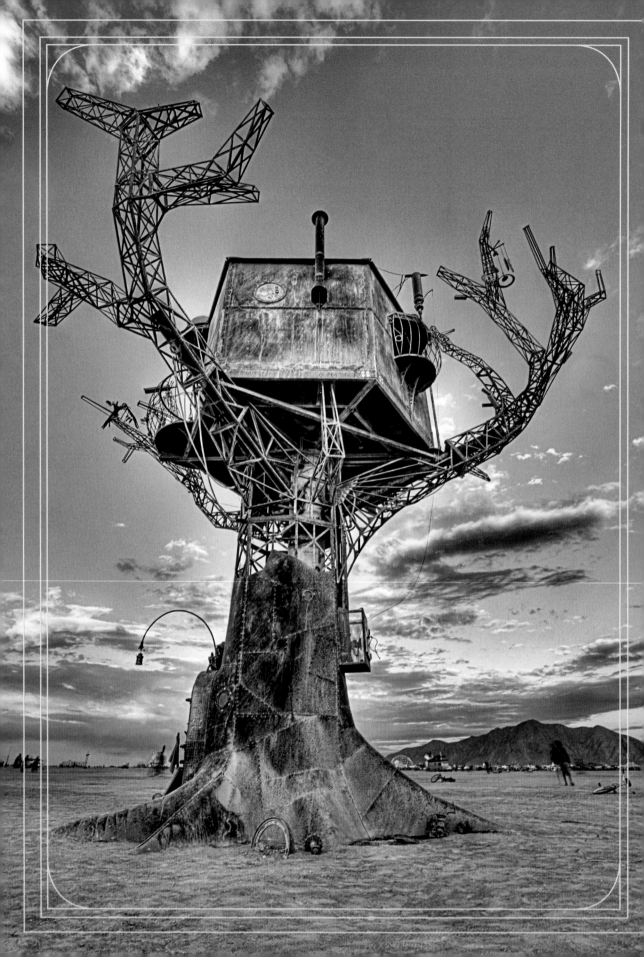

IT'S A CLOCKWORK UNIVERSE, VICTORIA

Measuring the Critical Mass of Steampunk

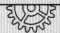

"Blinded by the bright lights, I looked down at the audience from the stage. How many people were out there? A thousand? Five thousand? I couldn't tell. All I knew was: These were my people. Steampunks. Some wore full-on period-correct Victorian outfits, but even more were dressed in an eclectic manner that combined Victorian clothing with punk and goth fashion along with elements common to the classic pulp or B-movie adventurer. Corsets, waistcoats, skirts, kilts, safari jackets, top hats, and goggles were all in evidence and worn with little regard to gender. This was way beyond my comfort zone. But I was not alone: The Steampunk band Abney Park was on stage with me. I turned to the lead singer, Captain Robert, and asked, 'Is it time?' The captain was bent double, sorting through cables on the deck. He turned, smiled, and said, 'It's all you!'"

Jake von Slatt, California Steampunk Convention, San Jose, October 2008

BY THE TIME STEAMPUNK WORKSHOP FOUNDER JAKE VON SLATT HAD stepped onto that stage, Steampunk had already reached critical mass following the publication of Ruth La Ferla's article "Steampunk Moves Between 2 Worlds" in the Style section of the *New York Times* on May 8, 2008. This article merely reflected a full flowering of the retro-futuristic movement that had its roots in a fascination with Victoriana and the fiction of Jules Verne, but it also brought Steampunk to a wider audience and arguably legitimized the movement. Suddenly, projects like Sean Orlando's Steampunk Tree House (previous page) became the flagships of an aesthetic with more than just cult appeal, and tinkers like von Slatt were being treated like rock stars.

Steampunk had threatened to burst into full clockwork prominence at various times since the coining of the term by writer K. W. Jeter in 1987, but it took thirty-plus years of stops and starts for it to break out. In

a sense, Steampunk could only gain true popularity by moving away from its roots in fiction and becoming part of the broader world. Indeed, many of the people who today call themselves Steampunks have not read the literature, taking cues instead from history, visual media, and the original fashionistas who sparked the subculture in the 1990s.

What is Steampunk? This book explores that question, but here's one answer, an equation I contributed to a notebook cover created by English designer John Coulthart:

STEAMPUNK = Mad Scientist Inventor [invention (steam x airship or metal man / baroque stylings) × (pseudo) Victorian setting] + progressive or reactionary politics × adventure plot

While I admit the description may be a little tongue-in-cheek, even limiting, it does sum up the allure of Steampunk, both in fiction and the movement it spawned. First, it's simultaneously retro and forward-looking in nature. Second, it evokes a sense of adventure and discovery. Third, it embraces divergent and extinct technologies as a way of talking about the future.

Over the past fifteen years, Steampunk has gone from being a literary movement to a way of life and a part of pop culture. A Steampunk aesthetic now permeates movies, comics, fashion, art, and music, and has given a distinct flavor to iconic events such as Maker Faire and the Burning Man festival.

At this point, too, the term "Victorian" has become so malleable that its use no longer corresponds to its historical boundaries: the period of Queen Victoria's reign (1837–1901). For a Steampunk, it may encompass the succeeding Edwardian era (1901–10) or serve as a catchall to evoke the Industrial Revolution. At the extreme of Steampunk artifice, the term can be a received idea of "Victorian" as popularized in movies and elsewhere that has no historical basis.

Sometimes, too, a Steampunk creator riffs on a variety of influences in addition to the Victorian. For

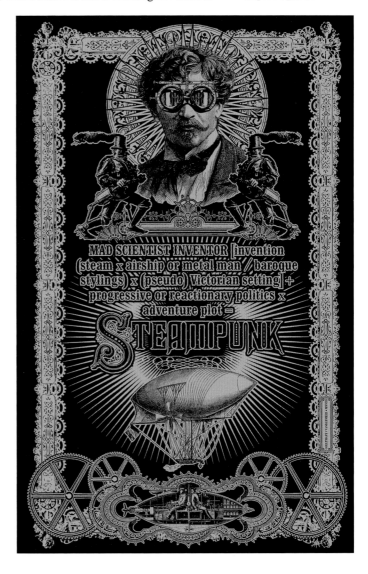

example, Jon Sarriugarte and Kyrsten Mate's snail car, *The Golden Mean*, is inspired by French puppets, a scene from the Dr. Doolittle books, and the concept of the golden ratio, a mathematical ideal believed, since the Renaissance, to calculate what is aesthetically pleasing.

Perhaps inspiration doesn't always come from the fiction because Steampunks are creating their own living fictions. It is commonplace for artists and adherents to invent their own Steampunk personas, or "steam-sonas," and accompanying personal mythologies. This seems to be an essential element of the transformation, borrowing heavily from the culture of role-playing games. Far from making them poseurs, these stories strike me as each individual's loving contribution to the Steampunk subculture and a useful way of entering the right frame of mind for creation.

Recently, the appeal of Steampunk has gone beyond pop culture and the maker movement into the realms of DIY activism and sustainable technology, an effort in part spearheaded by the U.K.-based *SteamPunk Magazine*. It draws people of diverse political persuasions, ethnicities, and social classes.

Steampunk's popularity—its incredible, almost viral rate of growth—has been widely documented in, and fed by, national and international media, including publications such as the *New York Times*, *Newsweek*, *Wired*,

BELOW
Jon Sarriugarte and Kyrsten Mate's *The Golden Mean*

Popular Science, and *Nature*. Each publication has chosen to highlight a different aspect of the Steampunk community. The *Times* Style section, for instance, focused primarily on Steampunk fashion. Techno magazines have covered those who remake and modify objects in the Victorian mode, while the journal *Nature* related Steampunk to science and education: "Steampunk is to science what Civil War reenactments are to history. . . . The people involved—many of them scientists and engineers—are interested in learning about the history of science. They do so by re-creation, converting electrical lamps to kerosene or fashioning telegraph sounders to tap out Web content updates. Their engagement thus becomes personal, tactile, and satisfying." (March 6, 2008)

ABOVE
A Steampunk wedding cake

At its best, Steampunk is unabashedly positive and inclusive in its outlook, encouraging applied imagination put to both fanciful and practical purposes. Although some Steampunks are escapists—using the accoutrements of the Victorian period without reference to imperialism or the social inequities of the era—many see their efforts as a way to repurpose the best of that time while correcting for the worst. Today, Steampunk enclaves exist all over the world, making the subculture truly international.

What is the driving force behind the involvement of *so many* people in Steampunk? The belief in Steampunk is something beyond a way of dressing, writing, or creating. The people who came to see Abney Park play and to hear von Slatt speak might have found their way into Steampunk through the music or the fashion, but they stay, in von Slatt's opinion, "because of that DIY impulse in a world where, today, you can't even fix your own car if it breaks down."

That impulse, whether it remains nascent or results in action, has created a wide demographic beyond the artists, musicians, and authors already recognized in the media. Steampunk has drawn in anarchists who give a distributed gift-based economy a decidedly Steampunk twist, "contraptors" who work to build a Steampunk future, crafters who earn a little extra spending money selling handmade goods on the Internet, and craftspeople who make a living by building intricate and functional devices for wealthy patrons. Steampunks are engaged people, doing things rather than simply dreaming and talking about them, a fact that makes all the difference between a subculture that endures and one that, fadlike, fades from view.

Coming from the fiction side of things, my wife Ann and I had limited knowledge of the larger Steampunk subculture when we published our short story anthology *Steampunk* in 2008. The book included works by such iconic Steampunk writers as James Blaylock, Michael Moorcock, and Neal

The User's Guide to Steampunk

By Bruce Sterling

Coauthor with William Gibson of the seminal first-generation Steampunk novel The Difference Engine, *Bruce Sterling was also one of the original Cyberpunks, revolutionizing science fiction and pop culture with works like* Islands in the Net *and serving as editor of the classic fiction anthology* Mirrorshades. *The following excerpt from his "User's Guide to Steampunk" explains his own complex relationship with the aesthetic.*

People like Steampunk for two good reasons. First, it's a great opportunity to dress up in a cool, weird way that baffles the straights. Second, Steampunk set design looks great. The Industrial Revolution has grown old. So machines that Romantics considered satanic now look romantic.

If you like to play dress-up, good for you. You're probably young, and, being young, you have some identity issues. So while pretending to be a fireman, or a doctor, or a lawyer, or whatever your parents want you to be, you should be sure to try on a few identities that are totally impossible. Steampunk will help you, because you cannot, ever, be an authentic denizen of the nineteenth century. You will meet interesting people your own age who share your vague discontent with today's status quo. Clutch them to your velvet-frilled bosom, because you will learn more from them than you ever will from your teachers.

ABOVE
Russian painter Vladimir Gvozdev's depiction of a mecha-elephant

Stretching your self-definition will help you when, in later life, you are forced to become something your parents could not even imagine. This is a likely fate for you. Your parents were born in the twentieth century. Soon their twentieth-century world will seem even deader, weirder, and more remote than the nineteenth. The nineteenth-century world was crude, limited, and clanky, but the twentieth-century world is calamitously unsustainable. I would advise you to get used to thinking of all your tools, toys, and possessions as weird oddities destined for the recycle bin. Imagine starting all over with radically different material surroundings. Get used to that idea. . . .

This dress-up costume play and these subcultural frolics will amuse and content ninety percent of the people involved in Steampunk.

However, you may possibly be one of those troublesome ten percent guys, not just in the scene but creating a scene. Frankly, the heaviest guys in the Steampunk scene are not really all that into "steam." Instead, they are into punk. Specifically, punk's do-it-yourself aspects and its determination to take the means of production away from big, mind-deadening companies who want to package and sell shrink-wrapped cultural product.

Steampunks are modern crafts people who are very into spreading the means and methods of working in archaic technologies. If you meet a Steampunk craftsman and he or she doesn't want to tell you how he or she creates her stuff, that's a poseur who should be avoided. Find the creative ones who want to help you, and who don't leave you feeling hollow, drained, and betrayed. They exist. You might be one.

⊠ ⊠ ⊠ ⊠ ⊠

Steampunk's key lessons are not about the past. They are about the instability and obsolescence of our own times. A host of objects and services that we see each day all around us are not sustainable. . . . Once they're gone, they'll seem every bit as weird and archaic as top hats, crinolines, magic lanterns, clockwork automatons, absinthe, walking-sticks, and paper-scrolled player pianos.

We are a technological society. When we trifle, in our sly, Gothic, grave-robbing fashion, with archaic and eclipsed technologies, we are secretly preparing ourselves for the death of our own tech. Steampunk is popular now because people are unconsciously realizing that the way that we live has already died. We are sleepwalking. We are ruled by rapacious, dogmatic, heavily-armed fossil-moguls who rob us and force us to live like corpses. Steampunk is a pretty way of coping with this truth.

The hero of the funeral is already dead. He has no idea what is happening. A funeral is theater for the living.

Steampunk is funereal theater. It's a pageant. A pageant selectively pumps some life into the parts of the past that can excite us, such as the dandified gear of aristocrats, peculiar brass gadgets, rather stilted personal relationships, and elaborate and slightly kinky underwear. Pageants repress the aspects of the past that are dark, gloomy, ugly, foul, shameful, and catastrophic. But when you raise the dead, they bring their baggage.

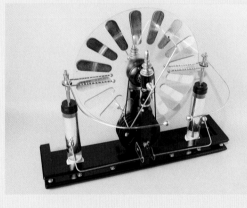

BELOW
Jake von Slatt's electrostatic generator, known as a Wimshurst machine

There's not a lot we can do about the past; but we should never despair of it, because, as Czeslaw Milosz wisely said, the past takes its meaning from whatever we do right now. The past has a way of sticking to us, of sticking around, of just plain sticking. Even if we wrap the past around us like a snow globe, so as to obscure our many discontents with our dangerous present, that willful act will change our future. Because that's already been tried. It was tried repeatedly. Look deep enough, try not to flinch, and it's all in the record. So: never mock those who went before you unless you have the courage to confront your own illusions.

The past is a kind of future that has already happened.

Stephenson, but as we attended Steampunk events, an interesting cross-pollination occurred. Steampunks who had come into the fold through fashion or film and had never heard of the authors in our book picked it up to learn more about the history, while we became immersed in the subculture as we met and learned from key figures like von Slatt. (This, too, had been in some small way facilitated by the *New York Times* article, as by coincidence our anthology had been published in the same month and as a result gained more attention.)

Were we late to the party? Not at all. The truth is that most Steampunks have been involved in the scene for less than ten or even five years. Authenticity is a function of the imagination you bring to your endeavors and the energy you display in your creations—whether you make clothes or jewelry, create machines, or "just" make up stories about your identity. This might be the true power of Steampunk: it allows for escapism and practicality, encouraging its practitioners to both *dream* and *do*.

Perhaps fittingly, the rate of invention in the Steampunk community has become so intense that no book can do more than provide a stop-motion image of the subculture's past, present, and potential future. My co-conspirator S. J. Chambers and I hope this book will inspire and delight you. We hope you'll use it not just as the jumping-off point to discover even more about Steampunk, but to become involved in your own unique way.

The sun might have set on the Steampunk Tree House, but Steampunk's day has only just begun.

Jeff VanderMeer, Tallahassee, Florida, 2010

STEAMPUNK

NEAL STEPHENSON JOE R. LANSDALE

MICHAEL CHABON JESS NEVINS

RICK KLAW JAY LAKE

TED CHIANG BILL BAKER

MARY GENTLE JAMES BLAYLOCK

PAUL DI FILIPPO MICHAEL MOORCOCK

EDITED BY **ANN** & **JEFF VANDERMEER**

ABOVE
Steampunk, a fiction anthology (Tachyon Publications, 2008)

OPPOSITE
A night view of the Steampunk Tree House at the Burning Man festival, photographed by Nick Winterhalter

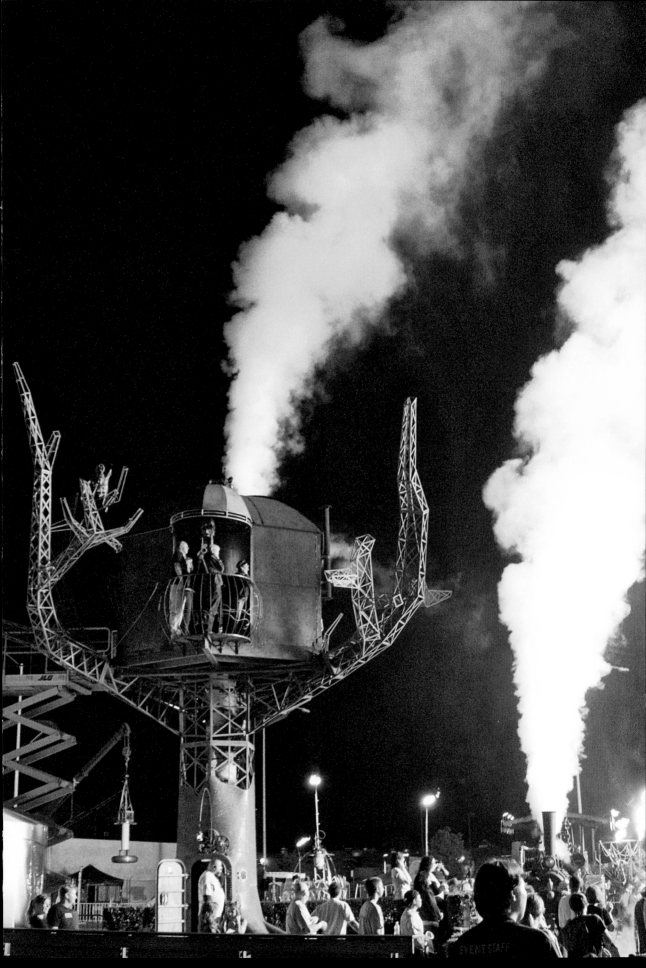

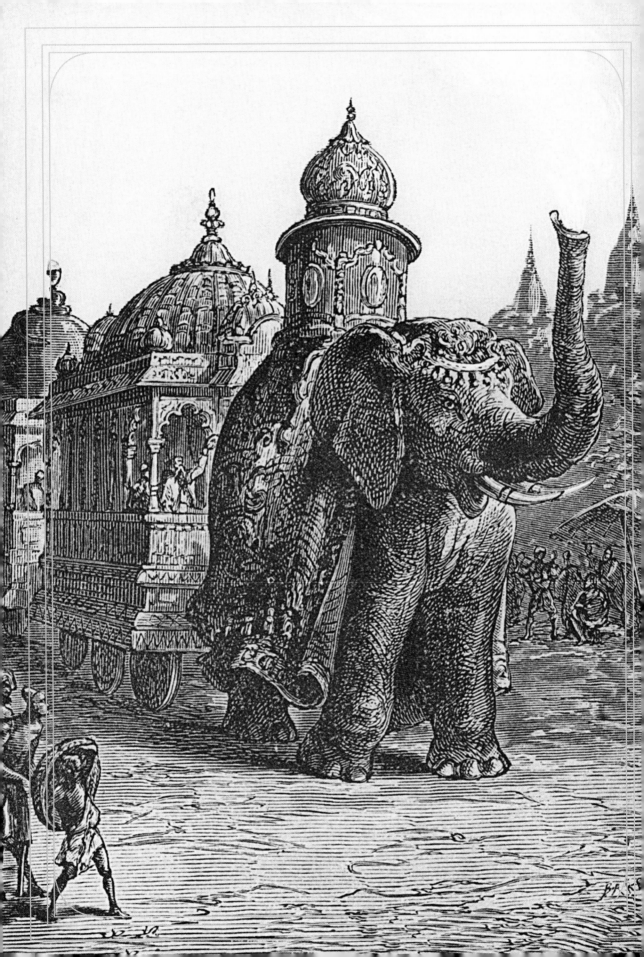

AN IMAGINARY VOYAGE TO THE PAST

Steampunk Origins
in Verne, Wells, and the
Industrial Revolution

☒☒

The mechanical elephant that forms the centerpiece of the Machines of the Isle of Nantes exhibit in France gives physical form to a central image from an early example of proto-Steampunk literature. This vast and whimsical creation—the crew actually enters through an aperture beneath the tail—is taken from the pages of Jules Verne's *The Steam House, Part I: The Demon of Cawnpore* (1880), a novel in which four Englishmen travel across India in a huge, steam-powered mechanical elephant.

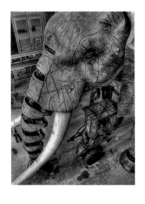

VERNE'S USE OF SUCH INVENTIONS IN HIS FICTION, INCLUDING THE famous *Nautilus* from *20,000 Leagues Under the Sea* (c. 1869–70), would prove a potent influence on Steampunk creators in the twentieth century. In such works, Verne also had begun to form an imaginative extrapolation about technology—in which elements of art and the decorative mesh with the functional—that would fascinate members of the modern Steampunk subculture, regardless of whether they also took from Verne's work the cautionary message about the excesses of invention.

At about the time Verne (1828–1905) published *The Steam House,* the young English writer H. G. Wells (1866–1946) had just begun to write the fiction that would make him a literary dynamo equal to Verne, if in a different way. A solid socialist, Wells would by mid-career publish mainstream literary novels influenced by the lower-middle-class experience and solidarity with the women's rights movement. But his first fictions, including *The War of the Worlds* (1898) and novellas like *The Time Machine* (1895) and *The Invisible Man* (1897), established him as one of the clear godfathers of science fiction. *The War of the Worlds* is a particularly complex book that has often been interpreted as pertaining to British imperialism, Victorian repression, and the theory of evolution. Like much of his fiction (and Verne's), it was considered "scientific romance" at the time, a term that could describe a fair number of modern Steampunk novels. However, Wells had a hard edge to his "romance," one that presaged the godless universe postulated by the SF-horror of H. P. Lovecraft and exemplified by this famous passage from *The War of the Worlds*: "Yet across the gulf of space, minds that are to our minds as ours are to those of the beasts that perish, intellects vast and cool and unsympathetic, regarded this earth with envious eyes, and slowly and surely drew their plans against us."

Like Verne, Wells took a cautionary stance regarding generally accepted ideas of progress and technology. Unlike Verne, Wells seemed more

apt to critique systems and to emphasize social class in his fiction. To Verne, rogue scientists were individuals who had gone mad due to their overweening arrogance and the power of their imaginations. To Wells, rogue scientists might indeed be arrogant, but their beliefs about the importance of scientific progress were empowered by nations and supported by society.

How did these two brilliant extrapolators, these proto-Steampunk fiction-contraptors whose works would influence not just Steampunk fiction by writers like Michael Moorcock, Tim Powers, Neal Stephenson, and K. W. Jeter, but also science and culture in general, come by their views of the world? How does the American Edisonade figure into proto-Steampunk, and what came after?

The answers, as any good Steampunk knows, can be found in the past. All you need is a time machine and a good pair of goggles. . . .

The Contes Philosophiques

BELOW
An Italian lithograph, artist unknown (c. 1881), that captures the sense of whimsy early science and aviation held for the public

WRITERS LIKE VERNE AND WELLS WHO CREATED "SCIENCE FICTION" were still more interested in the idea of exploring scientific theories and facts than the fictional aspects of their speculative stories. Why? Because

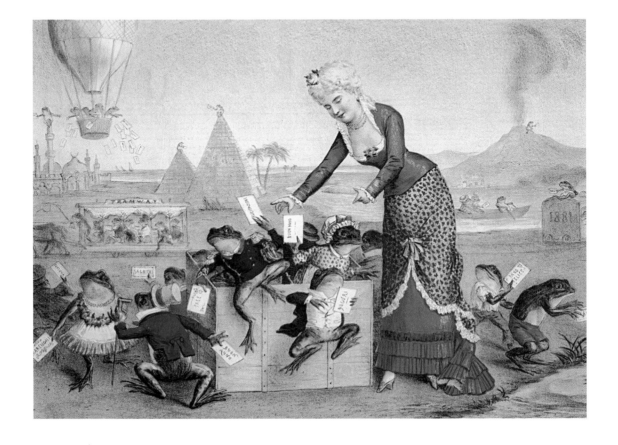

one of the biggest influences on these early creators was the centuries-old tradition of *contes philosophiques* (philosophical stories) based on the works of Francis Bacon (1561–1626), who refined and popularized the scientific method, and Johannes Kepler (1571–1630), who used fantasy as a way to explain the Copernican universe. *Contes philosophiques* usually took two forms that would become very important to Steampunk literature: the imaginary voyage and the dream story, which were often used together to explain otherwise inexplicable travel through the solar system or deep into the earth.

While useful to convey difficult (or even heretical) ideas in a wider context, the dream story in particular had its drawbacks as a fictional device. The astute reader soon came to realize that the stories always ended with the narrator waking up, every marvel merely a fictitious by-product of sleep. In addition, the "romance" in these stories in a sense undermined the science behind them. To maintain their freshness and their credibility, *contes philosophiques* would need a more believable narrative structure.

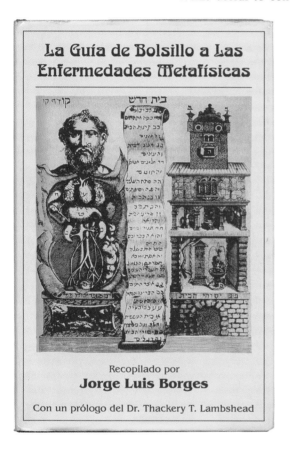

La Guía de Bolsillo a Las Enfermedades Metafísicas

Recopilado por
Jorge Luis Borges

Con un prólogo del Dr. Thackery T. Lambshead

The missing link, then, between these stories and Verne and Wells, was Edgar Allan Poe (1809–49), whom Brian Stableford, in his historical chapter in *The Cambridge Companion to Science Fiction*, notes is the first writer to solve this problem.

By Poe's time, early scientific writing had taken on its own fictionalized affect through metaphor and allegory, influenced by the *contes philosophiques* but abandoning the vehicle of the dream story. This conflation of fact and fiction often caused public confusion, as Laura Otis documents in her *Literature and Science in the Nineteenth Century* anthology, citing the example of a neurologist named Mitchell who "published textbooks about his patients' phantom limb pains, but when trying to develop his theory that people's bodies shaped their notions of identity, turned to the short story form. Ironically, readers found Mitchell's story so realistic that they mistook it for an actual case." (Far from being defunct today, this approach to medicine would actually inspire a modern example in the form of the Steampunk-influenced *The Thackery T. Lambshead Pocket Guide to Eccentric & Discredited Diseases*. Although published in 2003 and thus seemingly much too late to engage in active deception, it can still be found proudly displayed in many medical libraries.)

As editor of some of the day's premier magazines like *The Southern Literary Messenger* and *Graham's Magazine*, Poe knew that periodicals published technical scientific articles side-by-side with fiction and poetry, and

Edgar Allan Poe: Perpetrator of the First Steampunk Hoax?

By S. J. Chambers

Edgar Allan Poe is often portrayed in popular culture as a tortured, dark figure, but in pulling off a string of hoaxes in print he displayed a mischievous, prankish sense of humor. While Poe wrote several stories in a "plausible" vein, the best and most famous is "The Balloon Hoax." Published in the *New York Sun* as a newspaper article on April 13, 1844, it described a then-improbable balloon voyage across the Atlantic, completed within seventy-five hours.

The hoax was printed at the zenith of public ballooning enthusiasm, which had begun in Paris in June 1783 when the Montgolfier brothers brought a hot-air balloon to the city. A year later, Jean-Pierre Blanchard would soar over 12,500 feet in his hydrogen balloon, then cross the English Channel in January 1785. These gentlemen successfully captured the world's imagination with their dirigibles, and by the early nineteenth century, aeronauts like Blanchard and Henri Lachambre had become heroes and reigned over imaginations worldwide. The balloon had become so firmly established as part of popular culture that it was incorporated into Vaudeville performances and touted as an alternative means of Arctic exploration.

ABOVE
Edgar Allan Poe, 1848

However, the transatlantic flight still remained out of reach, and when the public heard the *Sun*'s claim, everyone clambered for a newspaper, buying out the afternoon edition, as well as fifty thousand copies of special issues. The story garnered thirty thousand more readers than the *Sun*'s previous hoax, Richard A. Locke's 1835 "Great Moon Hoax."

In feigning authenticity, Poe used characters named after real mem-

CONTINUED

DESCENTE D'ABSALON

Par MISS STENA

bers of the ballooning community. He based his protagonist Monck Mason on Thomas Monck Mason, who wrote several accounts of his ballooning excursions across England. Poe presented the majority of the story as dispatches taken from Mason's journal, and dated them the week before the *Sun* went to press. The dispatches were saturated with speculations so accurate that "the first transatlantic balloon voyage, exactly a century later recorded almost the same number of hours and many of the incidents in Mr. Monck Mason's log," writes Poe scholar Harold Beaver in *The Science Fiction of Edgar Allan Poe*.

Mason's log included atmospheric changes and geographical descriptions, and he promised more observations for the *New York Sun* after recovering from the landing in Fort Moultrie. In

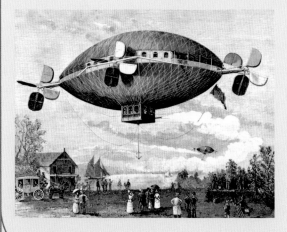

the end, neither Poe nor the editors could keep up the hoax, and the *New York Sun* retracted the story on April 15.

Poe later used this same method to imagine a future populated by leisure-cruise zeppelins in "Mellonta Tauta," and combined the Baconian method with poetry to anticipate Einstein's theory of relativity in his prose poem "Eureka."

this inspired him to test his own literary theory: that art combined with fact could yield new realities. The more absurd a story, the more Poe strove to make it authentic by writing in what he called the "plausible style," in which punctilious details were authentic enough to read as truth. As a result, Poe perpetuated several successful hoaxes, proving that, during times of rapid scientific advancement, fact and fiction are often indistinguishable to the layperson. In a similar manner, Steampunk writers today must make outdated inventions believable, much as a historical novelist must animate the past.

However, despite any personal delight Poe might have gotten from his science-based shenanigans, the greatest legacy of these works may lie in the fact that they advanced in a sophisticated way the idea of the *contes philosophiques*—de-emphasizing the role of the dream story while reinforcing the idea of the imaginary journey, using the context of publication to inspire belief. This evolution, through the vehicle of Poe's work, inspired Steampunk's patresfamilias Verne and Wells.

David Standish writes in his *Hollow Earth: The Long and Curious History of Imagining Strange Lands, Fantastical Creatures, Advanced Civilizations, and Marvelous Machines Below the Earth's Surface* that Jules Verne read Baudelaire's translations of Poe in various journals and newspapers, and "Verne responded chiefly to the cleverness, ratiocination, and up-to-date scientific trappings Poe wrapped his strange stories in." Wells would later

BELOW
"The progress of the century—the lightning steam press, the electric telegraph, the locomotive, [and] the steamboat," lithograph by Currier & Ives, c. 1876

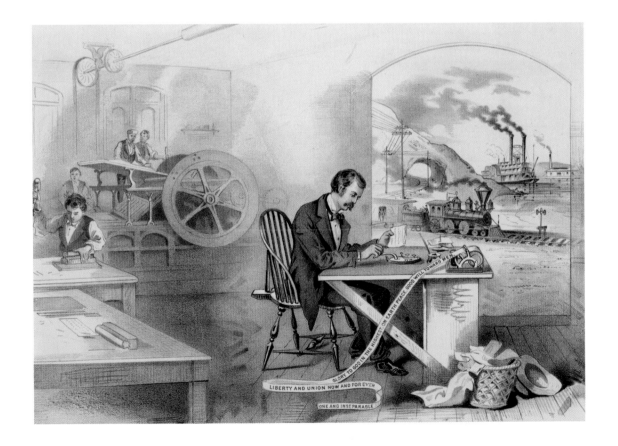

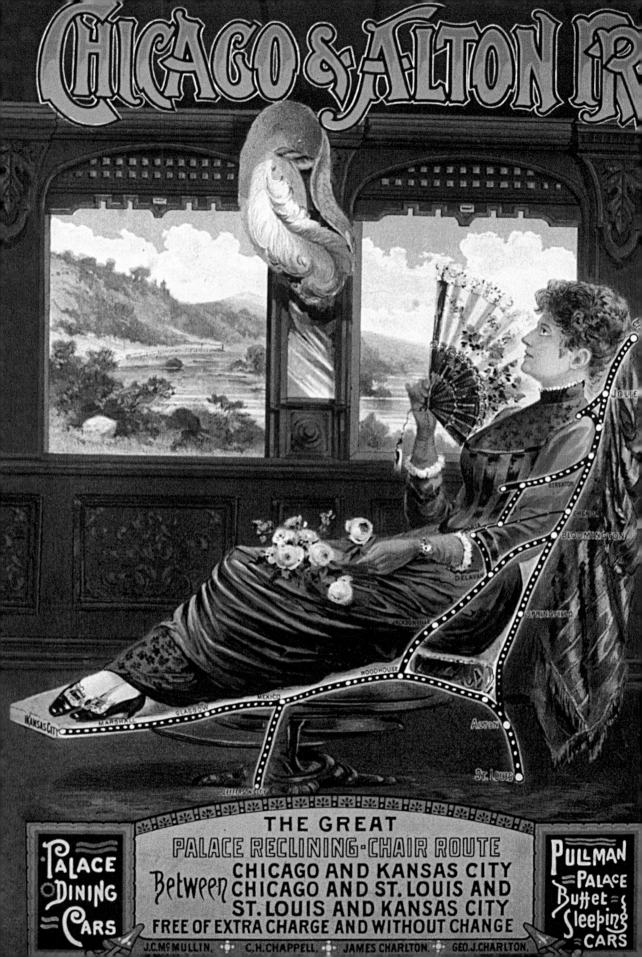

say that "the fundamental principles of construction that underlie such stories as Poe's . . . are precisely those that should guide a scientific writer."

Still, although Verne and Wells may have been heavily influenced by Poe's interest in technology, Poe's fiction doesn't seem to have the same proto-Steampunk spark, perhaps because the author did not live to see all the changes created by the Industrial Revolution. To Poe, the revolution must have seemed unambiguously a good thing. James Watt's (1736–1879) perfection of the steam engine in 1776 radically changed all aspects of everyday life, first in England, then in the United States and the rest of Europe. Factories limited by the location of resources could now operate anywhere given a steady supply of water and wood. The steam engine also revolutionized transportation by allowing for steamships and locomotives.

Meanwhile, certain aspects of the imaginary journey of the *contes philosophiques* had become *less* imaginary, due to the success of the steamboat, which lowered freight rates and expanded trade routes, cut transit time, and ultimately created new jobs. It also shrank the world much as social networking has done in the twenty-first century.

With decreased transportation times, as well as communication inventions such as the telegraph, early Victorians like Poe found themselves able to travel and communicate at an exponential speed. The world Poe would leave in 1849 was filled with progressive innocence and optimism; he would not live to see the devastating power industrialization could take on when applied to conflicts like the American Civil War (1861–65), which

OPPOSITE
"Chicago & Alton R.R.—The great palace reclining-chair route...," lithograph by Ballin & Liebler, c. 1880

ABOVE
A steam engine design, probably from a novel

BELOW
"Gen. J. C. Robinson and other locomotives of the U.S. Military Railroad," a wet collodion stereograph taken between 1860 and 1865 near City Point, Virginia

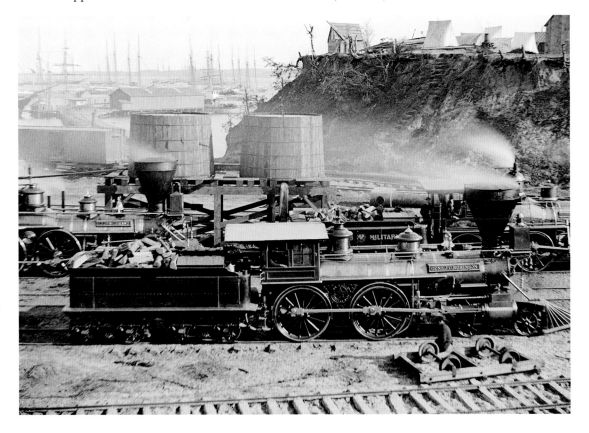

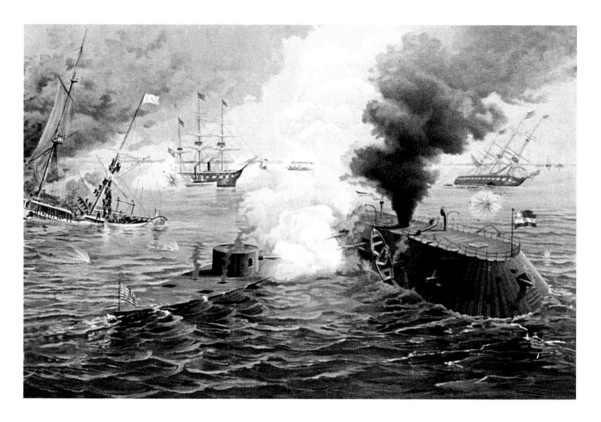

according to historian Tom Chaffin in *The H.L. Hunley: The Secret Hope of
the Confederacy* "produced myriad technological advances. Inventions came
on both the military and home fronts—from weaponry to medicine, from
transportation to communications."

The same advances that led to benign invention would also lead to
monstrosities such as the ironclad. Before the ironclads, warships were
made of wood, leaving them vulnerable to ramming and torpedo attacks.
But because of the pageantry of their battles, the combatants in the Civil
War brought the ironclad's true "benefits" to the forefront. For example,
the record for blockheaded obstinacy might be held by the C.S.S. *Virginia*
(formerly the U.S.S. *Merrimack*) and the U.S.S. *Monitor* during their leg-
endary battle of March 9, 1862. The two vessels repeatedly rammed and
bombed each other, but sustained minimal dam-
age while wooden ships sank around them.

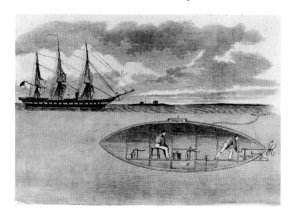

Another groundbreaking innovation with
relevance to the visions of Verne and Wells was
the submarine, created to furtively attack and
sink enemy ships. While great strides had been
made since Robert Fulton's 1803 designs, most
submarines sank before destroying their targets.
This changed when on February 17, 1864, the
H. L. Hunley left Charleston Harbor and sank the
U.S.S. *Housatonic* by ramming the vessel's hull
with its torpedo spar.

The horrors of war, the senseless, grinding purpose to which the new technologies were immediately put, could not help but have an impact on fiction writers of the era, which is why at times the term "scientific romance" seems so inadequate for the message conveyed by the works of both Verne and Wells. Perhaps it is hard to imagine, in the era of stealth bombers and drone aircrafts, the impact these advances had on the public imagination, but we sense it through the works of Verne and Wells.

How they each viewed and processed this brave new world would depend in part on their disparate upbringings and in part on being products of two different times and cultures.

Two Views of Progress

JULES VERNE WAS BORN IN NANTES, FRANCE, WHERE HIS MEMORY lingers in the form of the famous exhibit of mechanical animals based on his creations and the whimsical Jules Verne Museum. He began his adult life studying law, only to have his father cut his funding when he discovered his son still dabbled in playwriting. In 1850, cast out and without an income, Verne began supporting himself as a secretary and stockbroker for the Theatre Lyrique—that is, until he published his first novel, *Five Weeks in a Balloon*, which was influenced by Poe's "The Balloon Hoax" and "The Unparalleled Adventures of One Hans Pfaall." The book was a huge success, and Verne was able to spend the rest of his life writing.

Verne had been in love with travel long before he published a word of fiction. One legend has it that when Verne was a child, he stowed away on a ship embarking for India. When his father found him before the ship left port and punished him, Verne vowed: "I shall from now on only travel in my imagination." And travel he did, through all fifty-four of his *Voyages Extraordinaire*, which took his readers to the moon (*From the Earth to the Moon*, 1865), to the earth's core (*A Journey to the Center of the Earth*, 1864), and beneath the sea (*20,000 Leagues Under the Sea*, c. 1869–70) through feasible but unrealized technological prospects of his day.

By contrast, Herbert George Wells was born in Kent, England, to shopkeepers. He was an intellectually curious child, and received a scholarship to the Normal School of Science in London, where he studied biology

ABOVE
An image from Verne's *20,000 Leagues Under the Sea*, illustrated by Alphonse de Neuville and Edouard Riou, 1873

and awakened to the social and political issues that would inform his work. While Wells excelled in most of his studies, he failed a geology class, forcing him to drop out of the program and pursue freelance writing while scraping by as a teacher.

Wells's first success was *The Time Machine* (1895), a novel that captured the public's imagination and secured his career. The works that followed serve as some of the foundations of modern science fiction, including *The Invisible Man* (1897), *The War of the Worlds* (1898), and *The Island of Doctor Moreau* (1896). All of these fictions depend upon scientific authenticity and imaginative technology, but with themes that follow a clear sociopolitical agenda, unlike in the works of his literary compatriot Verne. In fact, Wells would abandon science fiction early on in his career to turn to sociological and historical nonfiction.

Jules Verne: Sane Invention, Insane Inventor

Verne augmented the tradition of the imaginary voyage with Poe's emphasis on verisimilitude, ensuring that every machine in his fiction was authentic and plausible. So vehement was Verne about verisimilitude that he would often condemn contemporaries like Wells for their carelessness and indifference to engineering and mechanics. This lengthy but fascinating passage, first published in a 1904 *Temple Bar* interview, clearly delineates the difference between the two writers, from Verne's perspective:

I consider him [Wells], as a purely imaginative writer, to be deserving of very high praise, but our methods are entirely different. I have always made a point in my romances of basing my so-called inventions upon a groundwork of actual fact, and of using in their construction methods and materials which are not entirely without the pale of contemporary engineering skill and knowledge.

Take, for instance, the case of the 'Nautilus.' This, when carefully considered, is a submarine mechanism about which there is nothing wholly extraordinary, nor beyond the bounds of actual scientific knowledge. It rises or sinks by perfectly feasible and well-known processes, the details of its guidance and propulsion are perfectly rational and comprehensible. Its motive force even is not secret: the only point at which I have called in the aid of imagination is in the application of this force, and here I have purposely left a blank for the reader to form his own conclusion, a mere technical hiatus, as it were, quite capable of being filled in by a highly-trained and thoroughly practical mind.

The creations of Mr. Wells, on the other hand, belong unreservedly to an age and degree of scientific knowledge far removed from the present, though I will not say entirely beyond the limits of the possible. Not only does he evolve his constructions entirely from the realm of the imagination, but he also evolves the materials of which he builds them. See, for example, his story 'The First Men in the Moon.' You will remember that here he introduces an entirely new antigravitational

ONNEMENT
3 MOIS
2 Fr
DMINISTRATION
& REDACTION
CE de la RÉPUBLIQUE
(Palais Consulaire)
ORAN

L'ALGERIE
COMIQUE & PITTORESQUE

INSERTIONS
S'ADRESSER AU
BUREAU DU JOURNAL
PLACE de la REPUBLIQUE
(Palais Consulaire)
BUREAU
DU PETIT FANAL
ORAN

M. Jules VERNE

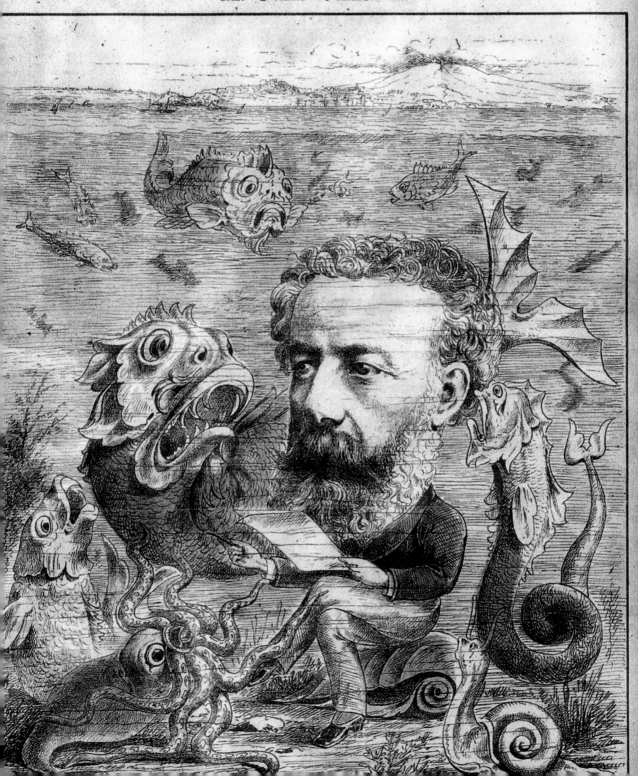

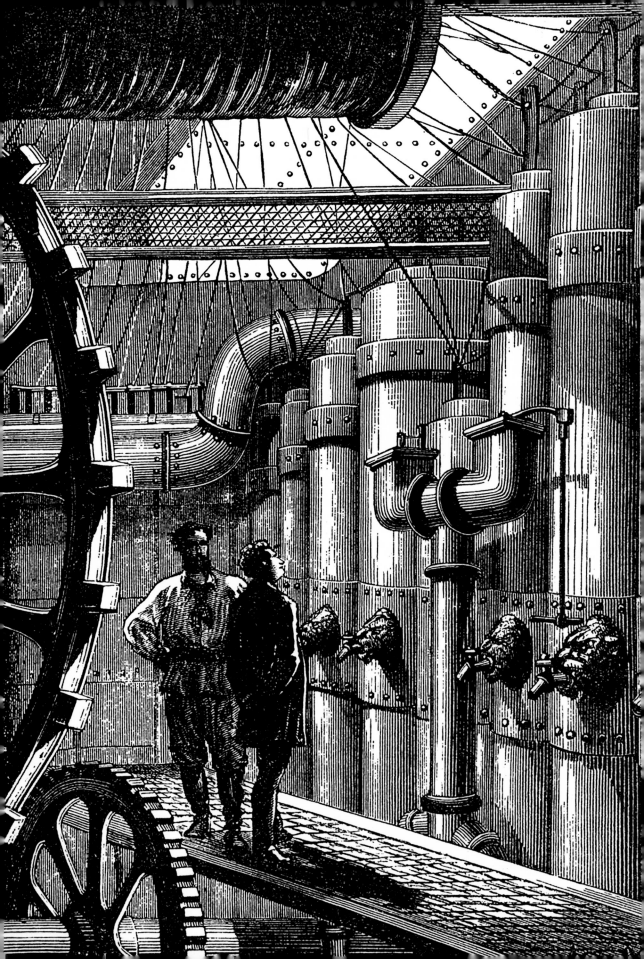

substance, to whose mode of preparation or actual chemical composition we are not given the slightest clue, nor does a reference to our present scientific knowledge enable us for a moment to predict a method by which such a result might be achieved. In "The War of the Worlds," again, a work for which I confess I have a great admiration, one is left entirely in the dark as to what kind of creatures the Martians really are, or in what manner they produce the wonderful heat ray with which they work such terrible havoc on their assailants.

Poor Verne—he could imagine a patently absurd steam-powered elephant, and yet Wells's brand of extrapolation seemed ridiculous and incomplete to him! Verne's obsession with creating realistic detail extended to filling books with verbal blueprints that justified and explained the technology in his novels. While this meticulousness may bore some modern readers, it is, by chance, specifically encoded to appeal to Steampunk makers and artists. The emphasis on the nuts-and-bolts reality of an improbable invention is a key aspect of the Steampunk aesthetic, especially in areas outside of the modern literature. However, the irony here is that on the big screen and in comics, visual depictions of Wells's creations often seem more plausible than those of Verne. At times, Verne's very specificity ensured his creations becoming outdated, while Wells's visions, which left more room for interpretation, more accurately mimicked the look, the progress, and the intent of modern technology. Wells was not an absentminded dreamer in his fiction, and Verne was not always the practical one.

Still, what makes Verne's novels unique and most inspiring to Steampunks is that his writing depended on inventing plausible technologies to drive his stories. Verne went to great pains to make that technology unique, and his mechanical marvels are as memorable as his characters, like the self-sustaining submarine *Nautilus* from *20,000 Leagues Under the Sea*. Shaped roughly like a narwhal, the *Nautilus* terrorizes the oceans while allowing its romanticized captain to live within it like a king. While the *Nautilus* was named after Robert Fulton's 1803 design, Verne most likely modeled his vessel after the *H. L. Hunley*, as Chaffin's description shows:

> Viewed from its stern . . . the craft resembles a whale . . . more so than it does any vessel of war. From a vantage immediately aft of the boat's propeller as one gazes down the craft's forty-foot hull, the appearance of this boat—with its elegant, tapered hydrodynamic shape—evokes the cetaceous more than the material. . . . It seemed obvious that the Hunley's designers [James McClintock, Horace Hunley, and Baxter Watson] wanted their boat to look, and move, like an animal that swims through the sea. . . .

OPPOSITE
The interior of the *Nautilus* from *20,000 Leagues Under the Sea*, illustrated by Alphonse de Neuville and Edouard Riou, 1873
ABOVE
A fanciful flying bicycle, one of many ideas for flying machines of the future

Verne takes the concept of the *Hunley* and expands upon its natural potential. The *Nautilus*'s spar and tapered body allow it to dive straight downward when submerging. Nemo replaces the oxygen in the vessel by surfacing to take on fresh air and release the stale. Even the flooding apparatus developed to moderate the vessel's buoyancy gives it a cetaceous appearance, as the flooding and draining of its tanks makes it spout water as if it were breathing through a blowhole.

ABOVE
Dirigible illustration
BELOW
Underground Explorer, mixed media by Tom Banwell, 2009

But the *Nautilus* is not just a clever narwhal-shaped machine. Verne describes it in the painstaking detail of a blueprint: "It is an elongated cylinder with conical ends. It is very like a cigar in shape, a shape already adopted in London in several constructions of the same sort. The length of this cylinder, from stem to stern, is exactly 232 feet, and its maximum breadth is twenty-six feet." (To save modern readers from falling into a state of "dream story" from which they might not awake, the remaining several hundred words of description are herewith excised; the curious can rejoin Verne's musings in the public domain, online.)

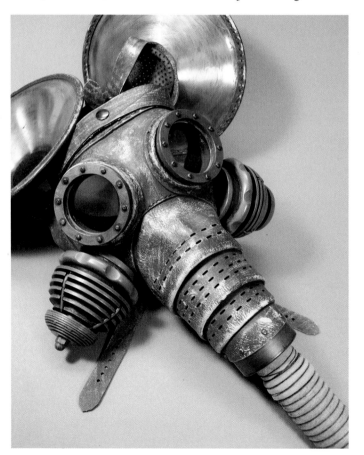

Verne's enthusiasm for combining the natural and mechanical didn't end with the whale, however; he also used this device in *The Steam House, Part I: The Demon of Cawnpore*. The Steam House is a mechanical elephant, armor-plated like an ironclad, which pulls two large houses across India at a speed of fifteen to thirty miles per hour. While most of *Demon of Cawnpore*'s plot is forgettable, the Steam House is not.

Brothers at Sea: Oshikawa Shunrō and Verne's Influence in Japan

By Jess Nevins

While Verne's novels have been influential to generations of writers and artists in the United States and in England, they also captivated Japanese science fiction writers, most notably Oshikawa Shunrō. His Kaitei Gunkan *(Warship at the Bottom of the Sea, 1903) fused the Vernian imagination with the late Victorian war novel. Leading creators of these novels, such as George Griffith and Douglas Fawcett, depicted futuristic conflicts featuring zeppelin armadas and submarine legions. As science fiction scholar Jess Nevins explains below in an excerpt from his* Encyclopedia of Fantastic Victoriana, *Oshikawa merges these themes with fanciful machines manned by the Nemo-like renegade, Captain Sakuragi.*

Captain Sakuragi was created by Oshikawa Shunrō (1876–1914) and appeared in *Kaitei Gunkan* (*Warship at the Bottom of the Sea*, 1903) and four sequels. He has been called "the father of Japanese science fiction," although what he wrote was intended for children rather than adults.

Captain Sakuragi is a naval officer who grows disgusted with the Japanese government's inability to do anything to resist the imperialism of Western governments in Asia and Japan. Whites are carrying out various unnamed incivilities in Japan itself and are bullying other Asian countries. Worse, from Sakuragi's perspective, is that the Western countries are preventing Japan from expanding in Asia in the way that the Western countries did in China. Sakuragi also sees that the Japanese government is not willing or able to do anything about the coming, inevitable war with the Western powers. So Sakuragi quits the Navy and goes to an isolated island off the coast of Shikoku. There he builds himself the

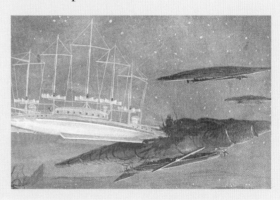

Denkō tei, an "undersea battleship" armed with futuristic weapons, including torpedoes and high-explosive shells, and capable of operating beneath the ocean's waves, on the surface of the ocean, and even in flight. Sakuragi staffs the *Denkō tei* with a small crew of faithful and patriotic sailors and begins fighting for Japan on the high seas. In *Kaitei Gunkan* the *Denkō tei* demolishes a group of white pirates who have been harrying Japanese shipping. In later novels the *Denkō tei* takes on the Russian, British, and French fleets and destroys them.

As with China, Japan has a tradition of novels with fantastic elements that goes back centuries. Chinese *wüxia*, such as *All Men Are Brothers*, were

CONTINUED

popular in Japan in the latter half of the Edo Period (1600–1868). *Wasobei Ikoku Monogatari*, a *Gulliver's Travels*-like novel, was published in Japan in 1774. Following the First Opium War (1839–1842), the Japanese scholar Mineta Fūkō published *Kaigai Shinwa* (1849), a recounting of the Opium War, which stressed the evil intentions of the British toward China. *Kaigai Shinwa* inspired a genre of fictionalized and semifictionalized retellings of the Opium Wars and the Taiping Rebellion, one of which, Iwagaki Gesshū's *Seisei Kaishin Hen* (c. 1855), features a Future War in which the daimyo Tokugawa Nariaki leads a Japanese army to China to defeat British imperial aims.

But modern science fiction began in Japan with the 1878 translation of Jules Verne's *20,000 Leagues Under the Sea*. Verne's work influenced Japanese writers, and imitations of Verne and *20,000 Leagues* began appearing within a few years. In 1890 Yano Ryūkei published *Ukishiro Monogatari* (*Tale of the Floating Fortress*), which took the basics of *20,000 Leagues* and replaced the misanthropic, romantic Captain Nemo with a stalwart Japanese patriot who, aided by a crew of Japanese naval ensigns, fought against and destroyed Caucasian pirates of no specific nationality.

Oshikawa went far beyond Yano. Oshikawa not only included flying machines and other Verne-style science fiction vehicles and devices, but injected a political subtext. Oshikawa's novels describe the evil designs of the Western powers and of Russia toward Asia and Japan and urge the Japanese to join the empire-building games of the Western powers. Oshikawa's work, with its Vernean techno-fetishism, strident patriotism, and negative portrayals of the Western nations, became popular, especially when the Russo-Japanese War of 1904–5 confirmed Oshikawa's years-earlier prediction of that conflict. Oshikawa became influential on his contemporaries, and it was not until the 1930s that Japanese writers of science fiction emerged from Oshikawa's influence.

BELOW
Illustration from *The Angel of the Revolution* by George Griffith, 1893

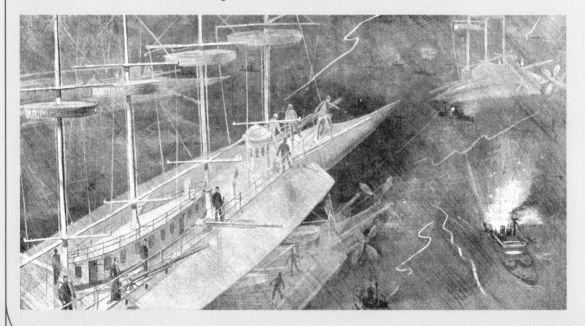

Whether it is a function of a general fascination with pachyderms or an echoing extension of Verne's original, mechanical elephants have become a recurring motif in modern Steampunk, from the work of Russian artists to creators of specialty gas masks.

However, Verne's inventions should come with a warning label: *Do Not Follow Close Behind—Intricately described, whimsical machines may be operated by madmen.* Writing about Verne's obsessed eponymous aviator from *Robur the Conqueror* (1886) in his *Encyclopedia of Fantastic Victoriana*, Steampunk scholar Jess Nevins explains how the Industrial Revolution changed perceptions:

> The engineer/inventor as a powerful and threatening creator is a variation on the mad scientist theme, but it is a departure from the Faustian aspect of the mad scientist. The Faustian mad scientist, best typified by Mary Shelley's Victor Frankenstein, is dangerous because he is not equipped to handle his new knowledge. . . . This is a typical attitude of the early Victorians. After midcentury, however, attitudes toward science began to change, so that it was not the knowledge itself which was dangerous, but rather what was done with the knowledge. In the last half of the nineteenth century portrayals of inventors generally fell into one of two types: the heroic adventurer or the megalomaniac.

It might be too mischievous to suggest that modern-day Steampunk makers and artists also can be identified as either heroic or megalomaniacal types, but all of Verne's characters, whether more or less harmful, fall into the latter category. Robur is an inventor who holds his genius over the world and imagines himself above the law, including regulations against kidnapping. However, compared to Captain Nemo he is nothing but an upstart. Half-martyr, half-murderer, Nemo is an archetype of scientific villainy. Submerged underwater in his self-made home, he tries to escape a dark past and re-create the world in his own image. He is a connoisseur of art and literature (as his grandiloquent library and eclectic museum demonstrate) and appreciates all the little details of his unique surroundings. Nemo can be so charming that even his own prisoners find it hard to hate him. It is this romantic sentiment that gives Nemo his appeal and makes it easier to ignore his murderous and hubristic *vendetta du monde.*

Wells and the Probable Man

Like Poe and Verne, Wells depended upon verisimilitude. In describing his inventions, he mingles scientific jargon and facts in his storytelling to make it seem authentic. However, Wells was interested in creating suspension of disbelief, not highly detailed realism. While enthusiasts can try to replicate the internal and external mechanics of Nemo's *Nautilus* by closely reading the text, the explanations of the Time Machine and the Martians' Tripods, along with their chemical ray guns, are not described so specifically that they can be re-created in the real world. (The irony is that despite their detail, Verne's creations probably wouldn't have worked as inventions, either.)

Wells viewed his stories as fantasy and his machines as art, not arti-facts—in a sense presaging modern Steampunk creators, who often blur the line between maker and artist. In his preface to the 1934 edition of *Seven Famous Novels*, Wells finally had a chance to address the ghost of Verne, writing:

> [Verne's] work dealt almost always with actual possibilities of in-vention and discovery, and he made some remarkable forecasts. The interest he invoked was a practical one; he wrote and believed and told that this or that thing could be done, which was not at that time done. He helped his reader to imagine it done and to realize what fun, excitement or mischief would ensue. . . . But these stories of mine . . . do not pretend to deal with possible things. . . . They are all fantasies; they do not aim to project a serious possibility; they aim indeed only at the same amount of conviction as one gets in a good gripping dream. They have to hold the reader to the end by art and illusion and not by proof and argument, and the moment he closes the cover and reflects he wakes up to their impossibility.

Indeed, Wells may have thought of his inventions as art, but scholar Brian Stableford views them as a narrative update necessary for science fiction to continue into the twentieth century. By revamping the tradi-tional science fiction narrative, Wells's inventions—which Stableford calls "facilitating devices"—made the dream story and future prediction more plausible.

Prediction was important to Wells, perhaps more than any other as-pect of science fiction. Despite his memorable machines, Wells was not interested in technological possibilities but in human beings' social and political potential. In the *War of the Worlds*, the Martians' devastating tech-nology serves as anthropological description. Comparing the Martians to nineteenth-century imperial powers, Wells is able to relate a parable—and astute modern creators like Ian Edginton and D'Israeli in the graphic nov-els *The Great Game* and *Scarlet Traces* have expanded upon these themes in their own work. *The Time Machine,* by way of contrast, is a vehicle for class commentary that fits well with the spirit of the age. For example, outside the realm of speculative fiction, American writers such as Theodore Dreiser were taking on social iniquities using the medium of the novel (and of-ten providing compelling character portraits as well). As biographer W. Warren Wagar states in *H.G. Wells: Traversing Time*:

> Now for anyone with the slightest knowledge of what was happen-ing in Europe and America in the late nineteenth century, the theme of Wells's tale is transparent. *The Time Machine* is a parable of class war-fare. Biology disclosed the possibility of devolution, but knowledge of the "Social Question," the intensifying conflict between capital and la-bor, suggested along what lines the devolution was most likely to occur.

It is Wells's preoccupation with the social question, not just with oth-erworldly gadgets, that informs certain aspects of Steampunk culture,

from the new awareness of the green movement to the anarchists who run *SteamPunk Magazine*. Social awareness is pivotal to the best practitioners of Steampunk, which has always been conscious of the nineteenth century's less inspiring moments. While that era featured great strides in aesthetics and technology, politically it was tainted by colonialism, imperialism, and racism—the first two issues, in particular, at the forefront of Wells's scrutiny. While Wells had his own share of Victorian narrow-mindedness when it came to race and conquest, his most influential novels grapple with the issues of sustainability and social justice. His particular gift was to use science fiction elements to combine an entertaining story with serious exploration of important issues. It is interesting that with those elements stripped away, Wells was unable to use entertainment as a delivery system for his ideas, and his mainstream, more realistic fiction is largely unreadable today.

In their own ways, both authors drew inspiration from the ambiguities of technological progress and built upon Poe's techniques to create parallel worlds filled as much with horror as with beauty. In so doing they would provide ample influence and provocation for the Steampunk culture of the late twentieth century and thereafter, which continues to be faced with a choice: to engage with similar issues, in a modern context, or to take from Verne and Wells just their Victorian settings and surface fascination with strange inventions and mad scientists. The extent of the dialogue still ongoing between the past and the present becomes apparent when one considers how Verne and Wells can be said to be in conversation with such diverse modern Steampunk creations as the updated antique mechanics of Jake von Slatt's Steampunk Workshop, the

ABOVE

An image from *The War of the Worlds*, illustrated by Warwick Gobles, and serialized in *Pearson's Magazine*, 1897

NEW YORK
FIVE CENT LIBRARY

Entered According to Act of Congress, in the Year 1892, by Street & Smith, in the Office of the Librarian of Congress, Washington, D. C
Entered as Second-class Matter in the New York, N. Y., Post Office, August 26, 1893. Issued Weekly. Subscription Price, $2.50 per Year. August 26, 1893.

No. 55. STREET & SMITH, Publishers, NEW YORK. 31 Rose St., N. Y. P. O. Box 2734. 5 Cents.

Electric Bob's Big Black Ostrich;
Or, LOST ON THE DESERT.

By the Author of "ELECTRIC BOB."

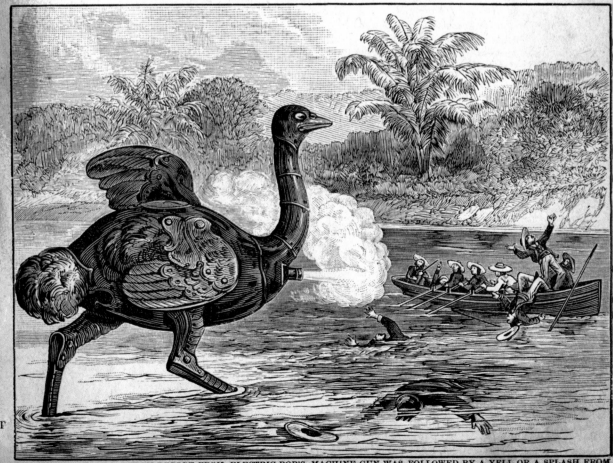

BANG! BANG! BANG! EVERY REPORT FROM ELECTRIC BOB'S MACHINE GUN WAS FOLLOWED BY A YELL OR A SPLASH FROM THE ENEMY.

colorful *Graham's Magazine*–like fashion portraits of Libby Bulloff, the mad scientists of the movie *City of Lost Children*, the mechanical compositions of Vladimir Gvordski, and Dr. Evermor's Forevertron structures. Not since art nouveau or even surrealism has one idea permeated culture so completely, or been dependent on two such peculiar and unique antecedents.

The Forgotten Influencer: The Steam Frontier

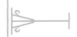

WHILE VERNE EXPLORED THE IMAGINATION IN FRANCE AND WELLS supplied political and social commentary on British imperialism, a peculiar offshoot of the imaginary voyage took hold in the United States, one that, it could be argued, created an optimistic, escapist form of the "mad inventor" theme with a limited but acute influence on modern Steampunk. Perhaps best known for popularizing the Horatio Alger stories, dime novels often served as proponents of the American Dream, portraying a rise from rags to riches. The Edisonade was the science fiction form of the dime novel and typically featured a young boy inventor escaping his stagnating environment and, usually with nationalistic implications, heading West using a steam vehicle built from scratch.

The first Edisonade, Edward S. Ellis's "The Huge Hunter, or the Steam Man of the Prairies," debuted in August 1868 in *Irwin P. Beadle's American Novels*, #45. Protagonist Johnny Brainerd is a hunchbacked dwarf who constructs a Steam Man, which, like Verne's mechanical elephant, pulls Brainerd and his sidekick Baldy Bicknell rickshaw-style to the Western frontier. There, he meets "The Huge Hunter," and together they mine gold, kill Indians, and return to Brainerd's hometown as heroes.

"The Huge Hunter" was reprinted in 1876, and its commercial success spawned a myriad of imitations. Among the most popular were Harry Enton's "Frank Reade and His Steam Man of the Plains" and its follow-up series, Luis Senarens's spin-off "Frank Reade Jr. and His Steam Wonder," which lasted for 178 stories. While the Edisonade tradition flourished for twenty years, the plots never strayed far from the original "Huge Hunter." Only the machines distinguished the stories from each other, and each magazine tried to outdo the others with fanciful and Verne-like contraptions like Robert Toombs's "Electric Bob's Big Black Ostrich"—recently parodied by an anonymous writer called the "Mecha-Ostrich" in "A Secret History of Steampunk" from the 2010 anthology *Steampunk Reloaded*.

The Edisonade offers an alternative model to the Verne/Wells "gentleman explorers"—mad geniuses with mad money—and the adventures of the former are that much more fantastical to lower-class dreamers as a result. The boy geniuses of the Edisonade are rich in intellect alone, but that

OPPOSITE
Original cover for the short story "Electric Bob's Big Black Ostrich," written by Robert Toombs, 1892

proves sufficient for success, providing, for white males, an affirmation of a "can-do" attitude.

But although the cover illustrations for these adventures often seem whimsical, the content would be appalling to present-day readers, full of unapologetic racism and jingoism. According to scholar Jess Nevins in the *Steampunk* anthology, the Edisonades' strongest contribution to Steampunk may be a tradition to rebel against:

> [H]owever unconsciously, first generation Steampunk writers used Steampunk to invert the ideologies of the Edisonades. Without too much exaggeration this inversion can be compared to what Claude Levi-Strauss described, in his *The Raw and the Cooked* (1970), as an axis of human culture, running from "the raw," the products of nature, to "the cooked," the products of human creation. Cooking, a quintessentially human activity, takes the basic elements and creates a meal, so that civilization is achieved through the act of cooking—or, more abstractly, through refinement, the winnowing out of the unhealthy, the crude, and the wild.

This idea harkens back to Wells's social awareness and scrutiny, making parts of Steampunk culture more than just an aesthetic movement. Steampunk focuses on the Victorian era not only because of its aesthetic and technology, but because it recognizes within that epoch issues similar to those facing society in the twenty-first century. As Nevins writes:

> Steampunk is a genre aware of its own loss of innocence. Its characters may be innocent in the context of their words, but Steampunk writers are all too aware of the realities which the Edisonade writers were ignorant of or chose to dismiss. . . . Accompanying this lack of innocence is an anger and a rebellion against much of what the Edisonade's [sic] stood for. . . .

That anger can be seen most fully in Joe R. Lansdale's mash-up "The Steam Man of the Prairie and the Dark Rider Get Down: A Dime Novel" (1999), which brings in elements from Wells's work to deconstruct the Edisonade in a perverse and willful fashion. The fast-paced adventure plot, the emphasis on innovation as a means to success, and the ambitious drive of Edisonade protagonists also can be seen in novels like Cherie Priest's *Boneshaker*, even if Edisonades are not the primary influence. Priest's protagonists come from lower-class backgrounds and, like Brainerd, use their wits to survive and conquer. Her alternative-history Seattle allows her to emphasize a Western setting similar to those in the Edisonade, but from a distinctly female, progressive perspective. Books like *Boilerplate* by Paul Guinan and Anina Bennett, meanwhile, have spoofed the Edisonade as part of a progressive approach to presenting historical detail.

BOILER PLATE

WEEKLY MAGAZINE,

Containing Stories of Adventures on Land, Sea & in the Air.

Issued Weekly—By Subscription $2.50 per year. Application made for Second-Class Entry at Post-Office.

No. 13. JANUARY 23, 1903. Price 5 Cents.

FROM ZONE TO ZONE; OR, THE WONDERFUL TRIP OF CAMPION, JR., WITH HIS LATEST AIR-SHIP

By "NONAME".

Clambering over the deck of the Dart were a number of fur-clad forms.
At first the explorers thought them human beings;
but a closer glance showed that they were huge white bears.

⊠ ⊠ ⊠ ⊠ ⊠

While all of Steampunk's various branches—painting, fiction, sculpture, fashion, film, comics, music, and making—can include the same innocent curiosity of early science fiction writers like Poe, the world Steampunk has inherited is the technological nightmare that Verne and Wells predicted at their most cynical, with regard not only to war, but also to issues like sustainability. Taking from Verne the gift of a fantastical and playful imagination, and utilizing Wells's sociological approach to facilitate changing the future, Steampunk rewrites blueprints, reinvents steam technology, and revamps the scientific romance to create a self-aware world that is beautiful and at times nostalgic, but also acknowledges dystopia.

Interestingly enough, whether it was the Edisonades as a catalyst or, more usually, Verne and Wells, these elements didn't result in the immediate establishment of a subgenre or movement. Instead, for many decades

BELOW
Art for the utopian travel notebook "Les mondes inventés" ("Imaginary worlds") by Stéphan Muntaner, 2008

these influences were used by forward-thinking writers as a foundation for extrapolation that created the modern genre of science fiction as we know it. Only in the 1970s would a form of "Steampunk" arise in literature, presaging a commensurate rise of a Steampunk subculture in the 1990s and aughts.

According to Nevins, "Science fiction didn't really become backward-looking until then. You certainly had alternate histories and historical fantasies before then, but the focus on the past, both technology (steam) and previous society (Victorian London), wasn't a feature in the thinking of SF or fantasy writers. . . . The concepts of Wells/Verne/Edisonades were influential during the non-Steampunk decades, but not in a way that manifested itself as anything even close to Steampunk."

When this type of science fiction finally did resurrect itself as "Steampunk," many of the themes would be the same, but the emphasis and context would be different, sometimes radically so.

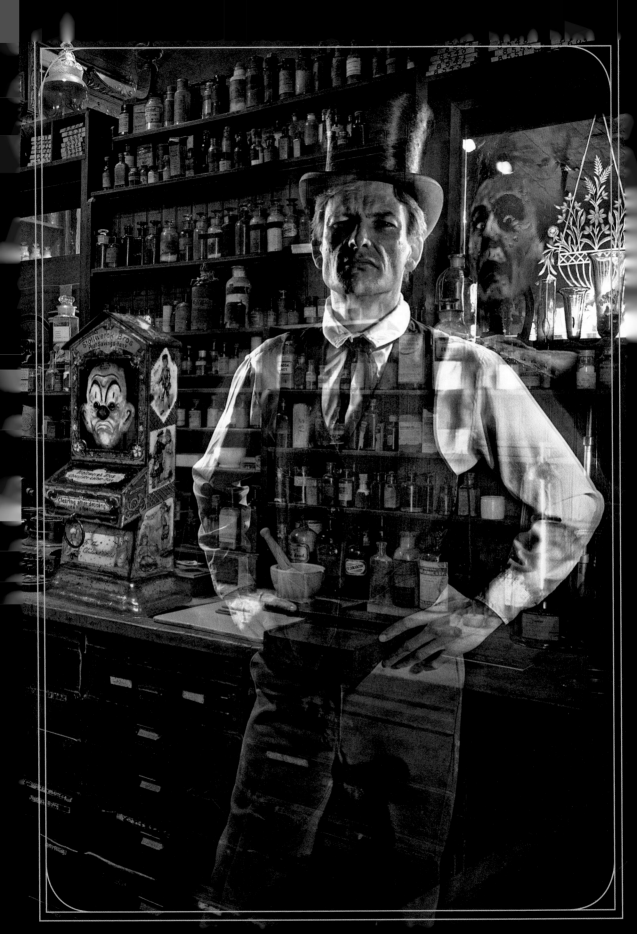

CLANKING
METAL MEN,
BAROQUE AIRSHIPS,
AND
CLOCKWORK
WORLDS

The Fiction, Illustrated Narratives, and Story Behind the Stories

"I think Victorian fantasies are going to be the next big thing, as long as we can come up with a fitting collective term . . . like 'Steampunk,' perhaps."

K. W. Jeter, *Locus Magazine*, letter to the editor, April 1987

Three Steampunks Walk into a Bar...

YOU COULD ARGUE THAT ALL OF THE PLEASURES AND CONTRADICTIONS of modern Steampunk originated in a bar called O'Hara's in Orange, California. It was there in the mid-1980s, a century after Verne and the Edisonades, that the three writers most closely associated with the rise of modern Steampunk would meet to drink beer and bat around ideas.

Then in their early twenties, Tim Powers, K. W. Jeter, and James Blaylock lived ten minutes apart and had read Victorian and Edwardian literature in college. Powers recalls that they would read one another's manuscripts and critique them, unaware, according to Blaylock, that they might be creating an entire subgenre of fiction.

"We'd kill pitcher after pitcher and work out plot details," says Powers. "Jeter was best at that, and frequently gave me plot twists that flat-out saved novels."

Blaylock doesn't remember using the term "Steampunk" much at all, but does recall "writerly research" and "Jeter saying something disparaging about my notion of science, suggesting that I wouldn't hesitate to have my characters try to plug a hole in space with a fits-all-sizes cork. I asked him if I could have the idea, and I went home and wrote the story 'The Hole in Space.'"

It was Jeter, Powers confirms, "who made Blaylock and me aware of the cornerstone of Victorian London research work (at least when you need seedy low-life color), Henry Mayhew's *London Labour and the London Poor*."

At the time, Blaylock says, "Neither Tim nor I considered ourselves part of any literary movement . . . and in fact later on I had forgotten entirely that Jeter was responsible for the term

PREVIOUS SPREAD, LEFT
J. K. Potter's cover art for James Blaylock's *Lord Kelvin's Machine* (Arkham House, 1992) as revised for the cover of Blaylock's *The Adventures of Langdon St. Ives* (Subterranean Press, 2008)

BELOW, LEFT
Tim Powers, 1997

BELOW, RIGHT
James Blaylock, 1996

[Steampunk], and blamed it for a period of time on editor and writer Gardner Dozois."

The works they created now identified as Steampunk include Powers's *The Anubis Gates* (1983), Jeter's *Morlock Night* and *Infernal Devices*, and Blaylock's *Lord Kelvin's Machine*. All three authors, each in his own way and in his own style, were writing a form of alternative history based in Victorian times. *The Anubis Gates*, for example, combines Wellsian time travel with a story of ancient gods and British rule over Egypt. Romantic poets make cameos, including the fictional William Ashbless, conjured up by Powers and Blaylock. *Infernal Devices* deals in Steampunk through clockwork inventions and automata. *Lord Kelvin's Machine*, an expansion of a long story published by *Asimov's SF Magazine* in 1985, features the historical Lord Kelvin, a physicist and engineer who made essential contributions to the laws of thermodynamics. Dirigibles figure prominently in the proceedings.

In these books, Blaylock, Jeter, and Powers created excellent adventure and mystery narratives, often with a social emphasis, a focus on clockwork/steam technologies, and a definite awareness of Verne and Wells. In a sense, these were American homages to England, but with attention paid to issues of class from a kind of Dickensian perspective.

Why Victorian fantasy?

Blaylock: "Mostly I'm attracted to the stuff: the airships, submarines, clockwork/steam technology. I'm pretty sure that most people were happy to dismantle old clocks when they were kids, just to take a look at the gears and mechanical debris inside. I like intellectual/scholarly efforts to explain

ABOVE
The Anubis Gates by Tim Powers (Ziesing Books, 1989)
BELOW
J. K. Potter's *Dr. Ignatio Narbondo's Submarine*, which appeared in James Blaylock's *The Ebb Tide* (Subterranean Press, 2008)

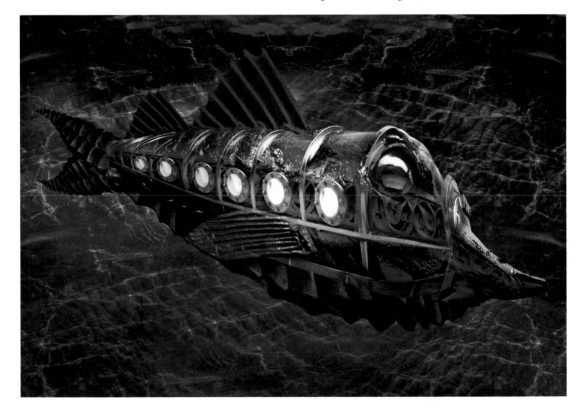

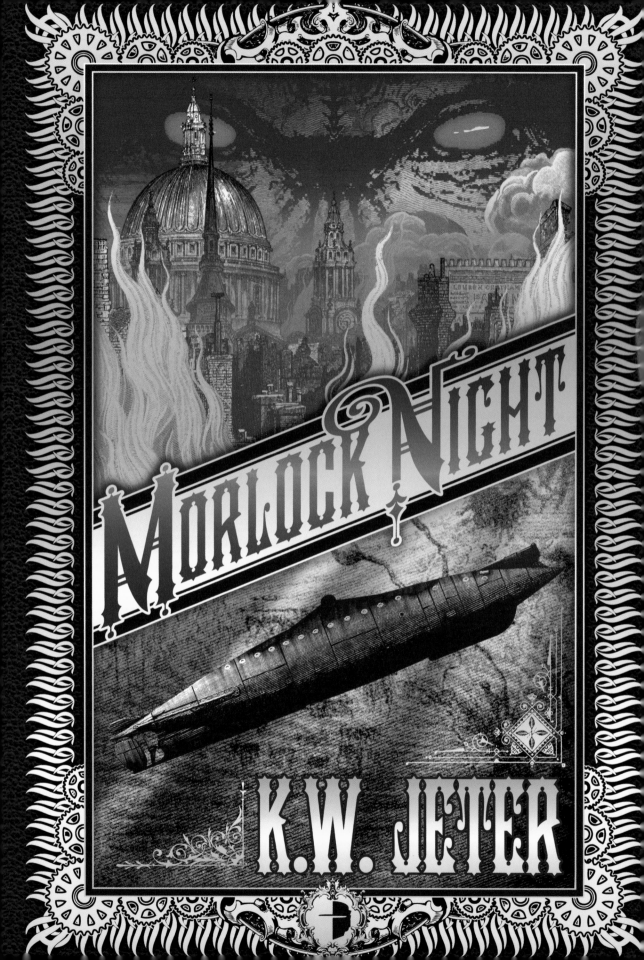

and define it but the costumes and the goggles with gears sprouting from the corner and the steam-powered rayguns are simply a lot of fun."

Jeter says that a good deal of his initial inspiration for *Infernal Devices* "came from a visit to London and discovering a shop [near Covent Garden] that specialized in old scientific gear. . . . You knew that real people living in a real time had created them, and that they weren't just stamped out of plastic in some hellhole factory in China." However, inspiration was also close to home: "The advantage of growing up in Southern California in the fifties and early sixties was that there was still some evidence of that sort of machine-age handcraftsmanship, such as the now-vanished Angels Flight tram in Los Angeles, the old steamship modern Pan Pacific Auditorium (now gone as well), the Craftsman bungalows in the old neighborhoods of Pasadena and Glendale, etc. So to some degree the whole Victorian craftsperson period seemed like a glorious tide that had once washed over the world, and left a few shining bits behind in odd places."

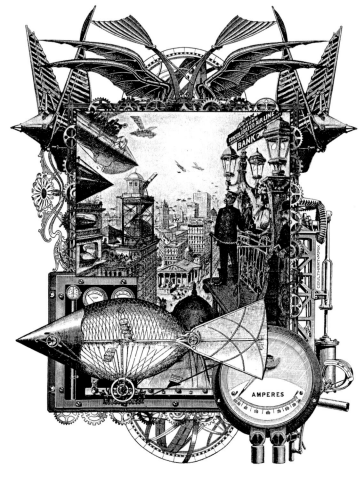

From the start, then, regardless of whether a particular fiction addressed political or social concerns, perceived "Victorian" technology would remain a constant focus. The ongoing Steampunk love for outdated and baroque technologies tends to emphasize the fanciful evolution of "big concepts" like airships and robots. By 1987, however, *very real* technological extrapolations envisioned for better or worse by Verne and in the gung-ho Edisonades had mostly come to naught—for example, the *Hindenberg* disaster that, legend has it, killed the dirigible as a viable competitor to the airplane. This fixation on the machines of yesteryear means that modern Steampunk fiction always runs the risk of descending into irrelevance. The tension between the real and the unreal has created works with a sense of irony and loss, but also those that operate by way of nostalgia and that achieve their effects using Steampunk images without any accompanying "weight of the real."

Another strain of the genre would seek to serve as a corrective.

A Young Steampunk's Guide to Subgenres

Steampunk fiction has become so popular that terms have been coined for several off-shoots. Are these actual sub-subgenres? Probably not. Are some of them frivolous? Perhaps, but having even more highly specialized terms is never a bad thing, right?

BOILERPUNK

The blue-collar answer to aristocratic Steampunk, incorporating the experiences and hardships of the workers actually shoveling coal to bring steam to the upper classes. Vive la revolution! *"Aimsley threw the hot coal at his supervisor's protective steam-powered mask; the man didn't even flinch, being accustomed to it from the proletariat."*

CLOCKPUNK

Clockwork technologies replace or supersede traditional steam power. *"Aimsley got his finger stuck in the gears and screamed, even as he realized his miscue would throw all of London off schedule."*

DIESELPUNK

A heresy in which diesel fuel and nuclear power replace steam power in alternate histories that often have a political component. *"Aimsley pushed the baroque OFFLINE button, but the diesel fuel continued to feed the reactor, with devastating consequences."*

GASLIGHT ROMANCE

A mainly British term for alternative histories that romanticize the Victorian era. Some Brits would argue that all American Steampunk is actually gaslight romance. *"Aimsley put on his monocle and, bypassing the door leading down into the boiler room and the brutes who worked there, went to the quarterdeck of the airship, there to enjoy a nice cucumber-and-prawn sandwich edged with gold leaf as the servants wiped the floor clean of the blood from the recent encounter with the enemies of the Empire."*

MANNERSPUNK

Fiction that may or may not be deemed Steampunk, in which elaborate social hierarchies provide the friction, conflict, and action of the narrative, usually in the context of endless formal dances. At parties. In mansions. *"Aimsley took the hand of Lady Borregard and swept her across the dance floor, away from that cad Bennington and his steam-powered shoes that never missed a step; 'Darling,' he said, 'what rumors do you hear of the Countess Automaton and her piratical sub-siblings in the boiler room; isn't it scandalous?'"*

RAYGUN GOTHIC

Although not strictly a subgenre, this type of retro-futurism based in part on art deco and streamlined modern styles has been used for a variety of science fiction settings, usually in movies. Coined by William Gibson, the term has become more useful in the context of Steampunk as the fiction has come to feature more and more tinkers and artists. *"Aimsley soldered the door to the boiler room shut in an attempt to stall the Revolution a couple of hours more, using his ultrachic GSG (Gothic Solder Gun), which he had baroqued-up on orders from the Queen herself."*

STITCHPUNK

Fiction influenced by the DIY and crafts element of Steampunk, with a prime example being the animated movie *9*, in which cute Frankenstein doll–creatures stitched together from bits of burlap sack try to save the world. In a wider context, Stitchpunk emphasizes the role of weavers, tinkers, and darners in Steampunk. *"Aimsley was soon accosted by the homeless tinker-weavers living in the shadows of the boiler room. 'Only through the loom may you be free, comrade,' they would say."*

THE HISTORY OF STEAMPUNK FICTION HAS HAD MANY STOPS AND starts, with outposts forming along the way that didn't necessarily influence the books written directly thereafter. While Blaylock, Jeter, and Powers may have spun excellent, imaginative adventures in the late 1980s, another kind of proto-Steampunk had been around since the 1970s in the form of Michael Moorcock's Nomads of the Air trilogy (1971–81).

According to Steampunk expert and critic Jess Nevins, "[the books] had the basic elements of the genre but were not full-fledged Steampunk, not least because I'm unsure that you can have Steampunk before the subgenre developed. In the same way, I'd call the mystery and detective stories which appeared before Poe 'proto-mysteries.'"

The airships in Nomads of the Air aren't always of the steam-powered variety, but this quibble aside Moorcock can almost certainly be considered a modern godfather of Steampunk. His series features fierce battles between opposing fleets of airships, along with complex political and military intrigue. The novels were, Moorcock says, "intended as an intervention, if you like, into certain Edwardian views of Empire. They were intended to show that there was no such thing as a benign Empire, and that even if it seemed benign, it wasn't. The stories were as much addressed to an emergent American Empire as to a declining British. I was shocked when the

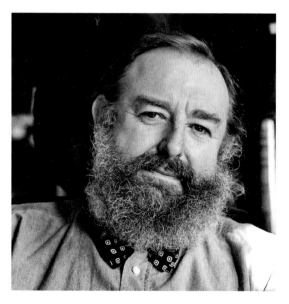

BELOW
Michael Moorcock, 1990s

tools I'd selected to tell [my Nomads of the Air stories] were taken up by many others merely (in my view) to tell cool adventure stories where airships buzzed about the skies and had big fights and stuff in a world, say, where World War II was still being fought or whatever. The very nostalgia I had attacked was celebrated!"

Moorcock's books rejected the gung-ho image of the inventor from the Edisonades and any other glorification of modern technology, arguing that such technology would almost always be used by governments for suppression. For this reason, he seems less of an influence on the California trio and more closely aligned with the seminal work of the first wave of Steampunk, William Gibson and Bruce Sterling's *The Difference Engine*, which rejects nostalgia completely. Published in 1990, *The Difference Engine* was nominated for the Nebula Award, the John W. Campbell Award, and the Prix Aurora Award. It is the work most cited by members of the Steampunk subculture who have not read much of the fiction, even though novels by Blaylock, Jeter, and Powers predate it.

The Difference Engine fits into the Steampunk canon as a form of "historical Cyberpunk." Most Cyberpunk is dark techno-fiction set in the near

future, but *The Difference Engine* is set in 1855 in a dystopian alternate reality in which Charles Babbage successfully built a mechanical computer, thus ushering in the Information Age at the same time as the Industrial Revolution. Lord Byron leads an Industrial Radical Party, antitechnology revolutionaries are suppressed, and the British Empire grows to be a superpower. Meanwhile, the United States has been fragmented into several countries, including the Republic of California and a Communist Manhattan Island Commune. In this context, the British Empire cultivates scientific achievement, giving Charles Darwin, among others, a peerage.

The novel's many Steampunk pleasures include jet-powered dirigibles fueled by coal dust and a vast and somewhat clunky mechanical AI housed in the facade of an Egyptian pyramid, occupying several city blocks in London and tended by white-robed monks with oilcans. The novel gives a nod to the Edisonades, in that one of the characters, Lawrence Oliphant, "is smuggling proto-SF Edisonade pulp novels to the crown prince of Greater Britain. 'Wheel-Men of the Czar' is one of them, as I recall," says Sterling.

These touches aside, Sterling and Gibson, like Moorcock, are mostly concerned with exploring the "what if" scenario of an expanding Empire intertwined with a concurrent Information/Industrial Revolution. They gleefully delve into the corrupting influence of even seemingly benign technology.

Did the work of Blaylock, Jeter, and Powers have any influence on *The Difference Engine*? Only in the most general way, according to Sterling: "I'd guess the greatest influence on us was the liberating willingness of these three Californian SF writers to boldly pretend to be experts on nineteenth-century Britain. That took some laudable nerve. That, and the good idea of reading Henry Mayhew."

Sterling and Gibson's association with Cyberpunk had a pervasive effect on fiction, movies, and pop culture. As a result, *The Difference Engine* would initially have a greater impact on Steampunk fiction than the novels that preceded it. Indeed, it would be tempting to say that the California trio, collectively, are to Steampunk what John Fitch was to the steamboat. Fitch created the first working steamboat, but it was Robert Fulton (as the parallel to Sterling/Gibson) who made the steamboat commercially successful. However, the truth is the influence and popularity of Steampunk fiction written in the 1980s would rise and fall until the late 2000s. Steampunk as a fashion wouldn't take hold until the late 1990s, and in the absence of a supporting subculture, Steampunk as fiction proceeded only in fits and starts, with no core fan base to fuel it.

 ## Interregnum and Rebirth

THE PERIOD FROM 1991 TO ABOUT 2007 COULD BE CONSIDERED A kind of Steampunk Interregnum, during which works came into print but were either described as science fiction, science fantasy, or alternative history. There was no brilliant, quintessentially Steampunk follow-up to *The Difference Engine* from Sterling and Gibson, or anyone else. Instead, a few novels and short stories began to take advantage of the space created by earlier works, incorporating what we now call Steampunk elements. These books form a lifeline between the original innovation by a few key authors in the 1980s and today's explosion of novels from a variety of writers.

In particular, three books published in 1995 built on the foundation of prior works in interesting ways: Paul Di Filippo's *Steampunk Trilogy*, Neal Stephenson's *The Diamond Age: Or, A Young Lady's Illustrated Primer*, and Philip Pullman's *The Golden Compass*. (Neil Gaiman would later be shoehorned into Steampunk by dint of an MTV interview, but his fiction is a brand of uniquely English fantasy that only vaguely touches on the concerns of Steampunk.)

The Steampunk Trilogy is a freewheeling series of three novellas that range from an outrageous romp about the replacement of the Queen of England with a giant salamander to a baroque affair between Emily Dickinson and Walt Whitman. Di Filippo's gonzo humor is on full display as he adds his own slant to Steampunk, influenced by the work of Blaylock and Moorcock. Stephenson's *The Diamond Age*, meanwhile, is often described as a "post-Cyberpunk" novel, but contains many neo-Victorian

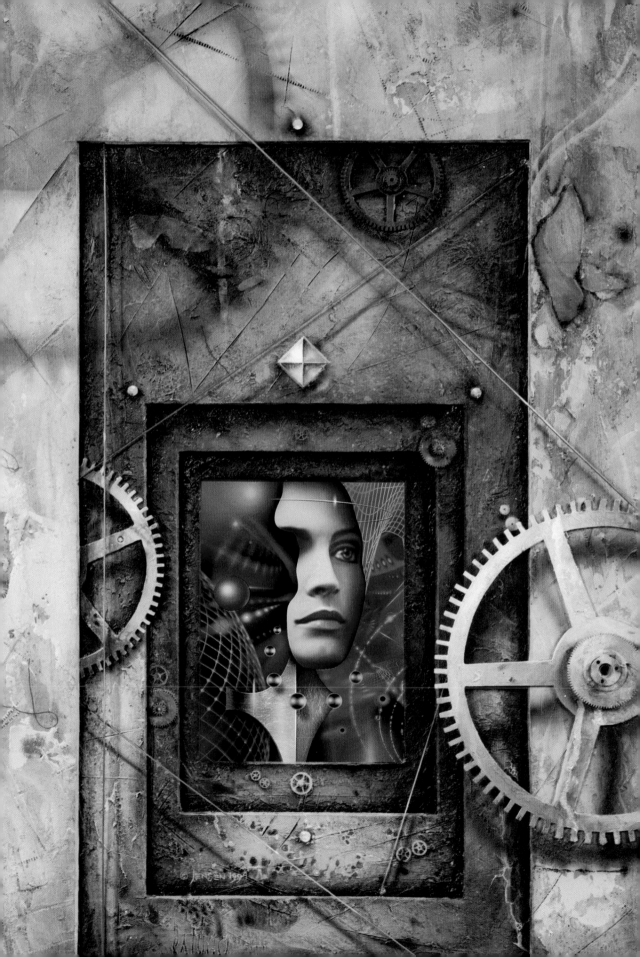

Blowing Off Steam

By Catherynne M. Valente

Are you concerned about the amount of steam in your Steampunk? So is Catherynne M. Valente, an award-winning novelist whose intricate fantasies such as Palimpsest *and the duology* The Orphan's Tales *combine avant-garde storytelling with traditional folktales. Her short story "The Anachronist's Cookbook" takes a hard look at the realities of the Victorian period. Here, Valente discusses the one essential element to Steampunk that often goes missing—the steam.*

There comes a time in the life of every young novelist when she starts to think zeppelins are *really* cool, and corsets and goggles and vague gear-based science seem to lurk around every corner, opening their jackets to her nubile gaze and revealing a lining sewn with all the books she might write involving Victoriana and steam-powered rockets.

Parents, talk to your children about Steampunk.

It's everywhere these days, isn't it? Anime, *Doctor Who,* novel after novel involving clockwork and airships. Young women going about in *bustles,* for heaven's sake! But it's just as easy for the kids these days to get impure Steampunk, cut with lesser punk materials.

Let me say it now and for all time, for the protection of your little ones: You can't have Steampunk without steam.

Most of the product on the street these days would more adequately be termed Clockpunk or Gearpunk—though the golden age of clocks was about a century too early to bear the ubiquitous Victorian sticker with which we plaster everything from the Enlightenment era to Belle Époque. If there's a corset and a repressed manservant, by God, it's Victorian. Steam power itself seems rather inconvenient, bludgeoned out of the way by corpulent balloons and quasi-Dickensian dialogue.

It is my understanding, poor, unhip child that I am, that Steampunk correlates precisely with Cyberpunk, substance of choice of the last generation: literature which addresses and delineates anxiety (hence the *punk,* also ubiquitous, also nearly meaningless now) concerning new technology, computers in the first case, steam power in the second. Yet in almost everything I've ever seen called Steampunk (besides the powerfully adequate *Steamboy* film), there is no actual steam power to speak of, and precious little anxiety. Because we, in our current, painfully neo-Victorian culture, think all that old-fashioned stuff is *so damn cool,* well, the actual Victorians must have loved it, too, right?

Dare to tell your wee wastrels that it's not all quaint manners and cufflinks—steam technology caused horrific scalding and often death, thrill-

ing explosions and utter terror and unfathomable joy (and which one often depended entirely on whether you owned the factory or worked in it). Tell them of a world which was changing so very fast, devouring itself in an attempt to lay just one more mile of railroad track.

Again, I return to *seriousness* as a necessary addition to fantasy: If you want Victoria in your coat pocket, if you want the world that comes with her, all that possibility, all that terrible, arrogant, gorgeous technology, *take it all*, make it true, be honest and ruthless with it, or you're just gluing gears to your fingers and running around telling everyone you're a choo-choo train. Get punk or go home—and think, for just a precious second, about what punk means, the rage and iconoclasm and desperation, the nihilism and unsentimental ecstasy of punk rock. I've heard the punk suffix mocked soundly by everyone I know—*but we should be so lucky as to live up to it.*

If you're going to go prowling for top-hatted villains at night, seek out the pure stuff, the real, filthy, ugly, euphoric sludge at the bottom of a spoon, because that's the Victorian era, that's steam power, that's a world shredding itself to death on the spindle of industry, hoping to wake up to a prince in a hundred years. No one wants to get screwed with a bag full of Drano and flaccid research.

But gears are so *pretty*. So *easy*. Why, you hardly need to know any science at all! Just stick a gear on it and it's golden! Come on, Mom, just one clockwork automaton, please? Don't be such a hardass.

And you can have them. They can talk like C-3PO and everyone can eat gearcakes with brass icing for tea, and it can be a beautiful thing, but you mustn't call it Steampunk.

ABOVE
Catherynne M. Valente (right) and S. J. Tucker, 2009

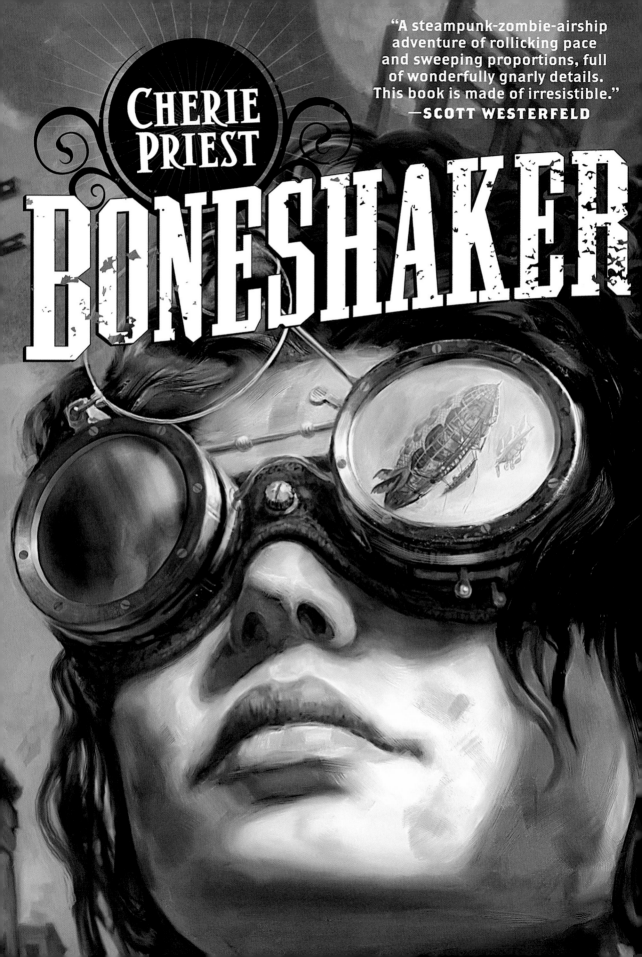

CHERIE PRIEST

BONESHAKER

"A steampunk-zombie-airship adventure of rollicking pace and sweeping proportions, full of wonderfully gnarly details. This book is made of irresistible."
—SCOTT WESTERFELD

elements wedded to nanotechnology; if *The Difference Engine* could be described as "historical Cyberpunk," then *The Diamond Age* could be described as "futuristic Steampunk." Pullman's *The Golden Compass* features an alternative, vaguely Victorian reality and a plucky female protagonist, but its dirigibles take a backseat to the ethical and religious issues in the story. Indeed, his intelligent bears, with their baroque armor, seem more Steampunk than anything floating in the air.

However, the true renaissance of the subgenre wouldn't occur until the late 2000s, sparked by a surge of participation within a community that was by then more than a decade old. This redefinition saw "Steampunk" used as a toolbox or aesthetic rather than as a term to describe a movement.

Three of the most commercially and critically successful Steampunk authors of the modern era—Cherie Priest, Gail Carriger, and Ekaterina Sedia—have brought their own twists to the subgenre.

For Priest, this means a revised American approach, featuring zombies and an emphasis on motherhood in the Hugo Award–nominee *Boneshaker*, which also radically rewrites the history of Seattle. For Carriger, the mix includes supernatural creatures and P. G. Wodehouse–style antics in her deceptively light but liberated Parasol Protectorate series. Sedia, meanwhile, used her novel *The Alchemy of Stone* to explore "steam technology in the context of social movements that usually follow along with technical innovation, ethnic conflict, and alchemy."

Sedia confesses to a love for Verne and Wells, although she is "less enamored of their modern-day imitators. I'm generally not impressed with anyone who writes as if the last century of literature and thought didn't happen. I do very much enjoy Blaylock and Powers, the latter being more of a direct influence, what with secret societies and alternative histories."

She defines Steampunk as "colonial and empire-based fiction, with steam technology. I suppose I could go all Babcock and stipulate steam-powered computers as strictly necessary, and maybe one day I might. After all, what would calculus be like if we had computers in the eighteenth or nineteenth century? They would be able to solve complex math problems the stupid way and much of calculus would never exist."

In *The Alchemy of Stone*, Mattie, an intelligent automaton, finds herself caught in a conflict between gargoyles, Mechanists, and Alchemists.

To Annalee Newitz, one of the editors of io9, a pop-culture website that frequently covers Steampunk, Sedia's approach is unique because "most Steampunk fetishizes the 'wind-up girl,' a gilded feminine creature. But Sedia shows us that the life of a windup girl is utter hell: Beholden to her

OPPOSITE
Boneshaker by Cherie Priest
(Tor Books, 2009)
ABOVE
The Alchemy of Stone by
Ekaterina Sedia (Prime
Books, 2008)
BELOW
Cherie Priest, 2010

A NOVEL OF VAMPIRES, WEREWOLVES, AND DIRIGIBLES

"[A] delicious rapier wit that recalls Austen and P.G. Wodehouse." —io9.com on *Soulless*

AN ALEXIA TARABOTTI NOVEL

CHANGELESS

GAIL CARRIGER

ABOVE
Changeless, the second book of The Parasol Protectorate series by Gail Carriger (Orbit Books, 2010)
OPPOSITE
The Immorality Engine, part of George Mann's Newbury & Hobbes series (Snowbooks, 2010)

maker, unable to live independent of his key, this windup girl doesn't have the luxury of being 'punk.' She has to work for a living and try to survive."

Newitz finds Priest's *Boneshaker*, which is arguably the most popular Steampunk novel of the last few years, perhaps less cutting edge than Sedia's work, but says that's not a bad thing. "*Boneshaker* is squarely in the Steampunk wheelhouse, though I love that it can also be read as an alternative history of the Civil War. Is it commercial? Yes, but Steampunk has always been commercialized—that's the story of all punk, really, going back to Malcolm McLaren marketing the Sex Pistols as a brand.'"

Priest's influences do encompass Verne and Wells, but also Mary Shelley and "pop-scholarly books about the nineteenth century," which included information about the Spiritualist movement and the Industrial Revolution. Steampunk "really gelled" for Priest sometime in the mid- to late 2000s. "That's when I first started meeting cosplayers and authors out in force—people who were having such a wonderful time playing in this weird little sandbox. I caught it and ran with it."

Cosplay and fashion also influenced Carriger, far more than the first wave of Steampunk fiction from the 1980s. "Long before I discovered Moorcock, when I still thought Jules Verne was destined to remain safely trapped away in the 1800s forever, I wore Steampunk. I proudly donned my Victorian silk blouses and little tweed jodhpurs. I didn't know there was Steampunk to *read*, I only thought there was Steampunk to *wear*." Like many modern Steampunks, Carriger came to the fiction through the fashion and art, but she also has an extensive background of studying the Victorian era. There are few authors in the field who are all flash and no substance.

Priest's editor, Liz Gorinsky, has been responsible for publishing many contemporary Steampunk novels, also editing George Mann and Lev Rosen. "I'm one of the folks who subscribe to the notion that I didn't find Steampunk, it found me," she says. Gorinsky, like many others, sees Steampunk as much more than a form of literature. "So many of the elements of the genre are things I've liked forever—the fashion, the gadgetry, the use of high-flown prose to add literary merit, even to action sequences. . . . I got excited by the extent to which the fiction and the community is pro-history, science-positive, with reverence for physical technologies."

According to Mann, author of *Affinity Bridge* and *The Immorality Engine*, "that reverence for physical technologies is a kind of fetishistic fantasy, in that a Steampunk setting allows a writer to conjure up the sort of cool toys we really wished *had* existed in the past, if only someone had been

THE IMMORALITY ENGINE

"Mann is leading the charge" The Guardian

A NEWBURY & HOBBES INVESTIGATION

GEORGE MANN

SNOWBOOKS
LTD

Scott Westerfeld on *Leviathan*

Best-selling Young Adult author Scott Westerfeld's 2009 novel Leviathan *pits "Clankers" against "Darwinists" in a rousing reimagining of World War I. Clankers use mechanized weapons while Darwinists harness living creatures for combat. The entire Steampunk tool kit is on display in these adventures of the teenage son of the Archduke Franz Ferdinand and a Scottish girl with dreams of joining the Air Force.*

What is your personal definition of Steampunk?

It's partly a set of nostalgias—for handmade and human-scale technologies, baroque design, and elegant dress and manners—combined with the puerile pleasure of mussing up a very stuffy stage in history, bringing a flamethrower to a tea party, so to speak. And this flamethrower extends to the political and social as well as technological, because Steampunk creates a new set of Victorian stories that expand the role of the colonized and otherwise subjugated in that era (girl geniuses, for example).

How long have you been interested in Steampunk?

My first literary encounter was with Bruce Sterling and William Gibson's *The Difference Engine*. I'd always been a sucker for alternative histories, but there was a more exciting energy here. Rather than the careful extrapolation from one shift in history, Sterling and Gibson were throwing everything at the wall, rewriting history in order to fill it with their own modern tech fetishes and fascinations.

But probably as important as any literary influence was Disney's take on *20,000 Leagues Under the Sea*, which is a somewhat crazy cultural object. It's a kids' movie adapted from an 1869 novel about a nuclear submarine made in 1954, the middle of the Cold War. It's a loving visualization of technology that was futuristic when the book was written, but commonplace when the film was made, using special effects that seemed fairly crude by the time I saw it in the 1970s. The whole effort creates a weird collision of beauty and menace (a nuclear sub with a pipe organ), as well as a collision of technologies both on and off the screen. In short, it fired all the same spark plugs in my head that more self-aware Steampunk works would in the 1980s. (Plus I went on the ride at Disney World when I was ten, and it was awesome.)

What differences do you see between now and when you started?

Steampunk was still largely a literary subgenre when I first became aware of it. But it has been continually widening into new creative spaces—jewelry, clothes, music—always becoming more physically and socially real. That's the most interesting thing about it to me, that you have a physical and social culture arising so quickly from a literary genre. By comparison, most physical culture in the rest of SF derives from specific film and TV shows.

OPPOSITE
Leviathan by Scott Westerfeld (Simon Pulse, 2009)

CONTINUED

LEVIATHAN

#1–NEW YORK TIMES BESTSELLING AUTHOR OF *Uglies*

SCOTT WESTERFELD

ILLUSTRATED BY KEITH THOMPSON

There's something wonderfully genre-celebrating about Steampunk. One rarely wears a costume saying, "I'm some kind of spaceman" or "I'm a generic manga character," but lots of people happily dress as a Victorian cyborg or sky pirate without reference to any specific work.

What Steampunk works influenced the writing of *Leviathan*?

In a strange way, the biggest influence on the text was Keith's illustrations in the book itself. Because there are fifty of them per book, we didn't follow the usual strategy of finishing the text and then producing illustrations. He was working alongside me, only a few chapters behind (or ahead at one point!), and whenever I got to a sticky place I would have his images to contemplate. It was a positive feedback loop, in that characters, beasties, and objects that *looked* cool got more screen time, and thus were expanded upon by still more art.

How do you think the Young Adult strain of Steampunk differs from its adult counterpart? What makes it endearing to young readers? Do you see it as part of the future of Steampunk?

Probably the differences between YA and adult Steampunk are the same differences that exist in any genre: the age of the protagonists, the centrality of identity as a theme, and the primacy of story. But Steampunk does have unique charms to some YA readers. Teens are native users of the mass-produced blobjects — iPods, cell phones, etc. — that Steampunk is partly a reaction against. So their adoption of a handmade aesthetic is less nostalgic and perhaps more revolutionary. My fan mail suggests that the whole flamethrower-at-a-tea-party aspect of Steampunk is part of the appeal too. Adults may have a half-remembered notion that Victorians were stuffy, but teens are stuck in actual history classes that are genuinely boring to many of them. So perhaps it's not surprising that radical rewrites of that history amuse and excite teens in a more visceral way.

ABOVE
"Mooring at Regent's Park," *Leviathan* interior art by Keith Thompson

weird enough or insane enough to create them. For me, the real draw of Steampunk is the way in which it plays with history, creating a fantasy landscape out of the past. There's freedom in that—the sort of pure freedom that only this type of fiction can offer. Science fiction, in its purest sense, is a forward-looking genre that relies on scientific accuracy, theory, and logic. Steampunk, on the other hand, leaves much more room for madcap fantasy, strangeness, and escapism."

Another prominent Steampunk editor, Lou Anders, agrees about the escapism factor. "The reason often cited for the Steampunk craze is that it returns us to a simpler time when we could build our own tech—you can't even open, let alone understand, your iPhone, etc. But I think that's bunk. I don't know how to build a locomotive or a Babbage Engine from scratch any more than an iPhone or an LCD television. Steampunk's appeal is the excuse it gives adults to have fun reading the sort of adventure previously found only in Young Adult books."

Newitz puts it another way: "Steampunk fiction is popular because people want to recapture the enthusiasm for progress associated with the industrial age. The other thing is that Steampunk books are delightfully meta—they're escapist fiction that pastiches a previous century's escapist fiction. And all hail escapism! We need it to survive, as long as publishers and promoters are making thoughtful, critical writing available, too."

The Wild World of Mecha-Gorillas and Girl Geniuses in Steampunk Comics

DOES JUST DRAWING AN AIRSHIP OR ROBOT MAKE YOU A STEAMPUNK comics creator? That question underscores the fact that "Steampunk" comics are often much less informed by a sense of the related subgenre or subculture. The comics artists identified with Steampunk by and large find certain kinds of technology-based images interesting, or have fond memories of reading Verne and Wells and pulp comics of a certain era. Historical comics from Victorian times, and from the heyday of airships in the early 1900s in the United States, could be considered a kind of proto-Steampunk, or just an accurate reflection of the era.

However, there *is* a useful starting point for the modern era of Steampunk comics: Bryan Talbot's Luther Arkwright series, published in the late 1970s. The crucial linkage comes from Talbot's source of inspiration—Michael Moorcock, author of the Nomads of the Air series and creator of the anarchistic protagonist Jerry Cornelius. A glam secret agent, Cornelius was a vehicle for Moorcock's fictional musings on social and

ABOVE
The Adventures of Luther Arkwright by Bryan Talbot (Dark Horse, 1990)

political inequities, often, at least originally, in the context of 1970s England. Eventually, the character also appeared in Moorcock's subversive swords-and-sorcery epics, a hint that Cornelius might be a contemporary avatar of the famous Elric, the Eternal Champion.

Talbot had read in the influential avant-garde SF magazine *New Worlds* that Moorcock had "designed Jerry Cornelius to be a sort of template [that] any writer was free to use," and promptly inserted the character into an eight-page adventure entitled "The Papist Affair." This rather scandalous comic bore little resemblance to the later Arkwright comics. Talbot describes it as "a tongue-in-cheek romp set in a parallel England rent by religious wars and with such unutterable silliness as machine-gun-toting, cigar-smoking nuns clad in black stockings and garter belts, the sacred relics of Saint Adolf of Nuremberg, and a kung fu fight with an evil archbishop."

Only later did Talbot step back from what he calls "unutterable silliness" to flesh out Arkwright's universe, creating a parallel world influenced by Moorcock's idea of an unending multiverse.

"I saw a serious story, bigger, more intricate, and more importantly, my own, a whole atheist temporal alternative at peace within itself, ruled by science and logic, and bent on maintaining the equilibrium in a multiverse infiltrated and corrupted by Disruptors. The story itself was a vague metaphor for the second law of thermodynamics."

Talbot sees the reinvention of his protagonist as "part of a literary progression that went something like Sherlock Holmes—Philip Marlowe—James Bond—Jerry Cornelius—Luther Arkwright," with influences including poet and visionary William Blake, writer Robert Anton Wilson, and legendary director Nicholas Roeg.

Not every Steampunkish comic has shared that distinct tie to the fiction, but from mecha-gorillas to rayguns, Girl Geniuses to a clockwork Versailles, the works since have featured plenty of adventure and eye candy. Here are a few examples.

ABOVE
The Empress of the World from Talbot's *Heart of Empire: The Legacy of Luther Arkwright*, a limited edition comic (Dark Horse, 1999)

⊠ ⊠ ⊠ ⊠ ⊠

Kazu Kibuishi's *Amulet*

Created by the editor of the fantasy comics anthology *Flight*, the Amulet series is a Steampunk comic specifically created for kids. After the death of their father, Emily and Navin move with their mother to an ancestral house that has a door to another world. When their mother disappears down a tunnel, the children must try to find her. They encounter all manner of peculiar creatures, from elves and robots to giant mushrooms used as parachutes and stampeding herds of huge tick-like critters. Steampunk fans will especially enjoy the flying ship and the house that can walk. In interviews, Kibuishi has cited Jeff Smith's *Bone* and Hayao Miyazaki films as influences. If so, the influence is subsumed enough that the Amulet series doesn't feel like pastiche.

Sydney Padua's *Lovelace and Babbage*

Originating as a Web comic in 2009, this strip takes an irreverent look at the lives and work of Charles Babbage and Ada Lovelace. "Mostly," Padua says, "I'm inspired by the people and spirit of the period—I read a lot of primary documents from Victorian science, and I'm very lucky to live in London, in a warehouse district in the East End where a lot of the industrial architecture is still around, with restored steam railways and steam engines being run by volunteers."

The comic started as a "fortuitous accident" when Padua created "a short bio comic for Ada Lovelace Day, an initiative to talk about inspiring women in technology. I think I was vaguely aware that there was a science fiction idea of some kind about alternative history, so I used that as what you might call the punch line. From there, it started to take over my brain."

For Padua, Steampunk is "about playing with the idea of science and modernity, of rapid change and its accompanying nostalgia. I love that so much of the stuff we take for granted is the product of 'well it seemed like a good idea at the time.' My own style with it is essentially playful. I'd call myself more of a steam-ironist than full-fledged Steampunk."

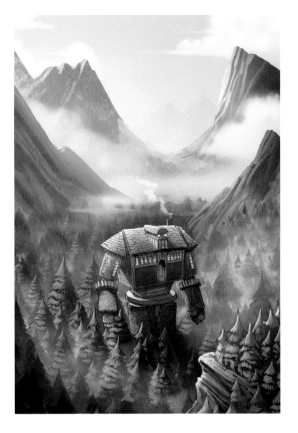

ABOVE

Interior page from *Amulet, Book Two: The Stonekeeper's Curse* by Kazu Kibuishi (GRAPHIX, 2009)

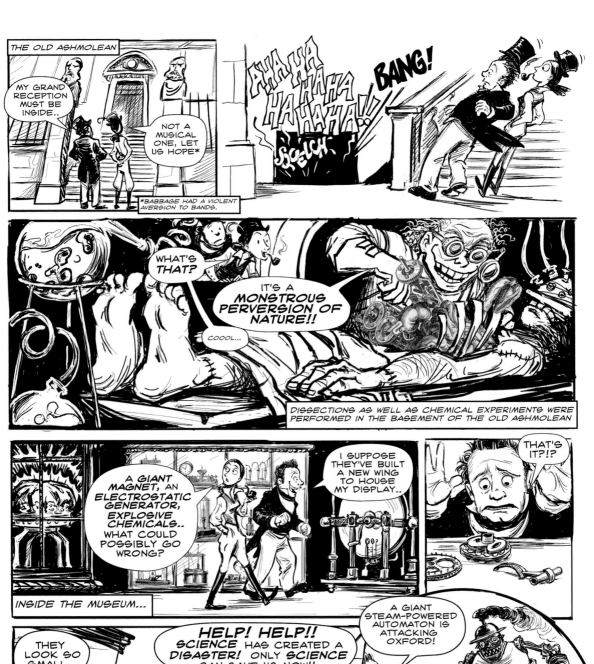

Greg Broadmore's *Doctor Grordbort's Contrapulatronic Dingus Directory*

Marvels of retro-futuristic design that showcase a remarkable variety of rayguns, Broadmore's books also send up colonialism and ideas of empire. "The influences," Broadmore says, "are pretty wide. I set Grordbort's world in the 1920s, or that general period, but I've taken cues from 1940s and 1950s pulp covers, as well as much earlier fiction like Jules Verne and H. G. Wells." He notes that it was the "visualization of their fiction that had a huge impact on me."

Is what he does Steampunk? "It's a fair enough label, but from my point of view, I am simply taking classic sci-fi and reinterpreting it. The naivety of it is an aspect I revel in and attracted me in the first place."

The books feature amazing schematics of various weapons, which are also being fabricated by Weta Workshop sculptors. "As *Dr. Grordbort's* has grown, encompassing collectibles, publishing, a traveling exhibition, animations, films, and games, the demands of art direction and management have grown, too. But what I always come back to are art, drawing, painting. It's what I love to do. The actual crafting of my designs is done by various amazing Weta Workshop sculptors and model makers, like David Tremont, who has built the majority of my rayguns, and Jamie Beswarick, who has sculpted some of the creature collectibles." Broadmore has worked on many movies as a designer and sculptor, including the *Lord of the Rings* trilogy, *King Kong*, and *District 9*.

OPPOSITE
Excerpt from *Lovelace and Babbage Make a Great Exhibition of Themselves* by Sydney Padua, created for the Oxford Steampunk Exhibition, 2009

BELOW
A postcard included in *Doctor Grordbort's Contrapulatronic Dingus Directory* by Greg Broadmore (Dark Horse, 2008)

NEXT SPREAD, LEFT
Dr. Grordbort's Workshop, David Tremont working on one of Greg Broadmore's designs

NEXT SPREAD, RIGHT
A selection of rayguns designed by Greg Broadmore and produced by the Weta Workshop

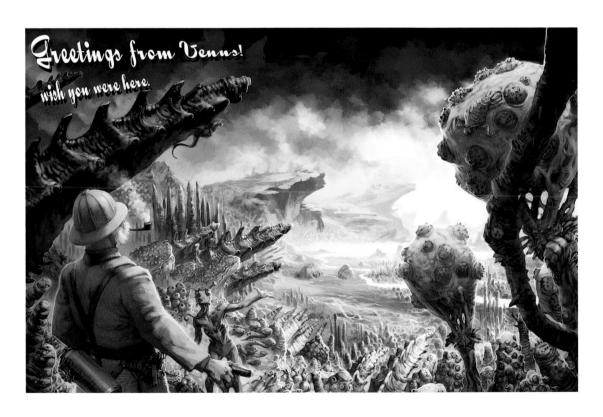

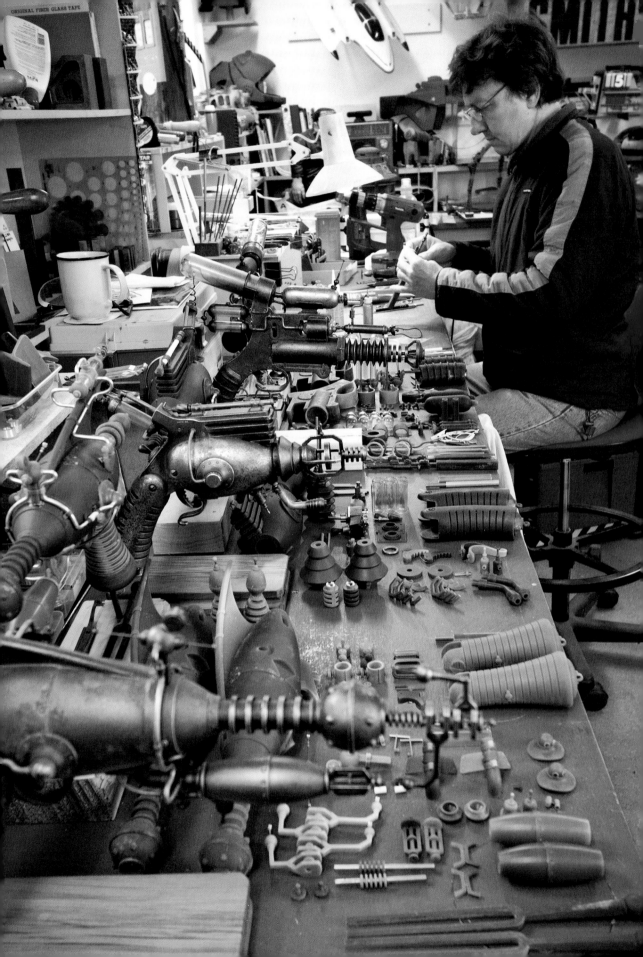

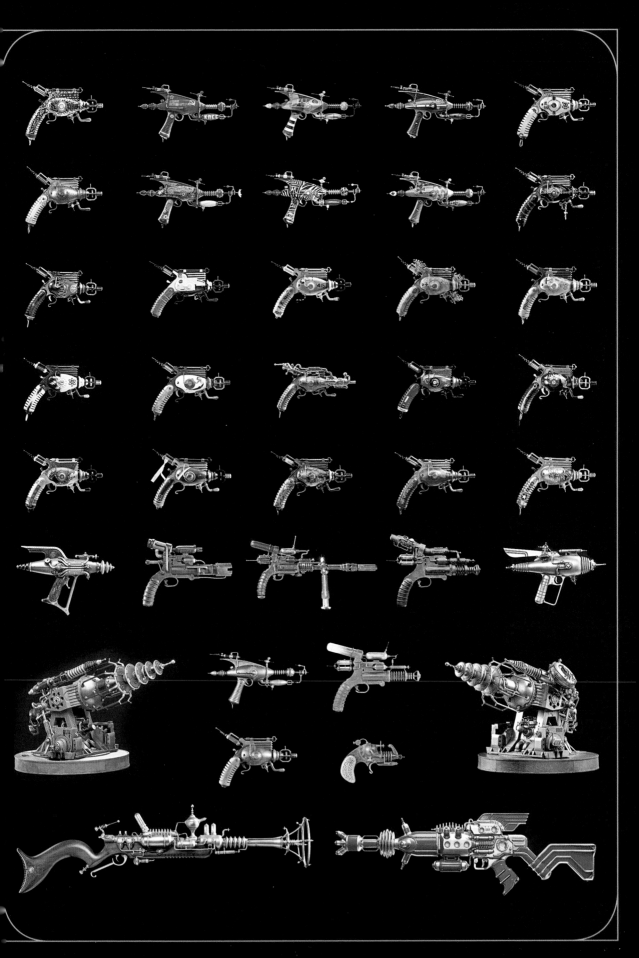

Mike Mignola's *Amazing Screw-On Head* and *Hellboy*

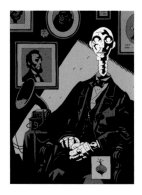

Mike Mignola's dark, flat style, which Alan Moore has called "German expressionism meets Jack Kirby," gains its unique power from the use of shadow to define space in each panel. Through the varying shades of darkness, color reaches the viewer as if from the bottom of a well. The contrast created by the shadow renders his use of color unexpectedly rich and deep. What should be opaque instead illuminates. This highly sophisticated approach is applied to, as Mignola puts it, "crazy plans" involving "guys trying to do some crazy thing, working themselves up into a frenzy over it. . . . I love guys who take themselves very seriously—even if they are a head in a jar riding around in the chest cavity of a robot of themselves." Mignola also very much likes drawing contraptions, cobbled together "from bits and pieces of old Victorian machines—old steam engines, farm equipment, phonographs."

Verne and Wells have both influenced him, although he "never could get through *20,000 Leagues Under the Sea*. It was the Disney movie that made a huge impression, especially the design of the submarine—that's almost certainly where my love of Steampunk machinery comes from." His famous *Hellboy* comic features the eponymous character, a possible child of Satan fighting for good, using in part a messed-up mecha-hand. Hellboy winds up fighting resurrected Nazi scientists and any number of biomechanical creatures. A side project, *The Amazing Screw-On Head*, takes place during the 1800s, as the hero secretly helps Abraham Lincoln foil various and sundry supernatural plots.

Mignola admits, "I just love combining human anatomy with machine parts—maybe something is wrong with me. At least it's something I've never tried to do in real life. That would be bad."

ABOVE AND OPPOSITE
The Amazing Screw-on Head™ ©2010 Mike Mignola (Dark Horse, 2002)

BELOW, LEFT AND RIGHT
Interior panels from *Hellboy Volume 5: Conqueror Worm* by Mike Mignola (Dark Horse, 2002), Hellboy™ ©2010 Mike Mignola

Phil and Kaja Foglio's *Girl Genius*

The Foglios' *Girl Genius* — "Adventure, Romance, MAD SCIENCE!" — is one of the rare instances of a Steampunk comic with strong central female characters. Phil Foglio says that rather than Steampunk, "we were trying more for the flavor of the old-time stuff that influenced Steampunk, such as H. Rider Haggard and Jules Verne. That's why Kaja coined the term 'gaslamp fantasy.'" On the Web radio show The Biblio File, Kaja Foglio said, "I was going through all of Phil's old files and I was filing all of the old

sketches, and I was coming across weird airships and cats in top hats with walking canes, and all of this wonderful kind of Victoriana sci-fi stuff. It was like 'Oh, this is everything I love!'"

After several years of working on the concept, the couple's first *Girl Genius* comic debuted in 2001, and later became available on the Web as well as in book-length print editions. The series posits a war between rival scientists with "supernormal powers" during the Industrial Revolution. The Girl Genius of the title is Agatha Heterodyne, a student at Transylvania Polygnostic University who gradually becomes aware of her own unique powers.

The Foglios have eagerly embraced the Steampunk subculture and usually have a table at conventions. "I love the subculture," Phil Foglio says. "The people who are into it are very enthusiastic [and] are busy creating all sorts of fabulous things."

ABOVE
Agatha Heterodyne from
Girl Genius by Phil and Kaja
Foglio
OPPOSITE
Interior page from *Girl Genius* by Phil and Kaja Foglio

Molly Crabapple's *Puppet Makers*

Molly Crabapple takes an unconventional approach to art, which has brought her a wide spectrum of work, from creating covers for underground magazines to illustrating for the *New York Times*, *Wall Street Journal*, *Weird Tales*, and more. Her most recent comic is *Puppet Makers* for DC Comics' digital imprint, Zuda. A collaboration with John Leavitt, the comic even includes a soundtrack. *Puppet Makers*, lettered by Chris Lowrance, is set in an alternate-history Versailles with overt Steampunk elements that include clockwork cyborgs.

In an interview with Annalee Newitz for io9.com, Crabapple said she got the idea in college. "I was reading some stories about the court, and came across the tale of a hapless courtesan of middle-class extraction, who, during her dozenth bow before the queen mother, collapsed of heatstroke. I realized between the wigs, corsets, and protocol, court life would have been better performed by robots than human beings."

The cyborgs are remote-controlled masks or "shells" for aristocrats, with definite war applications, giving an edge to a comic that is stunningly beautiful in its execution. As for other influences, Crabapple cites the art of Kevin O'Neill in *The League of Extraordinary Gentlemen* and the book *Baroque: Style in the Age of Magnificence*. As she told io9.com, "It's a fat photo-book of the decorative and mechanical arts of the baroque era—forks, wallpaper,

theatrical displays, church interiors. It's art that requires so much intensity of skill and effort as to be kind of unethical. Once you see that gold and eggshell, nymph-covered child's garden carriage—and think of all the skill, the man-hours squandered on a toy—you understand why the French revolution happened."

She believes Steampunk "is an amazing lens to explore the past, particularly the past's injustices and discontents, which technology can amplify. I also admit there's a certain jewelling-the-tortoise aspect to drawing all those little roses on gears."

Alan Moore and Kevin O'Neill's *League of Extraordinary Gentlemen*

Reenvisioning the Victorian age through some of its iconic fictional characters, Moore's classic series features Captain Nemo, the Invisible Man, Dr. Jekyll, and many others in a fantastic comics mash-up of Verne, Wells, and the writers of penny dreadfuls. How faithful is Moore to the source material? According to Victoriana scholar and *League* expert Jess Nevins, "It was intended as a parody of Victorian Boy's Own adventure fiction. But because of the serious material, I'd call it an intermittent send-up. . . . I also think they had different things in mind than most other Steampunk writers; the Victorian setting and characters were the framework, but the

OPPOSITE AND ABOVE
Panels from the digital comic *Puppet Makers* by Molly Crabapple and John Leavitt, 2010
BELOW
The League of Extraordinary Gentlemen: Century 1910 by Alan Moore and Kevin O'Neill (Knockabout Comics, 2009)
NEXT SPREAD
Interior page from *The League of Extraordinary Gentlemen: Century 1910*

message was not just parody of Victoriana but an exploration and celebration of the worlds of fiction." In this sense, Nevins argues, it doesn't have much in common with works such as *The Difference Engine*. Nevins credits the *League* with garnering Moore and O'Neill major attention outside of the comics world and helping to further popularize the idea of modern Steampunk.

Bryan Talbot's *Grandville*

Coming full clockwork circle, Talbot's *Grandville* is explicitly labeled "Steampunk" and features a cast of anthropomorphic characters. The inspiration was the work of early nineteenth-century illustrator Jean Ignace Isadore Gérard, who drew animals dressed in contemporary costumes. "His pen name was 'JJ Grandville,' and it suddenly struck me that 'Grandville' could be the nickname of Paris in an alternative world where it was the greatest city in the world. . . . The protagonist, Detective Inspector LeBrock of Scotland Yard, and the plot came to me very quickly over the next few days, and I wrote the script in less than a week."

Grandville allows Talbot to indulge in the fascinations of his youth. "I grew up at a time when all things Victorian were very much in vogue. There were TV series like *Sherlock Holmes* and *Adam Adamant*, a Victorian adventurer flung forward in time to arrive in the swinging sixties, and movies such as *The Wrong Box*, *The Time Machine*, and the Hammer *Dracula* films. Nineteenth-century military costumes were hot fashion, the Beatles famously wearing psychedelic versions on the *Sergeant Pepper's* cover. So, to me, Victoriana has always been cool. Steam trains, with their extremely loud noises, pistons, and blasts of steam, are way more exciting than their modern equivalents."

BELOW AND OPPOSITE
Interior pages from *Grandville* by Bryan Talbot (Dark Horse, 2009)

WHATEVER THE REASONS FOR THE CURRENT POPULARITY OF THE fiction, one thing is true: Steampunk is mutating into many different approaches and forms. In a sense, you could say that to save Steampunk, authors have had to deconstruct and recontextualize it.

Jay Lake's Mainspring series, for example—*Mainspring, Escapement*, and *Pinion*—is set on a giant clockwork world. Against this backdrop, clockmaker's apprentice Hethor Jacques embarks on a perilous journey to find the lost key that will rewind the mainspring. The world is cut in half by a rather impressive Equatorial Wall, which has a huge impact on cultures and societies. Though Lake has employed the entire Steampunk toolbox, from Chinese submarines to metal men to incredible dirigibles, the novels are most notable for popularizing the term "Clockpunk."

Lake doesn't believe "Steampunk really has a manifesto or movement behind it, as Cyberpunk certainly did, but it is one hell of a 'skin' overlaid on movies, art, comics, fiction, costuming, even music. So for me it's a kind of playground of the mind."

Other approaches are exemplified by novels like Karin Lowachee's *The Gaslight Dogs*, which incorporates Inuit beliefs into a commentary on culture clash and imperialism; or Dexter Palmer's *The Dream of Perpetual Motion*, which has rejuvenated retro-futurism by infusing it with a healthy dose of Nabokovian cruelty and twisted imagination.

BELOW
Pinion by Jay Lake (Tor Books, 2010)

Lowachee's novel documents an enervating test of wills between a captain in the Ciracusan army and Sjennonirk, an Aniw spirit-walker. The Victorian-era technology creates a clear parallel to the real world, and the author deftly portrays the alliances between the invaders and the native people, along with the armed revolt. There's nothing escapist about *The Gaslight Dogs*, and in taking on the viewpoint of the conquered, it speaks to Ekaterina Sedia's concern that "There's always the fantasy of the golden past—people who pine for the 1950s but forget McCarthyism or who love the Victorian past when people were refined and polite but forget the actual industrial nightmare and the Opium Wars."

"Writing," Lowachee says, "should be about upending expectation, breaking through boundaries, and challenging readers to explore—not just aesthetics and trappings and technological ideas, but exploration in everything: social mores, societal prejudices, political dogma, familial dynamics." What does she want from Steampunk? More evolution and adaptation. She hopes the future holds more "freedom of movement within

whatever definitions people have of it and the ability to incorporate new ideas."

Palmer's own critically acclaimed addition to the Steampunk oeuvre comes more or less from outside the established genre and culture, with the exception of the influence of Wells. *The Dream of Perpetual Motion* weds the "malevolent design" of retro-futurism to absurdism, surrealism, and a deconstruction of William Shakespeare's *The Tempest*. Palmer imagines an alternate twentieth-century America filled with machines, including steam-powered contraptions, mechanized orchestras, and omnipresent robot servants. Machines are the workers, while humans are the consumers. Against this backdrop, the "failed writer" Harold Winslow narrates the story of his life while imprisoned on an airship powered by a perpetual motion machine. With him are the cryogenically frozen corpse of the once-powerful inventor Prospero Taligent, and the mysterious, disembodied voice of Prospero's adopted daughter, Miranda, haunting Winslow over the intercom.

BELOW, TOP
The Dream of Perpetual Motion by Dexter Palmer (St. Martin's Press, 2010)
BELOW, BOTTOM
Dexter Palmer, 2010

"I got the idea for the setting while doing research for a paper I was writing in grad school [at Princeton] on H. G. Wells. . . . I came across a book called *Futuredays: A Nineteenth-Century Vision of the Year 2000*. It's reproductions of a collection of French cigarette cards, illustrated by artist Jean Marc Cote in 1899 and depicting his whimsical idea of what life would be like a hundred years later. Some of his predictions are dead-on: for instance, an image of a man who receives up-to-date news reports via audio recording. But some are hilariously inaccurate, like an illustration of a family warming itself at a fireplace that has . . . a hunk of radium sitting on a pedestal. I thought it would be fun to set a novel in that world—essentially, an alternative version of history in which the science is sometimes egregiously incorrect."

Even though the demands of a first-person narrator meant a lot of historical detail didn't make it into the novel, Palmer was adamant that none of the technology could reflect advances from after 1900, including plastics and transistors. This led to such fictional innovations as a retro-futurist reimagining of turn-of-the-century Coney Island and a printing press run by mechanical men. An answering machine "is mostly built out of recording technology available at the turn of the century."

Is this Steampunk in the "traditional" sense? Probably not, but Palmer, Lowachee, and several others are helping Steampunk avoid stagnation. "It's like that old idea that the more you say a word, the more meaning it loses," Lowachee says. "Repeat a word

long enough and it becomes gibberish to the ears. I want 'Steampunk: The Sequel.' And not the crappy sequel that nobody wants to see, but the sequel that brings new life to an established and well-loved idea."

Sedia also wants a second act for Steampunk fiction, which includes her hope that "the DIY/subculture camp and the literary camp will come together more and more, at cons and online. At its core, Steampunk has the potential to be a very equalizing movement, where creators are also fans and consumers. And it works for books as well as corsets."

Gorinsky echoes this sentiment, in part because of the sharp uptick in paint-by-number Steampunk novels being submitted for publication following the subgenre's newfound popularity. "I want to see Steampunk books set in countries other than Britain and America; that feature protagonists of different races, classes, ages, sexualities, and abilities. And in the movement as a whole, I'm excited to see Steampunk continue to increase its prominence as a viral carrier of the notion that it's incredibly cool to be able to make and modify and repair your own clothes, technology, and environment."

In addition to these developments, hybrids, like Ramona Szczerba's text-image mash-ups, have begun to surface in the subculture. Her "Tesla," for example, is neither comic strip nor fiction, but rather what she calls "dense, intense little collages of things that never happened to people who never were in places that don't exist, but should have."

"Tesla" is a lovely concoction with a backstory that postulates an older brother for the famous scientist "struck by lightning no less than 17 times before he (miraculously) reached adulthood, which is less unlikely than one might think given that his chief hobby appeared to be standing in the middle of fields holding a metal rod during thunderstorms." This Tesla, too, is a scientist, although his work at a lab in Zagreb was "arcane and all but incomprehensible to most, and he went through lab assistants like Bunsen burners. Perhaps they failed to see how testing jetpacks in the university quad during lightning strikes was apt to further their academic careers much past the morgue."

Just like Gorinsky, Szczerba says she would like to see "more and better character development and diversity, especially more female and feminist sensibilities. I love the tech but it's best when it's incidental and not the point."

What do the old-school Steampunk writers think about these new developments? Are they surprised by the resurgence?

"It's a little absurd," Blaylock says, "but in a

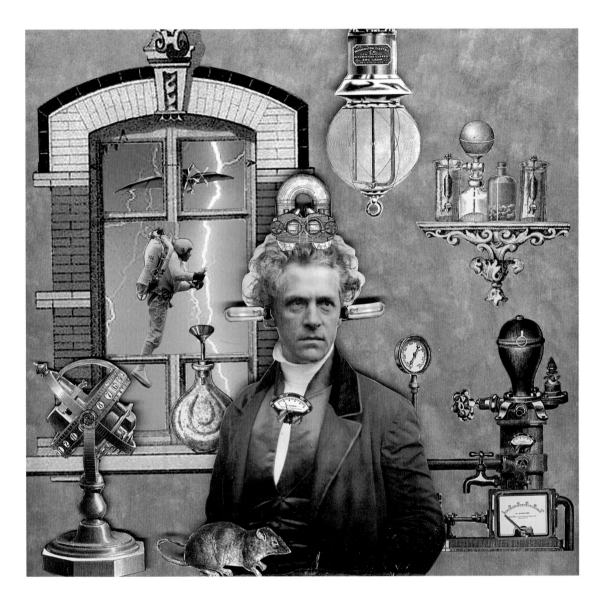

good way. . . . Now I'm getting fan mail for my current Steampunk projects and there are Steampunk conventions galore, and I'm enthusiastic about writing it again. As is true with everything else, we'd best enjoy it while it's still fresh and new. Funny that it took twenty-five years becoming fresh and new."

For Powers "it's very nice. There we were, drinking our beer, and underlining Mayhew and writing these screwy nineteenth-century London things, and now probably people who weren't even born then are reading them."

Of course, as befits a subgenre that's a form of alternative history, there's always a dissenting opinion. Not only does Jeter say he doesn't follow the current Steampunk movement; he denies that he, Blaylock, and Powers ever hung out in a bar called O'Hara's in Orange, California.

Steampunk! It reinvents the past, even changing a perfectly good origins story into something better.

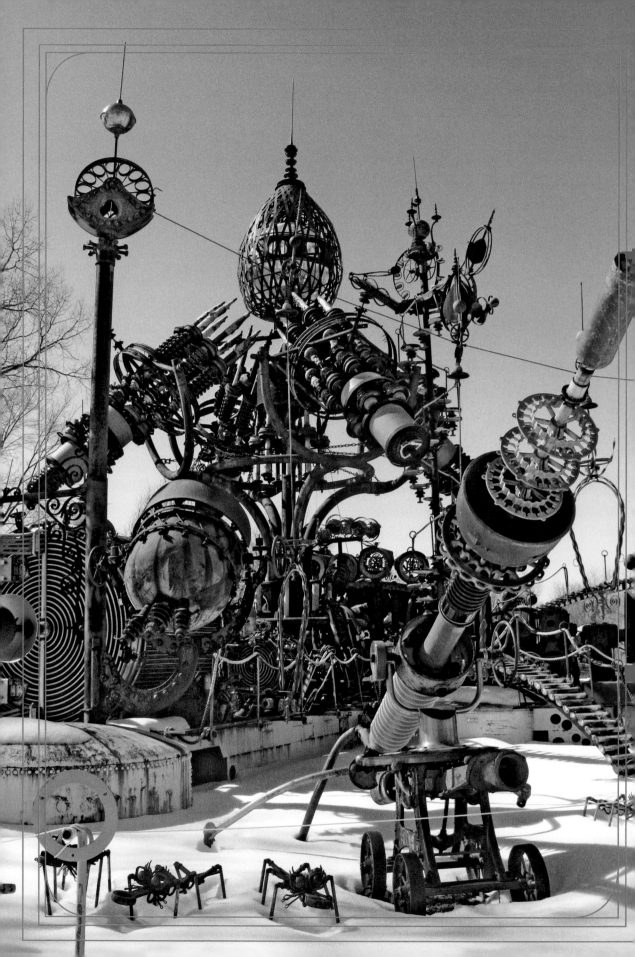

░░

Forevertron Park in Prairie Du Sac, Wisconsin, might just be the ultimate Steampunk art installation. Standing in its 120-foot-wide, 60-foot-deep, 50-foot-tall shadow, you can begin to understand the allure of Steampunk art, making, and crafts. Created by Tom Every, who goes by the moniker "Dr. Evermor," Forevertron partakes of Steampunk's core precepts such as the do-it-yourself movement, the salvaging and repurposing of existing machinery, and that element of "falling in love again" with obsolete technology, which is so often cited by contemporary Steampunk creators as the main reason they now self-identify as Steampunks rather than as tinkers, makers, artists, or craftspeople.

ONE ASPECT OF THESE TYPES OF TECHNOLOGIES, THEN, THAT MAKES them of interest is that they seem less inscrutable—you can see how things work, down to the gears and spouts and widgets. This applies even to aspects of making that produce decorative machines or overlays on existing technology rather than functional machines.

Every's story makes him a kind of godfather to the current explosion of Steampunk installations and arts and crafts. He blurs the line between "artist" and "maker" by using the formerly functional for both decorative and architectural purposes.

A retired engineer with a background in industrial reclamation, Every has had a lifelong interest in preserving historic machinery. In part, Dr. Evermor started work on Forevertron in 1983 because, as he recalled for a Wired.com article, "when I was working in industrial wrecking, it just killed me that people wanted to have these beautiful things melted down just for the monetary value of the metal. So I started saving things, and in about twenty years I had saved thousands of tons of stuff."

Among the beautiful "stuff" that makes Forevertron a kind of benevolent Steampunk Frankenstein monster are two electric dynamos constructed by Thomas Edison in 1882, as well as the decontamination chamber from an Apollo space mission. Thousands of tons of metal from the past century have given Forevertron a unique subtext: In addition to delighting visitors, it contains a true secret history of discarded parts.

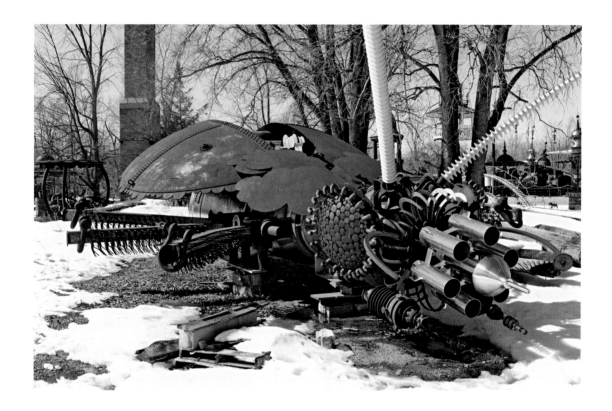

The confluence between making and a constructed persona, or "steamsona," that permeates the Steampunk community is present at Forevertron as well, if far more extravagantly. As also reported by Wired.com, Every has created a whole mythos for his character Dr. Evermor that also provides functionality for his art through storytelling.

When he was a child, Dr. Evermor witnessed a massive electrical storm with his father, a Presbyterian minister. Asked where lightning came from, his father told Evermor that such awesome power could only come from God. From that day on, Evermor dedicated his life to constructing an antigravity machine and spacecraft that would catapult him from the phoniness of this world to the ultimate truth and power of the next.

Dr. Evermor believes that if he can ever figure out a way to combine magnetic force and electrical energy, he can propel himself through the heavens on a magnetic lightning force beam. That glass ball inside the copper egg is his spaceship. There's also an antigravity machine made from an early X-ray machine, a teahouse for Queen Victoria and Prince Albert to observe the event, a telescope for bystanders to watch as Evermor flies off to his meeting with God, and a listening machine that will transmit Evermor's message back to Earth when he arrives at his ultimate destination.

PREVIOUS SPREAD, LEFT
Forevertron Park (with Cannon), Prairie Du Sac, Wisconsin
ABOVE
Jet Bug, Forevertron Park

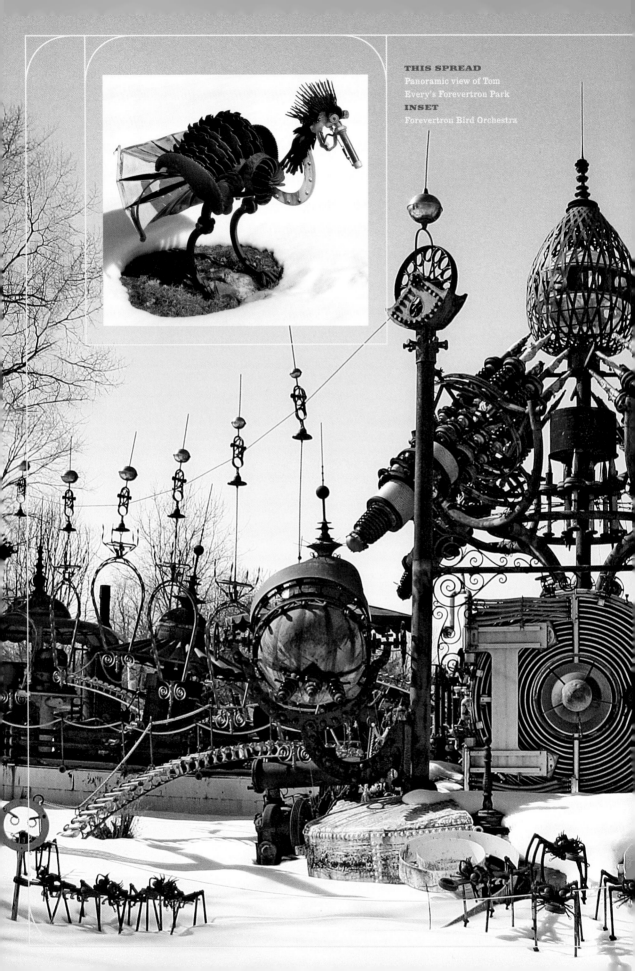

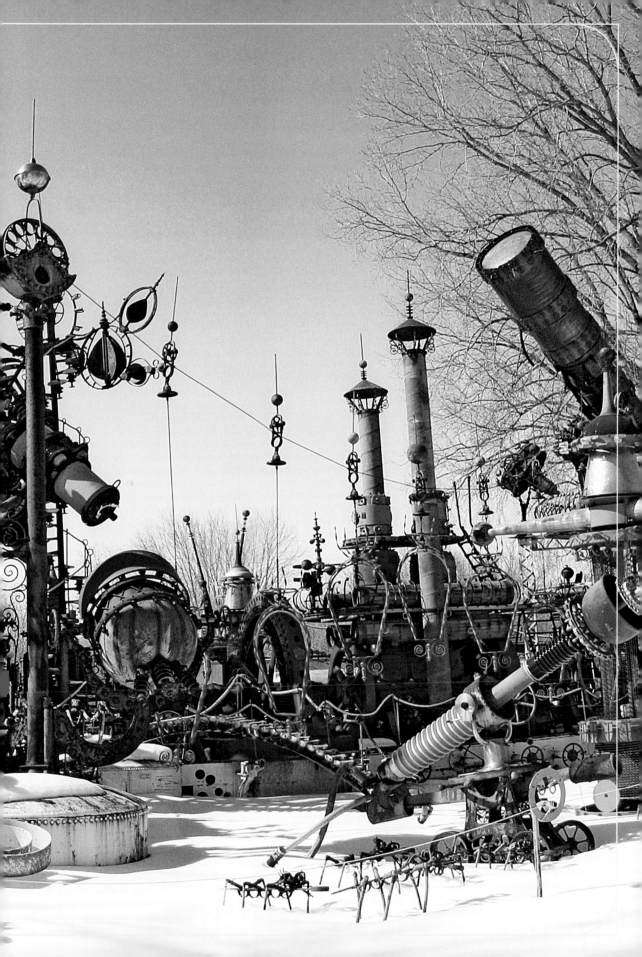

Steampunk "Artist" or Steampunk "Maker"?

Steampunk creators are often hard to pin down, despite their passion for a shared aesthetic. Some self-identify as artists and adhere to the general protocols and terminology of that community. Others self-identify as makers, which puts them in an entirely different realm along with tinkers, machinists, carpenters, and the like.

What's the main difference? Steampunk makers typically restore obsolete devices and modify modern technology. Steampunk artists create installations, sculptures, and other objects inspired by the Steampunk aesthetic.

However, the border between these two types of creators can be porous, even if someone self-identifies as a maker or as an artist. Steampunk makers sometimes create art pieces or metal sculptures that have only implied functionality, while Steampunk artists may cross over into making decorative pieces that also serve a practical function. There's never any guarantee that there won't be glorious contamination and influence from either side.

And what about fashion? Is that art or making or something entirely different? The fashion world is so vast that it needs its own chapter, but cross-pollination occurs between all parts of the Steampunk subculture, often to wonderful effect.

OPPOSITE
Church Tank, mixed-media sculpture by Kris Kuksi, 2008

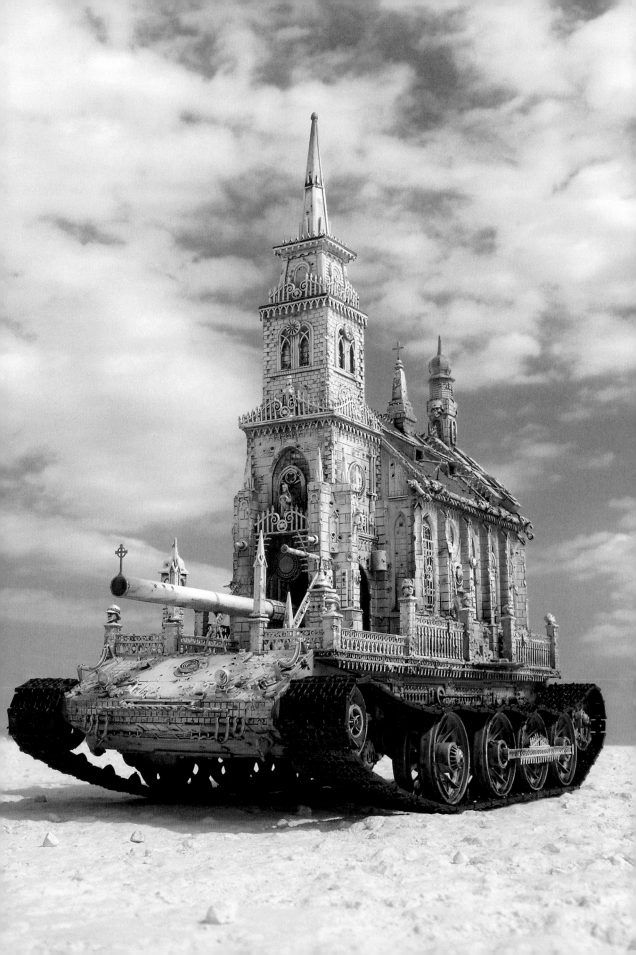

Not only does Dr. Evermor's elaborate tale echo the cross-pollination of art and narrative common in the Steampunk subculture; his rejection of "the sterile, rigid objects that modern designers and engineers are creating" also points to the interesting relationship between Steampunk art and making and fallout from the Industrial Revolution.

More recent examples such as Kris Kuksi's "Church Tank" have the appearance of functionality while serving as sculpture, just like Forevertron Park—except with an overt socio-political message that seems wedded more directly to bleeding-edge Steampunk concerns. Kuksi's purpose in creating such objects is to tackle the world head-on rather than blend with it or transform it in a whimsical way.

The very difference, if any, between "maker" and "artist" is probably less a quirk of the subculture than a natural progression from its Arts and Crafts roots. The late nineteenth century saw several attempts to marry fine and applied arts, including the Art Workers Guild (1884–present). According to the guild's founder, Walter Crane, these efforts were meant to emphasize that craft is the true root of art.

Just as many Steampunks claim that the subculture arose in part from dissatisfaction with modern, seamless, antiseptic technology, so too the Arts and Crafts movement occurred as a reaction against the inroads of industrialization. The terrible effects on health and the environment aside, the Industrial Age allowed manufacturers to streamline design in the service of increased productivity. Although this streamlining is the basis for today's flow of cheap products to consumers, it came—and still comes—at a price of worker exploitation and cruder products that lack individuality.

A major critic of industrialization, art writer John Ruskin (1819–1900), felt that this trend would threaten creative and intellectual freedom. In his famous essay "The Nature of Gothic," Ruskin wrote:

> [Y]ou are put to stern choice in this matter. You must either make a tool of the creature [worker], or a man of him. You cannot make both. Men were not intended to work with accuracy of tools, to be precise and perfect in all their actions. If you will have that precision out

of them, and make their fingers measure degrees like cog-wheels, and their arms strike curves like compasses, you must dehumanize them. All the energy of their spirits must go to the accomplishment of the mean act.

From this detailed but remote series of images, Ruskin then leaps forward to his own time period, urging the reader to "look round this English room of yours," decrying the kind of dead perfection to be found there as evidence of the slavery of workingmen. Ruskin slyly asks the reader to re-examine the "old cathedral front, where you have smiled so often at the fantastic ignorance of the old sculptors: Examine once more those ugly goblins and formless monsters, and stern statues . . . but do not mock them, for they are signs of the life and liberty of every workman who struck the stone."

The parallel couldn't be more obvious: Steampunks seek to reject the conformity of the modern, soulless, featureless design of technology—and all that implies—while embracing the inventiveness and tech origins of Victorian machines. They also seek to repair the damage caused by industrialization. This isn't simply an impulse to whitewash the classism, racism, and exploitation that partially informed the Victorian era—it is instead a progressive impulse to reclaim the dead past in a positive and affirmative way. Similarly, Ruskin's movement sought to return to the creative freedom exemplified for him by the medieval workshop, while rejecting the context of a political/social system more oppressive and unfair than the one in place during Victorian times. In both cases, creative renovations are meant to lead to innovation.

Or, as ardent Steampunk supporter and Boing Boing cofounder Cory Doctorow says, Steampunk "exalts the machine and disparages the mechanization of human creativity."

Therefore, it's no surprise that Every's credo resonates with the current generation of Steampunk creators, including Sean Orlando, the central figure behind such iconic installations as the Steampunk Tree House and the Raygun Gothic Rocketship:

> I think that there are a lot of people out there who are simply dissatisfied with throwaway bottle-fed art and consumption artifacts that have been forced upon us by sheer repetition and rote consumption. So, as an antidote, we look to a time when care, design, and artistry were applied to the everyday life in a more lasting way. We are appealing to a different nondominant ideology. Modern design can be very cold and rectangular, so hidden as to be aesthetically unreachable, smooth, a zipless totalitarianism.

This, too, echoes Ruskin's call to arms, which led to the opening of crafts schools in England like Felix Summerly's Art Manufactures, where students were instructed to beautify household objects like shaving bows—per Every's own reminder that "in the past, engineers were artists. They made beautiful, elaborate objects that had many purely decorative components." The legacy of this heritage is a complex relationship between technology and the creative impulse.

Sean Orlando on Creating the Raygun Gothic Rocketship

San Francisco–based maker Sean Orlando is one of the lead artists responsible for conceptualizing and managing the creation of two of the most iconic large-scale Steampunk-inspired creations in recent years. The first, the Steampunk Tree House, was a collaboration with Kinetic Steam Works (see page 6). The second, the Raygun Gothic Rocketship, was created in partnership with Nathaniel Taylor, David Shulman, and the Five Ton Crane arts group. "Raygun Gothic" is a term taken from the William Gibson short story "The Gernsback Continuum," first published in the anthology Universe 11 *in 1981. In the story, a noted pop art historian is writing a book about "raygun gothic" titled* The Airstream Futuropolis: The Tomorrow That Never Was. *The term now describes an offshoot of the Steampunk aesthetic influenced by the work of Fritz Lang and exemplified by such movies as Tim Burton's* Mars Attacks! *and* Sky Captain and the World of Tomorrow. *Orlando shares his thoughts here on the process of making these ambitious projects a reality.*

ABOVE
Schematic for the Raygun
Gothic Rocketship

What did you want to be when you were a kid?

It may sound strange, but I always wanted to be an artist . . . it was either that or an astronaut.

Do you remember when you first encountered the work of Jules Verne?

My first encounter with Jules Verne was when I was very young and my parents took me to Disney World in Florida. It was there that I first encountered the *Nautilus* from one of Jules Verne's most well-known books, *20,000 Leagues Under the Sea.*

How do you decide what projects to do, given that many are large-scale installations?

Both the Tree House and Rocketship are experiments that were developed as a way for our friends to come together and create in a non-competitive and collaborative environment. Over sixty Bay Area artists, engineers, scientists, programmers, and educators contributed to creating both projects.

As far as the Rocketship goes, I woke up one morning, and it just came to me. I immediately texted my friend Nathaniel Taylor and asked him if he wanted to build a rocketship with me. He said "that's weird because I've just been dreaming about building a submarine. . . ." We met half an

hour later and worked out the idea for the Rocketship over coffee. We then brought in David Shulman to help lead the project and met with the rest of the crew to sell them on the idea. The entire crew was of course skeptical, but very enthusiastic at the prospect of building a rocketship.

Is there a moment when the abstract idea reaches a point where it's so concrete it just has to exist?

That moment is the very moment when the project is conceived. There is a second moment, though, more concrete than the first, when you discover a funding source for that idea and you receive your first check. There's no turning back then!

Can you describe the process for beginning a project—from inspiration to the point when you actually start building?

Designs, sketches, website, email lists, assembling the crew, sourcing materials, promotions, logo, marketing, schwag to sell, fund-raising, engineering, timelines, budget, establishing a build space, meetings, meetings, meetings . . . and more meetings. For both the Tree House and Rocketship, we spent three to four months working on logistics, engineering, and designs and only three to four months actually building and fabricating.

How do you balance the needs of your imagination against the limitations of reality? Your biggest projects have an element of inspired genius to them. Some people might talk themselves out of even attempting them.

There are very few limitations that can't be overcome with the right amount of ingenuity and imagination. Both the Tree House and the Rocketship could not have been attempted without the support and involvement of one of the most talented and inventive communities of artists that I've ever had the honor to work with. It also helps that there are a number of warehouse spaces in the Bay Area that can accommodate such large projects, which are run by people who support the kinds of art that we create. There have been hard lessons along the way involving the limitations of transportation, structural engineering, accessibility, availability of heavy equipment, etc., . . . but some "limitations" can be good and can help you to refine the overall vision to create a more efficient build and assembly process.

Describe what it's like to be in the thick of working on a project like the Rocketship or Tree House. And what would you compare it to? Is it like fighting a war? Making a movie?

I worked for many years as an event producer, so it feels to me a lot like producing a large event. It takes a lot of coordination and patience. There are a lot of moving pieces with many different people involved in its

CONTINUED

production with varying personalities. You have to keep people motivated, on task, interested in what they're doing, and make them feel appreciated. Much of the work is volunteer-based and many people are discovering how to do things for the first time. It's important to be a clear communicator and good listener.

How do you deal with what may have begun as an individual vision becoming a communal property—not just in terms of putting together a crew, but the reaction of an audience to what you've done?

We're creating more than a physical object to be put on display. We're creating a collaborative experience that only works if you take the "me" out of the equation. One of the most important things that you can do to ensure a successful group project is to try to keep ego out of it. You may have had the idea, but when dealing with larger projects, that idea could never have been realized without the collective power of the group. Both of the large-scale projects that I've been involved with are more than I could have ever imagined because of the creative contributions and collective genius of everyone involved. I know that I've done my job when I overhear a crew member say, "That's my Rocketship" or "That's my Tree House."

What do you most love about what you do?

Coming up with the next big thing.

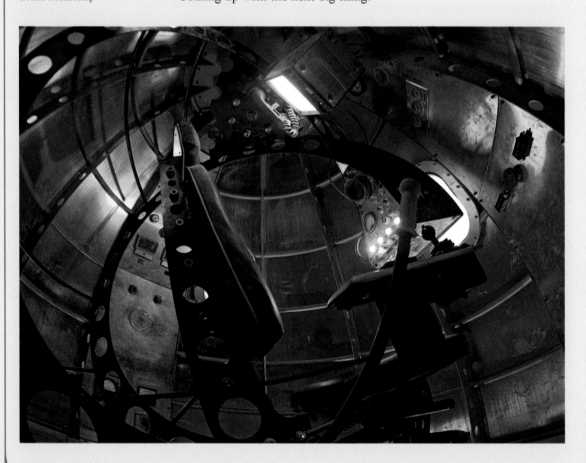

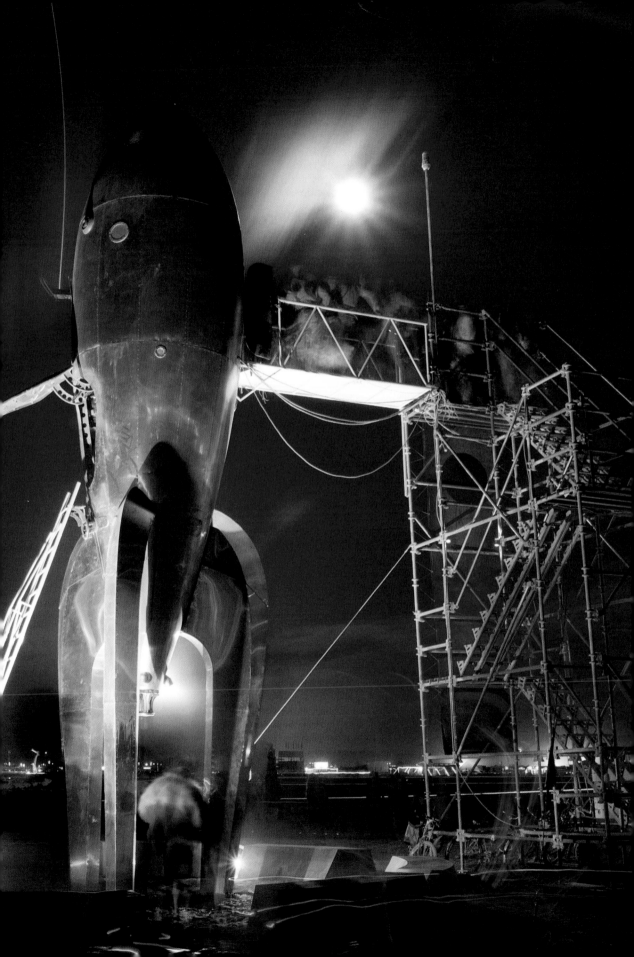

Sweat, Steam, and Mods: Steampunk Makers

Today, the modus operandi of the British Arts and Crafts movement—simplicity and high-quality materials—is clearly reflected in the Steampunk objects created by Jake von Slatt, Datamancer, the Kinetic Steam Works, and many other talented makers.

Jake von Slatt's Steampunk Workshop

Unlike Every, whose creation is really sculpture with a machine backstory, Boston-based Jake von Slatt works to restore a retro-aesthetic to functional or neofunctional objects. He works mostly from found objects and materials. At first, he used this approach to save money. But he soon found that when he tried working from new stock "the results were less than stellar." Eventually, von Slatt realized that his talent lay less in conceptualization than in "seeing how things naturally came together."

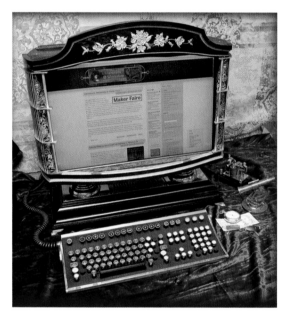

Some of von Slatt's more famous creations, featured on his Steampunk Workshop website, are a modified keyboard, an all-in-one personal computer mod, a Stratocaster guitar for the band Abney Park, and a working old-fashioned Wimshurst Machine (an electrostatic generator of electricity). Projects like the personal computer modification required much more than just creating a facade for an existing PC. Von Slatt took the entire computer apart to re-create its aesthetic.

Although von Slatt has only self-identified as a Steampunk for a few years, the process of "becoming" a Steampunk wasn't something new. Like many Steampunks, he says, "I have always been one. I just didn't know it by that particular name."

ABOVE
Victorian All-in-One PC, modifications by Jake von Slatt

OPPOSITE
A Bassington & Smith Electro-Mechanical Analog Brain, unfinished, created by Jake von Slatt for *The Thackery T. Lambshead Cabinet of Curiosities*

Von Slatt is as drawn to the "punk" part of "Steampunk" as to the "steam." "This rings absolutely true for me, as I grew up during the punk era and have always been a fanatic do-it-yourselfer or maker."

Experiencing the resulting "flow" is the major reason he finds such happiness in the act of creation. "Flow is when my brain is just a step or two ahead of what my hands are doing, and a piece seems to be coming together almost of its own accord."

But despite the highly personal relationship between von Slatt and his work, the idea of audience is also important—and one reason why he established the Steampunk Workshop, which functions as a clearinghouse for all things Steampunk. "The community itself is really, really important

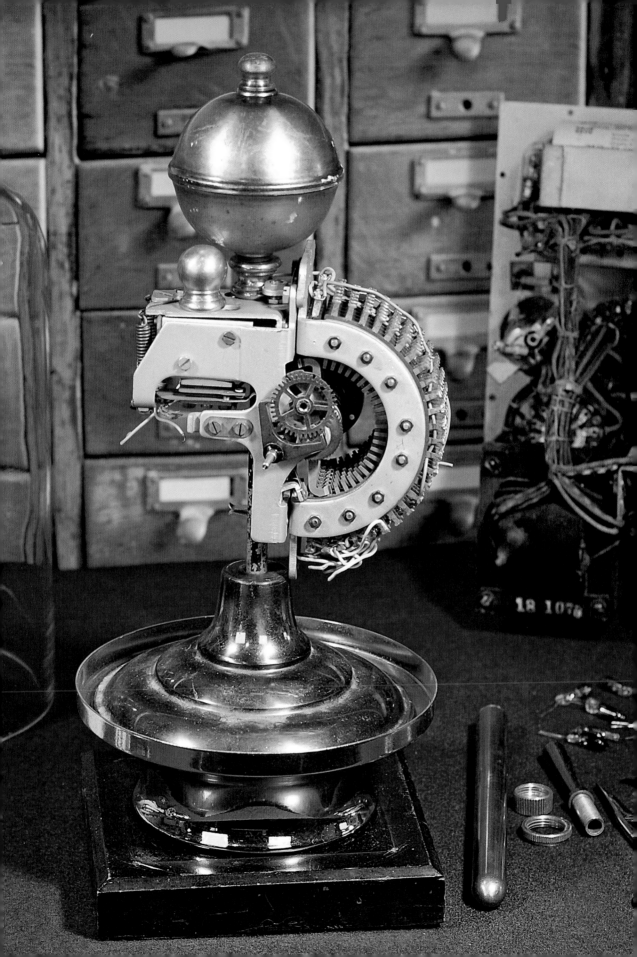

for happiness. It's friends, it's the people you surround yourself with, and the conversations you have. But not just the spoken ones, the ones you have sharing art, music, and culture. When I started posting online it totally changed how I felt about it; it made it so much more important because of the people it connected me to. Our modern lives tend to isolate us; there simply isn't enough time in the day to pursue things that we're passionate about. When something like Steampunk breaks through that shell, it really is a gift."

Datamancer's Mods

Dr. Evermor and von Slatt aren't the only ones to channel their inner Steampunk through a name-change. The maker Richard "Doc" Nagy goes by the name "Datamancer" and calls himself "a Steampunk contraptor, technical artist, and jackass-of-all-trades." A consultant for the television show *Warehouse 13* (Syfy channel), Datamancer has been modifying objects for many years. His signature creations include the Steampunk Laptop and the Archbishop Gothic PC. The backstory of his persona might best be summed up by the subtitle on his website: Prestidigital Datamancery & Paraphrenalic Technofetishism.

For Datamancer, Steampunk is a design aesthetic, the "perfect marriage of historical romanticism, elegant craftsmanship, antique style, and fetishized functionality." Steampunk, Datamancer believes, "re-empowers people with the culturally obsolete arts of fabrication and ingenuity" as a defense against rampant consumerism.

He came to Steampunk through electronics and computers because he found modern PC design "dull and utilitarian," but he was also inspired by an antique-dealing aunt. "Her house looks like a mini-museum. When I would visit as a child, I became fascinated with the way that each piece was a vignette of history and perfectly captured a moment in time."

Datamancer began "case-modding" when "there were maybe four search results for 'Steampunk' on Google." For inspiration, Datamancer spends countless hours on the Internet poring over images, discovering esoteric keywords, and pulling up galleries of devices to study. "A lot of cross-inspiration and complementary idea-pooling happens in the community, with surprisingly infrequent copying of ideas."

He then builds everything in his head "about twenty times," until "one day it just sort of hatches as a finished product and I whip it together using methods and taking precautions I've already mentally outlined." The rough idea in his head is more conceptual than physical, "like a collection of themes or ideas . . . I'd like to bring to life."

Datamancer's "design psychology" is very important. "Everything has to sort of make sense to me, visually, functionally, and ergonomically. Victorian devices are a lot of fun because the technologies involved were

ABOVE
Detail of the Steampunk
Laptop by Datamancer, 2007

still very novel and it made more sense from a marketing stance to show off the mystical inner workings of a device rather than hide it away, as we do today. Still, there is a very subtle art to the way they framed things, steering the eye toward certain things and away from others."

This repurposing of the past while still respecting the original intent speaks not just to Datamancer's view of design but also to how design affects our attitudes about the future:

> Sometimes I think that we're all stuck in the future, waiting for the future. In the eighties, we fetishized the future with computer synth music; boxy, stylized cars; and wild fashions. In the nineties, we fetishized it again with grungy cyberpunk aesthetic, in the [aughts] everything looked like biomechanical space-eggs. Here we are in [a new decade], and I think we've run out of future. We're living in an amazing age where entire computers fit in your pocket, robots build our consumer goods, we tweak and rewrite genetic codes, we put robots on other planets, weave clothing that deflects bullets, and do many other things that sound like they've been pulled out of a sci-fi novel.

Ultimately, Datamancer thinks looking back to the era of adjustment during the Industrial Revolution strikes a chord because "We've been desperately craving the future for so long that we don't know what to do with

it now that it's here. It's no wonder that we look to the past to try and find analogues and metaphors to help us adjust."

Kinetic Steam Works

The most madcap Steampunk artists and makers might belong to the San Francisco–based Kinetic Steam Works, founded in 2005, which reimagines and engineers real steam engines. Their mission statement? "Steam power, kinetic art, industrial art, and education creatively connected!"

The self-proclaimed father figure of KSW is Zachary Rukstela, an industrial artist, long-time volunteer on the steam-driven liberty-class ship S.S. *Jeremiah O'Brien*, and one of the builders of *La Contessa*, a desert galleon that roamed California's Black Rock Desert for several years.

According to Rukstela, the members of KSW prefer to call themselves "Steamdorks" as they consider the term "Steampunk" too limiting.

"A friend said our ship was at sea, and we passed Steampunk several times," says Rukstela, who definitely sees a divide between those who call themselves makers and those who don't. Rukstela thinks of Steampunk as "theatrical, whereas KSW tends to be rather mechanical."

Almost as obsessive as trainspotters, KSW members are true steam geeks from the inside out. "The point of KSW originally was to marry two realms—to get people to interact with vintage steam while giving it relevance to the times."

Their projects have included a retro steam engine named *Hortense*, a steam-powered boat named *Wilhelmina*, and a massive contraption simply known as *The Dingus*, based on the remains of a 1930 German Iron Worker, that smashes and squashes things.

General steam aficionados tend to focus on appreciation of old-fashioned trains, but KSW wanted to differentiate itself from the "old-timers." The members decided to meet the challenge of attracting a new generation appreciative of steam by creating original kinetic and industrial art. Rukstela is proud of having many people in the organization "who have had no previous steam experience and are now ready to participate in vintage steam shows."

Rukstela is unabashed about why KSW loves steam, and the reason is more primal than a rebellion against antiseptic modern technology. Rukstela says that "steam offers engineering elegance." But beyond that, "It's hot and wet—it's incredibly sexy, with pistons moving, dipping, moaning. Incredibly organic."

At the same time, it provides an atypical view of technology that appeals to the KSW crew. "It's insanely powerful but quiet. The ship I work on, the *Jeremiah O'Brien*, was where the boiler rooms in the *Titanic* movie

OPPOSITE
Steampunk Laptop by Datamancer, 2007
ABOVE
Beneath the boiler jacket of *Hortense*, Kinetic Steam Works, 2008

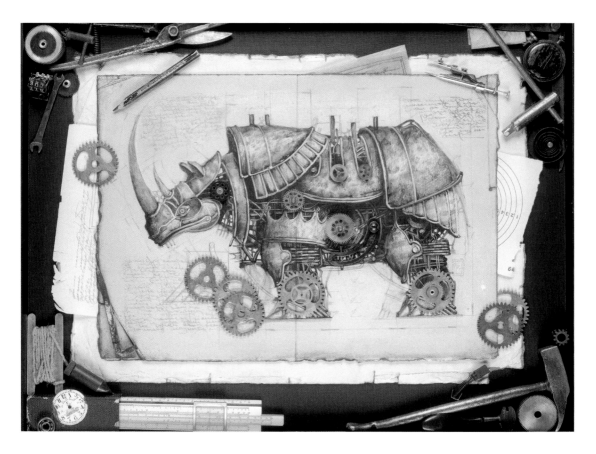

were filmed. The engine is two stories tall, and you can stand next to it and have a conversation without raising your voice. No exploding fuel, just steam expansion."

To Rukstela and his cohorts, steam interest is a virus, a "steambug," as the old guys call it. Catching the bug comes with responsibilities, not just symptoms.

"If steam isn't respected, it can be deadly," says Rukstela. "The 'steam' in 'Steampunk' refers to a boiler—and a boiler not managed correctly is a bomb."

 # The Mecha-Organic Impulse in Steampunk Art

THE SAME CLEAR IMPULSE TO HUMANIZE AND PERSONALIZE TECHNO-logy found in the projects of prominent makers can also be found in Steampunk art. It doesn't attempt to reinvent and reimagine functional machines or the facades of functional machines. However, it often fuses the organic and the mechanical, as if trying to reconcile two opposing impulses.

Russian painter Vladimir Gvozdev, for example, reimagines the Industrial Revolution in a semi-whimsical way with his depictions of clockwork or steam-driven animals. In paintings like that of a mecha-frog, there's even a hint of the pseudo-Victorian impulse to see how things worked through dissection. His delightful mecha-elephant and mecha-rhino, meanwhile, echo and reinforce the continued influence of Jules Verne in Steampunk creations.

Gvozdev has always been attracted by the aesthetics of technical drawing and images of animals, but in this series he wedded those elements to a fascinating story dating back to 1918:

> Once, I was told about a German mechanic who lived in Russia at the beginning of the twentieth century. After Germany's defeat in the First World War, the mechanic went mad and was held in a lunatic asylum for life. There he began inventing *vergeltungswaffe*, a German term for "vengeance weapons." I never saw his blueprints, but I liked the story so much that I tried to make via my blueprints a sort of portrait of the inventor himself—to create a little museum out of the mind of that German mechanic.

The three-dimensional avatars of Gvozdev's images were constructed with help from his friend Giuseppe and provide a different perspective on the art through their use of rougher textures. These sculptures have a more gritty, earthy feel, bringing the diagram-based material to life.

Similarly, Boston resident Mike Libby's Insect Lab, featuring three-dimensional clockwork insects, creates fascinating intersections between the organic and the mechanical. The results are decorative but also suggest delicate, impractical machines.

"I want to honor, revere, and play off of the minute, unique, beautiful details, shapes, textures, and colors of each specimen," Libby says. "I want them not to look like bastardized, Frankensteined mutant freaks of nature, but have a sense of whimsy and luxury, like they come out of a great sci-fi story."

The process of creating his insects is involved and difficult, but he also admits that on some level "it really is as simple as it sounds: dead bugs and broken watch parts."

BELOW, LEFT
Fish sculpture by Vladimir Gvozdev
BELOW, RIGHT
Snail sculpture by Vladimir Gvozdev

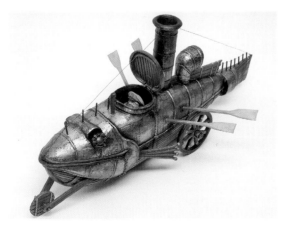

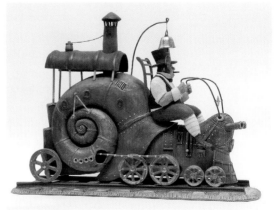

The complexity derives from how he synthesizes these elements. "I use a whole variety of glues, tweezers, files, pliers, archival markers, saws, heat, and sandpaper to finesse all of the metal watch parts, and I don't cosmetically alter the insects—they are beautiful without alteration."

Libby believes he is tapping into a common gestalt. "Robotlike insects and insectlike robots are the stuff of science fiction and science fact. In science fiction, insects are frequently featured as robotic critters, either scurrying across the galaxy as invading aliens or as robo-bug counterparts to a futuristic human race. From *Cronos* to *The Golden Compass*, the insect/robot archetype has been used, reused, and reimagined countless times."

Yet, Libby's creations are also inspired by the way engineers study insects when developing new designs and new technology. "Insect movement, wing design, and other characteristics [can all be important because sometimes] the most maneuverable and efficient design features really do come from nature. Ironically and often, this technology closely resembles the musings of science fiction."

His purpose in creating his Insect Lab was to celebrate "these correspondences and contradictions. The work does not intend to function, but playfully and slyly insists that it possibly could."

The ultimate incarnation of this impulse might be the Machines of the Isle of Nantes exhibit, created by "urban sculptors" François Delarozière and Pierre Orefice and exhibited in the industrial warehouses of the former shipyards at Nantes, France. As noted on the website devoted to these creations, "The designers let their imaginations roam . . . building a bestiary of living machines. Like doors to the world of dreams and magical journeys, they give this island a mysterious feel."

The "Sultan's Elephant" (see following spread) is, along with most of the exhibit, a complex tribute to the works of Jules Verne, who lived in Nantes. Accompanying the elephant, an ensemble cast of smaller creatures also helps to demonstrate the impulse toward humanizing technology through incorporating the organic. Visitors are beguiled by the seeming lifelike qualities of the pachyderm, and yet its creators have been careful to show the gears, in a sense—the joints and the interior hydraulics. In addition, Delarozière and Orefice have made available all of their sketches and blueprints, so that visitors can understand the process of building these amazing machines. The elephant and its cohorts are not just physical, and of the world, but also serve as a wonderful symbol of the ability of human

PREVIOUS SPREAD
A mecha-frog by Vladimir Gvozdev
ABOVE
Dynastidae: Eupatorus Gracilicornis, Rhino beetle with brass/steel gears, parts and spring, by Mike Libby, 2009

OPPOSITE
Poster advertising The Machines of the Isle of Nantes exhibit, by Stéphan Muntaner, 2007

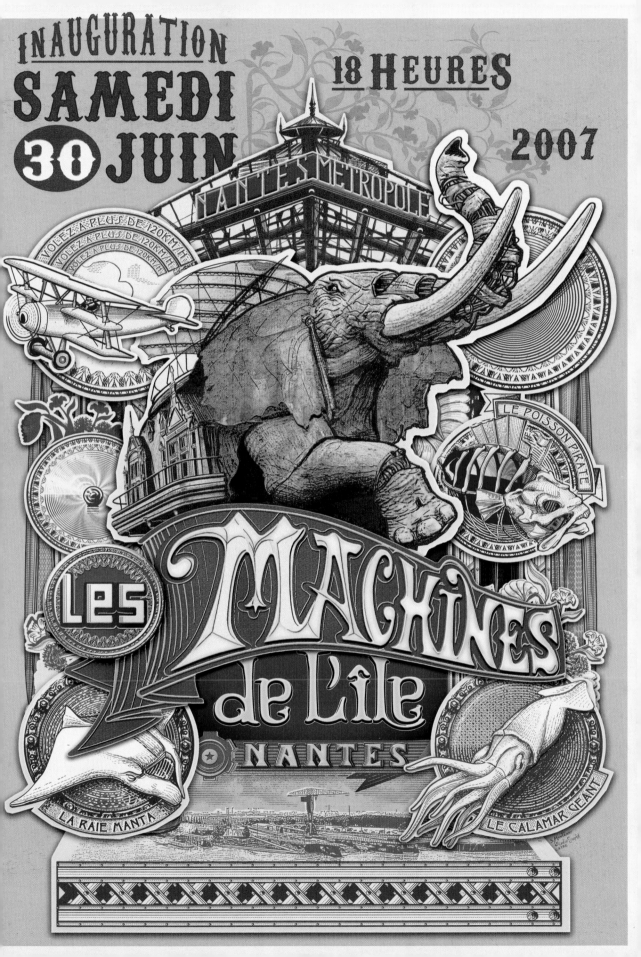

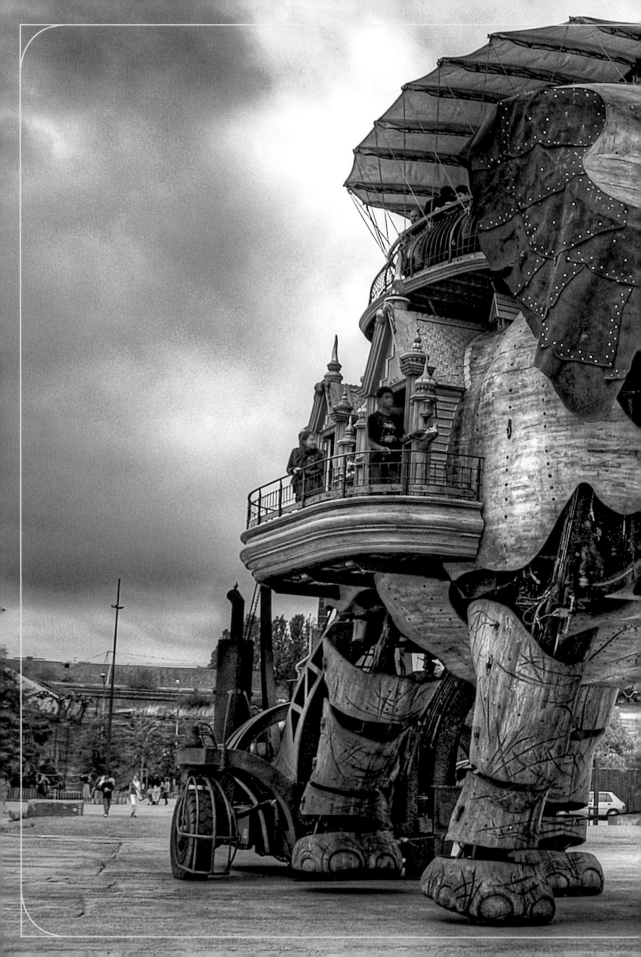

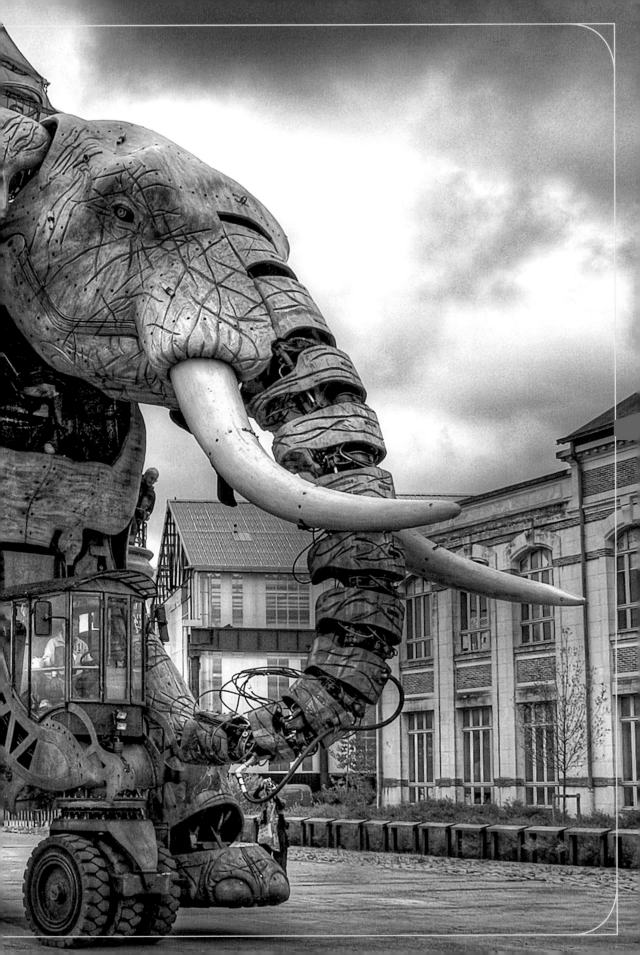

The poster text reads:

NANTES MÉTROPOLE
PLONGEZ DANS LA GALERIE DES MACHINES

Chevauchez un Crabe
Explorez les abysses
Affrontez la Tempête
Domptez le Calamar géant

www.lesmachines-nantes.fr

beings to believe in the impossible. The "world of dreams and magical journeys" they evoke is a direct link to Verne.

Such hybrids are also fascinating because they mimic the way people have increasingly come to function in an artificial world that is informed by the natural world but not perceived to be as dependent on it as in prior generations. There is an odd sense of hopefulness or perhaps even idealism in the idea of human technology and animals coexisting in such a harmonious fashion—it echoes the primary Steampunk directive of repurposing the excesses of the Victorian era and, yes, replicating its triumphs.

Oxford's Steampunk Exhibition

These same impulses were on display at perhaps the greatest evidence yet of the legitimacy of Steampunk art: Oxford's Steampunk Exhibit, curated by Art Donovan and held at the Museum of the History of Science from October 2009 to February 2010. Billed as "The World's First Exhibition of Steampunk 'Devices + Contraptions Extraordinary,'" the show was divided into "practical" and "fanciful" sections. It featured creators from not just the United States and the United Kingdom, where Steampunk is most prevalent, but also Japan, Belgium, Switzerland, and Australia. Press coverage from as far away as Turkey and China made the exhibition one of the most publicized Steampunk events ever, even eclipsing the effects of the 2008 *New York Times* article that brought the idea of Steampunk to critical mass.

"The main point of the exhibition was to illustrate the aesthetic and artistic aspects of practical scientific devices," Donovan says. "In Steampunk, we celebrate the device as a work of art. The form of an object must be equally impressive as the function. This illustrates the value of the object to the user."

Many of the art pieces displayed the same fascination with the idea of combining the organic and mechanical, including work by Dr. Grymm, Molly "Porkshanks" Friedrich, and Tom Banwell. Others are amazing mash-ups of several different ideas, like the sculptures of Kris Kuksi, which combine various modes of transportation with urban architecture.

Donovan's own *Shiva Mandala* is a marvelous melding of influences and cultures, and inadvertently served as the catalyst for the exhibit: "I decided on using an ancient Persian astrolabe as the central part because of their remarkable design and geometry. Perusing the Internet, I found that the Museum of the History of Science at Oxford had the most comprehensive collection of astrolabes in the world." The process of selecting an astrolabe from the museum's collection led to the idea of a full exhibition that would complement pieces in the museum's permanent collection.

In keeping with the Steampunk impulse toward spontaneity, and perhaps in part to break out from his thirty years in commercial art and design, Donovan has no set routine for creating his art. "Once I convince myself that a particular idea will work, I go directly to cutting and welding metal

STEAMPUNK
The World's First Museum Exhibition of Steampunk "Devices + Contraptions Extraordinaire"

The Museum of the History of Science at the University of Oxford, UK

October 13, 2009 through February 21, 2010

Artists hailing from:
Japan
Canada
Belgium
Australia
Switzerland
The Netherlands
The United States
The United Kingdom

Presented by Dr. Jim Bennett and Curated By Art Donovan
www.steampunkmuseumexhibition.blogspot.com
Art by Sam Van Olffen

ABOVE
Oxford's Steampunk Exhibit poster, design by Art Donovan, with art by Sam Van Olffen, 2009
BELOW
Mechanical Crab at The Machines of the Isle of Nantes exhibit

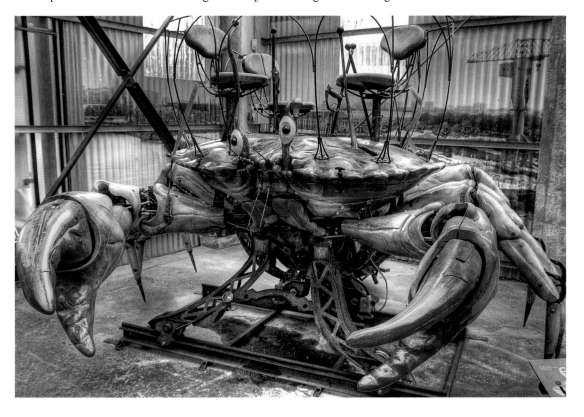

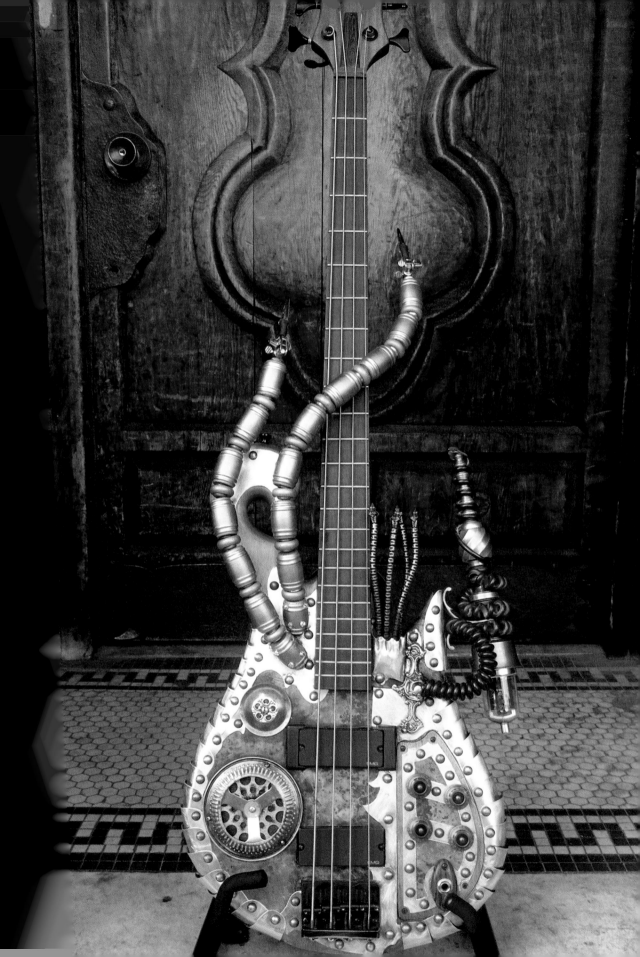

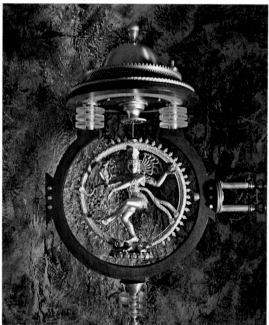

and shaping wood. . . . I never fall in love with a concept because that is the kiss of death for creativity and flexibility. All of my materials are simply raw brass, raw steel, mahogany lumber, and a myriad of lamp parts—thirty-two thousand at last count."

The works by Donovan and other artists not only garnered critical praise and media attention, but according to the final count it was the most highly attended exhibition since the museum opened in 1683.

"When I arrived back for the show closing in February of 2010, the queue for the exhibit ran through the entire museum and all the way around the block," Donovan says. "The museum staff was astounded at not only how popular the show was but also how Steampunk had appealed to such a wide demographic and people of all ages. The exhibition docents had never seen such a joyful response to any exhibit. There was laughter, shrieks, chatter, and a *lot* of finger pointing."

Attendees seemed fascinated by an exhibition that not only displayed new creative works, but also celebrated long-lost aspects of fine craftsmanship. "Most contemporary arts celebrate the purely conceptual, which of course is fine," Donovan says, "But in Steampunk, there is a tangible 'substance' to the works that transcends the merely conceptual."

Whether it's through events like the Oxford exhibit or the wonderful "Sultan's Elephant," Jake von Slatt's Steampunk Workshop or Sean Orlando's Raygun Gothic Rocketship, Dr. Evermor's repurposing of a century's worth of junk or Gvozdev's inspiration from the tale of a mad German mechanic, all of these creators are harnessing amazing imagination and skill with a vision of technology that isn't barren or sterile, but instead full of life and retro-innovation. The do-it-yourself impulse behind Steampunk making and art means that still more idiosyncratic, insanely ambitious, and fun projects are right around the corner.

OPPOSITE
The Elder Bass Guitar by Molly "Porkshanks" Friedrich
ABOVE, LEFT
The Victrola "Eye-Pod" by Dr. Grymm Laboratories, 2009
ABOVE, RIGHT
Shiva Mandala by Art Donovan, 2009

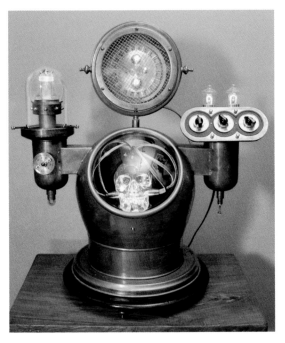

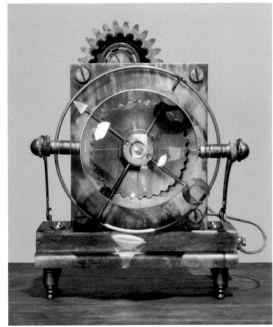

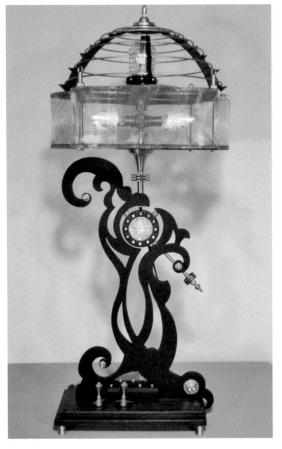

TOP, LEFT
The Electric Skull by Art
Donovan, 2009

BOTTOM, LEFT
The White Duke (lamp) by
Art Donovan, 2008

TOP, RIGHT
Steampunk Clock by Art
Donovan, 2009

BOTTOM, RIGHT
Aethertide Gauge by Molly
"Porkshanks" Friedrich

Etching Tins with Saltwater and Electricity

By Jake von Slatt

Not every Steampunk project has to be large-scale—the point is for everyone to get involved. Here's an example of a small-scale project presented by Steampunk Workshop founder Jake von Slatt. For detailed, step-by-step instructions, visit his website, http://steampunkworkshop.com. This process requires chemicals and heat as well as electricity and water. All are potentially dangerous, so please review the safety information on von Slatt's website before starting your own mint tin project.

In the past, merchants stocked sealed cans and boxes made from tin for many products. Variable shipping methods, and the indeterminate time that a product might remain on the shelf, meant that a durable container made a great deal of sense. Today, we see the same concept in mint tins that can commonly be found at supermarkets and drugstores. These small tins are ideal for storing sewing supplies such as pins and needles, paper clips and pushpins on your desktop, or nuts, bolts, and other hardware in the workshop.

BELOW
Etched tins

CONTINUED

This project will show how to turn plain toffee and mint tins into beautiful boxes suitable for display. But this project is about more than just decorating the surface—it also shows how to etch into their very substance using saltwater and electricity. Make sure to have protective eyewear and rubber gloves on hand, read warnings and instructions before using chemicals, and work in a well-ventilated area. The finished tins are completely safe to touch, but you should not store food or candy in them unless you line them with a food-safe material. Do not let very young children play with them or put them in their mouths.

Preparation

Tins to be etched need to be free of paint or varnish. Any of the chemical paint strippers available at your local hardware store will work, just follow the manufacturer's instructions. You can also use a hot plate or plumber's torch to burn the paint and then scrub it off with a scouring pad. Be sure to do this outside and avoid older tins that may have lead in the paint. You can also simply sand the paint off with fine sandpaper or an abrasive pad.

Creating the Image

Your image or design must be black-and-white, not grayscale. For the example used here, I drew the outlines of a clock escapement in black pen and then scanned my drawing into the computer at a high resolution. I then used a paint program to fill in all of the areas that I wanted to be completely solid. Once you're happy with your image, use your paint program to invert the colors and then flip it left for right so that the "mask" will print out in the orientation you desire.

Printing the Mask

You'll need to find the right kind of paper to transfer the printer toner mask to the tin lid. The flimsy coated newsprint used in Sunday circulars is ideal.

However, this kind of paper is too delicate to be run through most laser printers. You'll first need to make a protective "sled" for it by taking a sheet of regular printer paper and folding over the top ¾-inch. Insert your flimsy paper into the printer under this flap.

Transferring the Mask to the Lid

Clean the lid thoroughly with rubbing alcohol. Repeat at least twice until

you have removed all traces of dirt and oil. Set the printed mask face down on the tin and heat with your iron by placing it on top of the mask for a second or two (use the iron's highest setting). *Do not move the iron sideways at all during this process!* Support the back of the lid with a block of wood cut slightly smaller than the lid.

Next, lift the iron and move it to cover the area you have yet to heat—again, without sideways movement. This process "sets" the image, partially melting the toner from the laser printer onto the tin. To complete the transfer, cover the whole lid with the iron and begin to slide the iron to one side. Follow behind the iron closely with a Popsicle stick, rubbing in a circular fashion so that you cover every millimeter of the top of the lid. Doing so will ensure that the toner is completely fused to the metal. Repeat this process on all areas of the tin for about two minutes.

Once you have gone over the entire tin with the Popsicle stick several times, drop the tin into some warm water and wait about ten minutes for the paper to soften.

Now, pick up the tin in both hands and rub it gently with your thumbs to remove the paper, leaving the toner adhered to the tin. As you remove the backing, rub progressively harder to remove bits of paper on fine and dense features of your image. Don't be afraid to rub hard. If toner comes off, it was toner that would have come off anyway during the etching process. Once all of the backing paper is off, set the tin aside and prepare the etching equipment. The spots where the toner rubbed off can be repaired with small dabs of model paint prior to etching.

ABOVE
Etching supplies

Gather Etching Supplies, Including Electricity

For the next part of the process, you will need a three-quart plastic container, table salt, some solid copper wire or a coat hanger to fabricate supports, electrical tape, and duct tape to secure the tin lid while you etch.

Most important, you will also need a source of electricity. The most convenient source will be a "wall wart" transformer or power supply from a piece of discarded electronic equipment.

Power supplies have three main characteristics: voltage, amperage, and whether they provide direct current or alternating current. An ideal supply would read "12 VDC/1 Amp" or something similar—literally anything that produces direct current will do. However, a supply that reads "9 VAC/1 Amp," for example, would not be acceptable because it produces alternat-

CONTINUED

ing current. The higher the rating, the faster the etch, but avoid anything over 24 volts. The supply used in this example will deliver 12 volts of direct current at 1 ampere, which is perfect for our needs.

Once you've selected your power supply, cut the connector off of the end of the wire and strip the ends so you can connect them later. In general, the positive wire will have a stripe or rib or some other marking, but don't worry if it doesn't. As you'll see, there is an easy way to tell if you inadvertently reverse the connections.

Preparing the Tin

Bend the wire or coat hanger into a double hook. You will use these hooks to hang the tin lid over the edge of the container. The tin lid needs to be suspended below the surface of the water and parallel to the opposite side of the container. Use duct tape to secure the wire to the lid as shown.

Do the same for your tin bottom, and hang it on the far side of the container.

Prepare the lid for etching by tightly wrapping vinyl electrical tape around the perimeter of the lid. Because of the stamping process used to make most lids, the metal at the corner of a lid is very thin. The etching process can eat straight through these corners. Protecting the corners with tape solves this potential problem.

ABOVE, TOP
Coat hanger bent into a double hook

ABOVE, BOTTOM
Prepare the tin for etching by wrapping vinyl electrical tape around the lid's perimeter.

Etch!

Submerge the tin cover and base into the container and attach the power supply (turned off!), twisting the bare wires to the supports or using alligator clips if you have them. Connect the positive lead to the lid and the negative lead to the base, and once these connections are made, plug the

supply into the wall. If you have an ammeter (a device to measure current), attach it and begin to stir in salt until your ammeter reads slightly less than the rating of your power supply. In my example, I am using a 12 volt, 1 amp supply and my three-quart solution required one level teaspoon of salt to draw 800 milliamps or 8/10 of an amp. *Remember to keep all connections to the wall or extension cord well away from the container of saltwater.*

If you don't have an ammeter, a good rule of thumb is to add ¼ level teaspoon of salt per quart

of water; this should work well for the vast majority of common power supplies. Check the temperature of the power supply during the etching process. If it seems to be getting too hot, disconnect the power supply, dump out the saltwater, and start again, this time using a smaller amount of salt.

As soon as you apply the electricity to the solution, bubbles will start to rise from the base (the negative side) and the water will turn a rust-brown color. If the majority of bubbles are coming from the tin lid, you have the leads reversed! These bubbles are composed of hydrogen. *Although this project only produces a tiny amount of hydrogen, please remember that it is a flammable gas.*

Continually check your tin lid, turning off the power and removing it from the solution every few minutes to observe the progression of the etching by feeling it with your finger. The time needed to etch your tin is variable—initially up to twenty minutes but as little as five—and decreases with any increase in the solution's temperature. You should expect to ruin the first couple of pieces until you get a feel for the process!

Removing Toner

A touch of paint stripper or solvent on a piece of steel wool will remove all of the toner from your etched pieces and leave them ready for the next step.

There are many ways to finish your tins: One of my favorites is plating with a copper sulfate solution, and you can read about that and view more detailed step-by-step instructions for this project at http://steampunkworkshop.com.

OPPOSITE, BELOW
Power supply, which should be turned off when attaching to the container
BELOW
Finished projects before paint or copper sulfate is applied

HAIR STAYS, GOGGLES, CORSETS, CLOCKWORK GUITARS, AND IMAGINARY AIRSHIPS

Fashion, Accessories, Music, and the Steampunk Subculture

Fashion is *the* window into the Steampunk subculture — it's both the way casual dabblers buy a day pass to the show and the physical proof of transformation for the makers and artists who decide to invent a persona (or "steamsona") in support of their new obsession. It's the one element that uniquely identifies a Steampunk from any other kind of punk, the outward expression of an inner narrative. The clothes give a human touch to Steampunk that counterbalances the emphasis on antiquated technology and machines, opening up whole new avenues for participation.

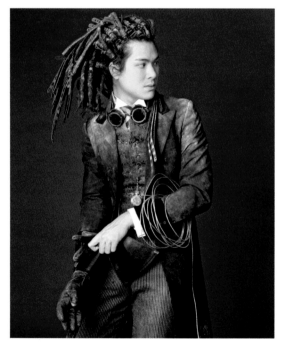

FASHION ALSO PROVIDES THE MISSING LINK BETWEEN STEAMPUNK literature and the rise of the subculture. As Steampunk mover-and-shaker and New York City resident Evelyn Kriete notes, the subculture's fashion origins can be traced back to a small group of artists in the late 1990s, the key figure being Kit Stølen, a costuming and design student in the New York City area who made his own clothing and preferred Victorian styles.

Stølen combined Victorian garments with accessories, including the invented "hair falls" look that has been copied by subsequent generations of Steampunks.

As Kriete notes, "Other people at the time had a similar interest in Victorian clothing, but Kit was the first person to identify his style as Steampunk," the term created by novelist K. W. Jeter in the 1980s, "and the first to be immediately and widely identified wearing that style."

Stølen's active presence in the New York club scene, along with photographs posted on the Internet, helped initiate the spread of a nascent Steampunk fashion sense to many people who were unaware of any wider context than a peripheral knowledge of Steampunk fiction and an appreciation of the works of Verne and Wells.

Perhaps more importantly, pictures of Kit and other Victoriana-loving artists demonstrated that Steampunk fashion was a viable style that

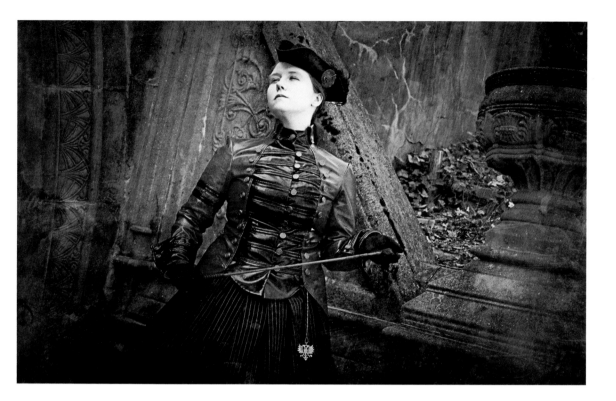

could be worn regularly. Stølen's clothing was not just club-appropriate, but also could be worn in daily life. This idea of "wearable chic" is as central to Steampunk fashion as the idea of "beautiful functionality" is to Steampunk arts and crafts. Steampunk fashion tends to combine a do-it-yourself punk aesthetic with an elegance that separates it from pure punk or Goth approaches to fashion.

Of course, the punk element can have a greater or lesser influence on Steampunk fashion depending on whom you talk to in the community, and the simplicity of Stølen's approach is perhaps lost on some.

SteamPunk Magazine cofounder, professional photographer, and Seattle resident Libby Bulloff says that, in general, there are two basic factions within Steampunk: "Serious cosplayers, con-goers, reenactors, and [on the other side] a 'Steampunk casual,' a more palatable daily-wear look that pulls from a plethora of vintage influences." According to Bulloff, "The former group is obsessed with details and often chooses to portray various Steampunk icons such as airship captains, tinkers, and pirates, but only at specifically Steampunk-friendly events. The latter group seems more relaxed and less obsessed with period correctness or characterization."

ABOVE
Evelyn Kriete, photographed by Lex Machina
BELOW
Self-Portrait Red and Blue by Libby Bulloff

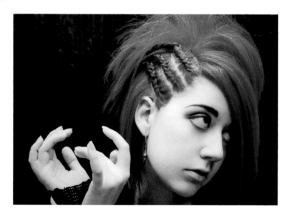

When Bulloff recently photographed Steampunk Workshop founder Jake von Slatt, she reimagined him in a grittier, more casual Steampunk style, providing a startling contrast with his typical persona, which is still casual but less edgy.

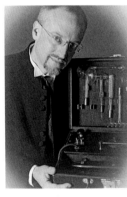

Bulloff believes this approach is important to reinvigorate current Steampunk fashion. "The only way to save Steampunk fashion is to, ironically, casualize it. So many Steampunks I see are not ready to commit to rocking the aesthetic as their regular attire, claiming that it's too difficult, expensive, or socially inhibiting."

As a result, Bulloff believes it's not mainstream interest that threatens to make "steam fashion" fadlike; "it's the folks within the subculture who misguidedly view only heavily embellished outfits containing goggles, functionless gears, and sepia and brown as the one true look of Steampunk."

Perhaps reflecting a difference between West and East Coast approaches to Steampunk, Kriete takes a more traditional approach, believing that Steampunk should still function as part of a much larger "neo-vintage" tradition. Much as the larger Steampunk movement can be seen as a reaction against seamless, sterile technology, neo-vintage is in part a reaction to the modern status quo that demands "a sort of neo-casual T-shirts-and-jeans look that avoids ornamentation and fine detail," a "cult of the ultra-casual" as active Steampunk creator G. D. Falksen has put it.

Steampunk should rebel against this impulse by, as Kriete puts it, "adopting formalism, intricate clothing, highly detailed and personalized possessions." To Kriete, people who object to this kind of fashion "are the new reactionaries because they are trying to force mainstream society's ultra-casual status quo onto the Steampunk culture."

Many Steampunks seem to split the difference. Author and scholar Gail Carriger was active in the community for years before selling her first

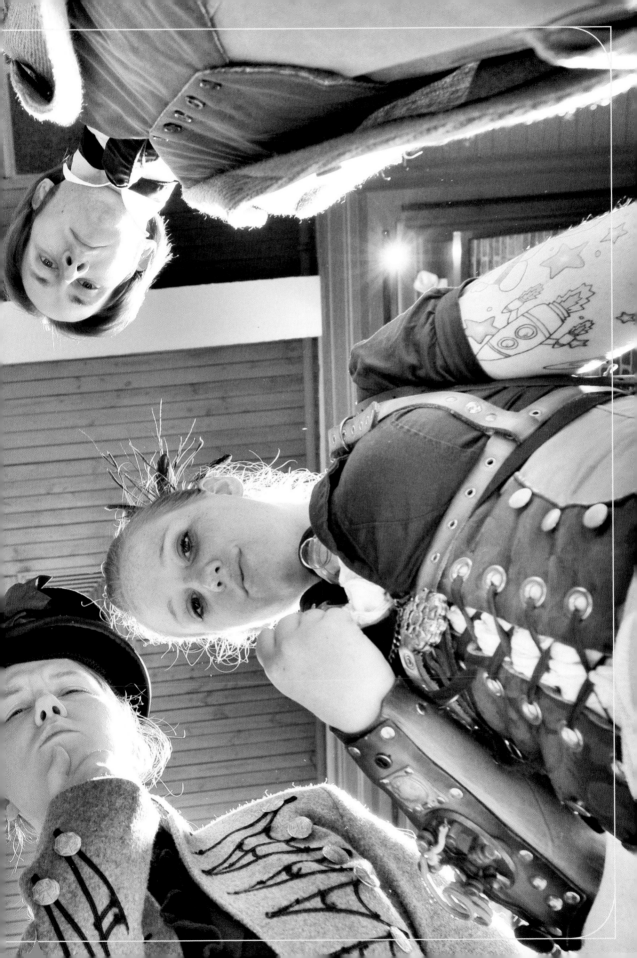

Steampunk Fashion: Four Styles

By Libby Bulloff

Several fashions have emerged from the Steampunk zeitgeist. Said modes can generally be cataloged according to social class and occupation—after all, fashion really is the simplest form of social networking. Steampunks challenge traditional Victorian societal restrictions, so I have endeavored to describe these fashions rather than define them. We modernists are allowed the autonomy to choose our garb as we please, and are not restrained by stringent rules. I encourage defiance of the ideas presented here. One should consider the following as only guidelines to discovering one's personal style.

The Street Urchin

THE STREET URCHIN

These folks dress in the most "punk" styles of Steampunk. We're talking tatters, filth, safety pins, old leather, bashed-in derbies, and the like. This style of dress is functional, can be mucked about in, costs little to hack together,

and nods smugly to the lowest classes of society. It looks good dirty. Torn stockings puddled around one's knees or tacked up with garters and pins are delicious. Wear your spoiled petticoats over a pair of knee breeches, ladies. Gentlemen—there's nothing sexier than suspenders over a tea-stained sleeveless undershirt, especially if you have tattoos. Street urchins and sweeps are the truest modifiers of garments, and they're fearless when it comes to waste, stains, rips, and sweat. Cross-dress, by gods! There are no rules, besides do-it-yourself.

Search for garments at thrift and antique stores. Tear up old lingerie or suits scavenged from Goodwill and add your own trims or pockets. Tea-stain striped tights and white shirts or creatively bleach sections of dark clothing. If you're unable to sew, pin, or tie fabric into the proper shape, then solicit assistance from a tailor friend.

Be adventurous and go for a wicked mohawk under your hat or leather-and-wire-bound bundles of dreadlocks. Tease your hair or shave it all off. Do not fear to splash your locks with vivid dyes. A brilliant surprise tucked under a dingy topper is delightfully subversive!

The Tinker

These are the risk-takers, the do-ers, the makers of things, who prefer well-designed garments with places for tools. Protective eyewear is required (the ubiquitous goggles or other such spectacles). Functional clothes that are impervious to spills and grease are ideal. Look for garments made of canvas, denim, leather, wool, and rubber. I picture the tinker in utilitarian garb, and the inventor in an eccentric amalgamation of cast-off lab wear and well-worn Victorian pieces. Locate a vest or jacket with lots of pockets—think cargo Victorian. Carry your tools of trade as accessories by making a pocketed belt to harness useful implements.

Don't forget the wild hair! Or rather, ladies and gents, feel free to forget to comb your locks before you go out. Or, give yourself a proper fauxhawk with tinted tips and tuck a wax pencil behind one ear.

Look for treasures at surplus stores or see if you can snag an old lab coat or rubber apron online. Goggles can be acquired from a plethora of locales, including army-navy surplus stores, antique shops, and eBay, though they should be left at home for parties and projects unless one's day job involves welding or working with chemicals.

THE TINKER

The Explorer

Explorers are, by definition, "persons who investigate unknown regions." Take note of this when dressing. Think tailored garments, but more military-influenced and less off-the-rack. Explorers look fine in earth tones, but let a little color peek out here and there. Silk, linen, tall boots, pith helmets, flying goggles—the list of explorer gear is endless. Try wearing mid-length skirts with the hems buckled up, revealing cotton bloomers. Billowing sleeves or bustled skirts with tight leather vests or corsets are indispensable. Borrow Middle Eastern and Indian flair from belly danc-

CONTINUED

ing fashion or take inspiration from pioneer garb. Ladies, search eBay or vintage stores for old-fashioned fan-laced medical cinchers, or make a DIY corset from a pair of military gaiters. Gentlemen, tuck your trousers into the tops of your boots and hang a pocket watch from your belt, or don a kilt and sporran.

Well-slicked hair with a bit of a devilish wave is marvelous for gents, and sleek updos and ponytails look lovely on the gals. If you have the distinct ability to grow muttonchops or a rakish goatee, do, by all means. Don't feel like dealing with your hair today? No worries—jam the lot of it under a flying cap and goggles or into a wool beret or helmet.

Scavenge about at your local army-navy shop for uniforms, footwear, eyewear, and headgear. Make your own skirts and trousers and decorate them with grommets or buckles.

The Aesthete

These are the fellows in nicely rendered Victorian and Edwardian suits, brainstorming infernal machines over cigars and brandy, and the ladies in high-button boots who dabble as terrorists when they aren't knitting mittens. This is neo-Victorian nostalgia with elements of anachrotechnofetishism and bohemianism.

Ladies, try dressing like a male dandy. Wear a cravat, vest, and tuxedo, and carry a cane. I know a dame ballsy enough to rock a crepe handlebar moustache and a greased pompadour.

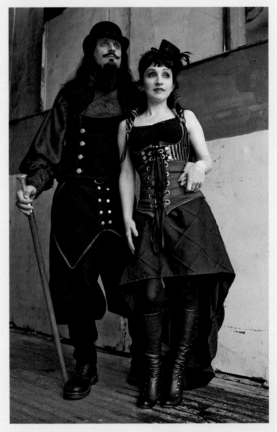

THE AESTHETE

Gentlemen, take note of Elegant Gothic Aristocrat garments. Japanese designers are commendable for incorporating metallic hardware into proper-looking clothing.

The dandy knows to accessorize; details make the look. Dainty pince-nez or monocles are a must, as well as corsets, handkerchiefs, cigarette cases, gloves, etc. Do invest in a top hat or dapper derby, and create your own neckties from interesting scraps of brocade. Finely waxed moustaches and lace gloves with the fingertips removed are encouraged. Throw a pair of spats over pointy boots to look fancy. Search online for jewelry consisting of glass, wire, lace, chains, and ephemera.

Hide your hair under a proper topper, try fingerwaves, or pile it up into a Gibson Girl bouffant anchored with roofing nails or chromed chopsticks.

❖ ❖ ❖ ❖ ❖

I beg you to use the aforementioned as inspiration, not a set of restrictions. Be uninhibited when dressing the part, which I encourage whenever the fancy strikes.

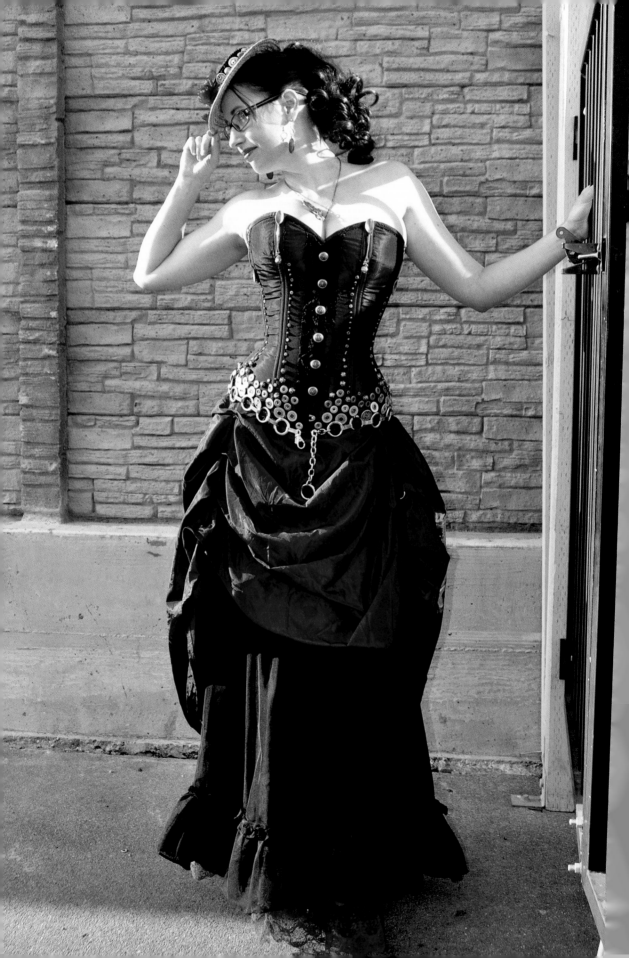

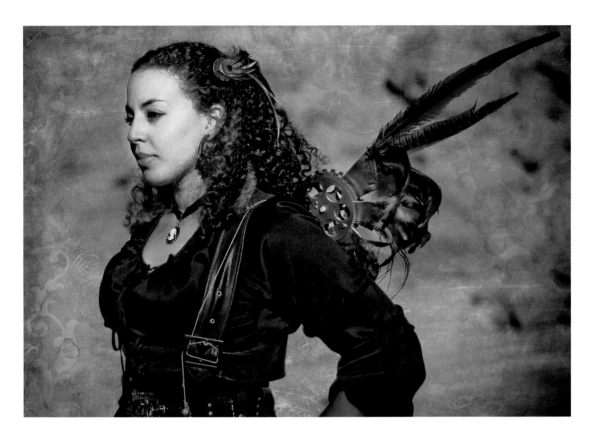

novel, and she loves both aspects of the aesthetic. Her description of one of her dresses perfectly exemplifies the marriage of these impulses:

> The top part is a Dark Garden corset I deconstructed (read: tore apart). I then sewed a whole bunch of old metal buttons and beads of different sizes onto the bottom and attached an old metal belt. Along the bust line I attached brass teaspoons from the 1950s I found in the garage . . . and I used brass paperclips to attach cover buttons down the front. The skirt part is made from two thrift store finds with curtain ruffles attached. Hanging from my belt are some World War II army pouches. The hat is made from a 1960s velvet fez, bent into a new position, and decorated within an inch of its life.

The result is stunning but also compact and wearable while incorporating both DIY ingenuity and the idea of fashion as art. The wearability of Steampunk can have highly specific purposes, too. A formal use of the aesthetic comes into play for Steampunk weddings, for example.

Professional designers like Berít New York's Britney Frady-Williams and Lastwear's Thomas Becker seem to have many of these concerns in mind when using the Steampunk aesthetic. Frady-Williams is a newcomer to Steampunk, while Becker has been creating designs that fit the aesthetic for about six years.

Steampunk fits into Frady-Williams's overall goal of bringing Old World charm to modern living. The aesthetic gives her "the freedom to

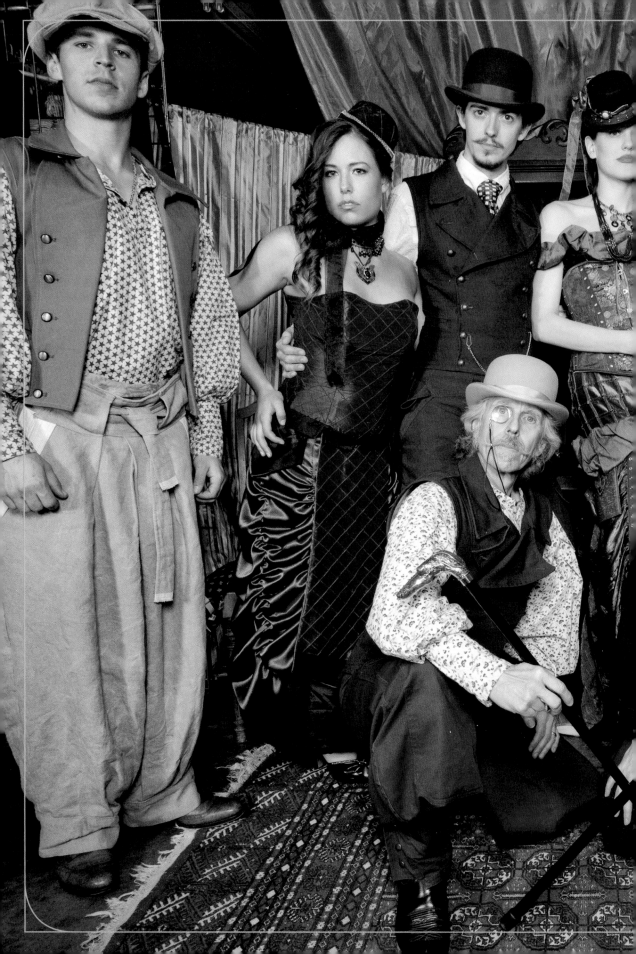

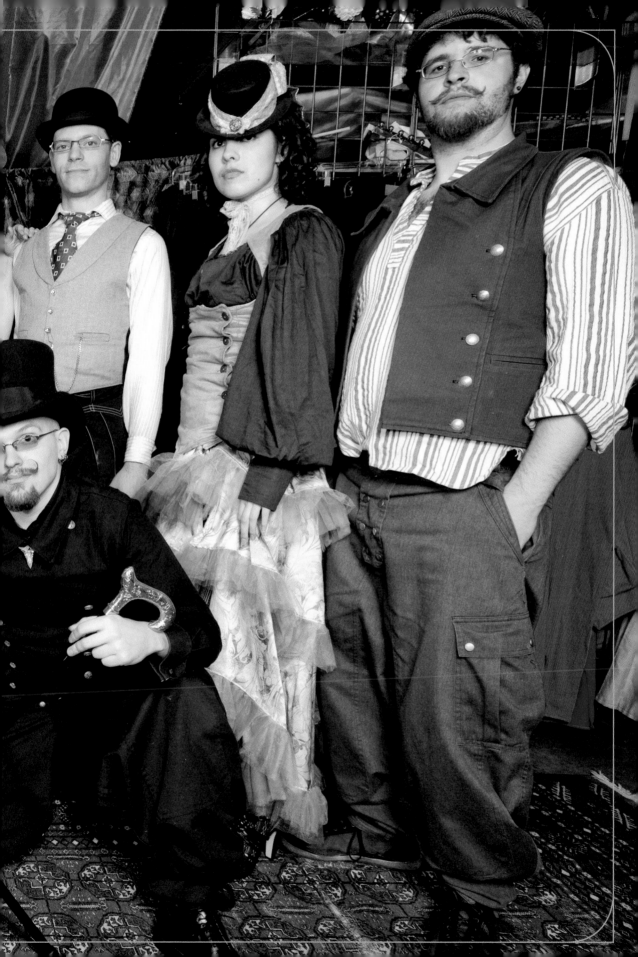

make historically inspired pieces that can still operate outside of history and in my imagination." Echoing makers like Jake von Slatt, she feels as if she was always designing within a Steampunk aesthetic, but "now I know what I was doing has a name."

Becker, meanwhile, calls Lastwear's clothing "temporally eclectic" and notes that it's only in the past couple of years that people have started defining it as "Steampunk." Influences on Lastwear's approach to fashion include everything from early medieval Europe, Meiji Japan, 1860s Western wear, and Napoleonic uniforms, right on through to art deco and Prohibition-era styles.

He defines Steampunk fashion as "gypsy, rag 'n' bone, tattered chic, engineer monkey, high Victoriana, and Western gunslinger," while Frady-Williams calls it "well-mannered rebels and civilized psychopaths."

As Steampunk has become more popular and gone beyond DIY, professional designers have tapped into conventions and other aspects of the community. "It's now almost expected to see a Steampunk fashion show at any given convention or science fiction event," Frady-Williams says.

Along with Lastwear and Frady-Williams's work, design shops like Steampunk Emporium, which picked up on the Steampunk subculture early, and Gibbous Fashions, which Bulloff describes as "the king of tattery, rotting, luscious clothing," reflect the full array of the movement's current fashion approaches. Today, there are more Steampunk fashion designers and do-it-yourself hobbyists than ever before.

Will Steampunk fashion eventually become too mainstream?

Becker dismisses this concern. "The DIY folks won't care. Some people who give a toot about what's popular may drop off from the scene when they decide that they're too hip for it, but that always happens. Every scene goes through that cycle. I do think, though, that there's something deeper that Steampunk is an expression of that represents real change, and I expect that to last."

Part of what may help Steampunk fashion endure is encountering and absorbing non-Anglo influence. Frady-Williams, for example, comes from a Cherokee heritage, and this informs her fashion. "My grandmother was a very skilled craftswoman and would teach me things as a kid. I grew up close to my tribal roots and would regularly visit my family near Cherokee Nation in North Carolina. During my trips to the reservation I would study the crafts and jewelry for sale, and that was how I learned to do beadwork and make other native crafts like headdresses, pottery, jewelry, and dream catchers. I don't think that influence will ever leave

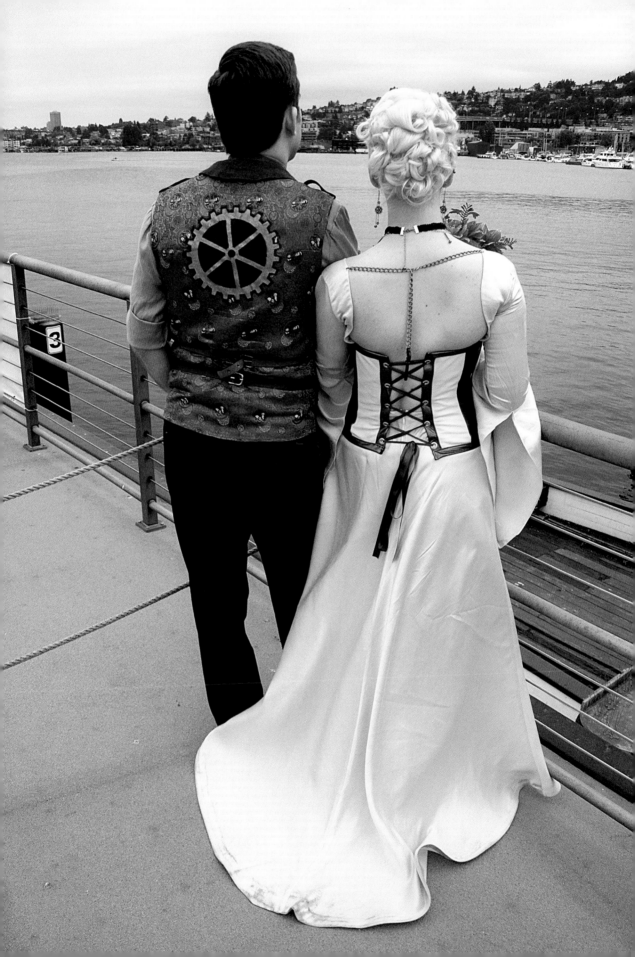

me." She likes to veer toward the Wild West vein of Steampunk, incorporating Native American textiles, cowboy fashions, and, naturally, exotic technology.

Members of the subculture like New Yorker Ay-leen the Peacemaker—Diana M. Pho in "real" life—a self-identified Steampunk of Vietnamese descent, bring their own unique cross-cultural exchange to the fashion of Steampunk. Ay-leen incorporates interests like literature, cosplay, and theater into her Steampunk persona and clothing choices. She's created a "steamsona" character and is "very much into fantastical props, costumes, and acting-over-the-top more than historical accuracy and prim reenactment like some Steampunks."

Ay-leen's obsession with nineteenth-century literature in high school, including Jane Austen and the Brontë sisters, helped fuel her love of Steampunk, along with her first chapter books as a child, which included illustrated versions of *20,000 Leagues Under the Sea* and *Journey to the Center of the Earth*.

She describes her brand of Steampunk as "a transcultural blend of East and West. . . . My 'steamsona' has a backstory based on alternative historical Indochina, where China and Japan are superpowers actively competing with European nations for control over Southeast Asia, and that's how the area becomes a center for multicultural interaction.

"So my character wears Vietnamese *ao dai* with tall Victorian boots and waistcoats, she gets Empire dresses made from silk brocade, and she totes a steam-powered Chinese hand cannon as her weapon of choice. She speaks French, Vietnamese, English, and pidgin Chinese, and she's able to share in other cultures while remaining proud of her own."

Ay-leen sees Steampunk "as a chance to rewrite the typical white, male-oriented, European-dominated past to reflect voices that had been silenced, ignored, or oppressed." In a sense, then, her steamsona is a living embodiment of rewriting the status quo, and indeed she is also the founder of the Beyond Victoriana website, which champions non-Anglo Steampunk.

Frady-Williams says that people of all different ethnic/racial backgrounds attend Steampunk events, each with an individualized approach to the fashion aesthetic. "I think the Steampunk community as a whole is very welcoming, and it embraces multiculturalism. I also think that the more we incorporate other cultures from the nineteenth century outside of Wild West America and upper-class Britain, the better and more imaginative the movement will be."

ABOVE, TOP
Lastwear men's fashion by Thomas Becker
ABOVE, BOTTOM
Air Baron Among Airships, from the Historical Emporium, photographed by Chris Allen
OPPOSITE
Twins, design by Britney Frady-Williams of Berít New York, photographed by Judith Stephens

ABOVE
Ay-leen the Peacemaker,
photographed by Matthew M.
Laskowski

Ay-leen agrees. "I'm seeing a lot more acceptance of things . . . outside the Victorian London framework. People are willing to experiment with the term 'Steampunk'; they're eager to individualize it to reflect their own personal experience. At the same time, the Steampunk community has accepted these perspectives, and instead of fragmenting the community, it has diversified and strengthened it."

In a more general way, Bulloff believes that ongoing transformation is the key to staying fresh. "We're no better than our wealthy, trendy, hipster counterparts when we cease continuous metamorphosis of our look. . . . As long as Steampunks encourage each other to make their own clothing, or at the very least buy garments from small, independently owned design houses . . . the mainstream won't usurp the spirit behind Steampunk. If we give up on constantly honing and reenvisioning our aesthetic, then we lose."

Kriete, however, sounds a cautionary note about Steampunk fashion: "You simply can't take the Victorian or Edwardian [element] out of Steampunk, because they are the core of its identity, the aesthetic of that age. One of the things that allows Steampunk to be so diverse and so harmonious is that it has a clear core aesthetic to build on, and then a great deal of freedom to explore using that core aesthetic as a base. Thus, there's always a common ground that its fans can fall back on to resolve their disagreements of interpretation."

Jewelry and Other Accessories

INVENTIVELY ACCESSORIZING CLOTHING WITH AN AT-TIMES BEWILDERING number of options is an important part of Steampunk fashion, and another way in which anyone connected to the subculture can participate creatively.

Jema Hewitt, a.k.a. "Emily Ladybird," is one of the best-known designers of Steampunk jewelry, which she sells on her website. She also teaches classes on a variety of subjects from millinery to corsetry. She has written two books on beaded jewelry, produced an instructional CD on tiara construction, and is a regular contributor to *Making Jewellery* magazine. Her latest jewelry book is *Steampunk Emporium* (2010). According to her

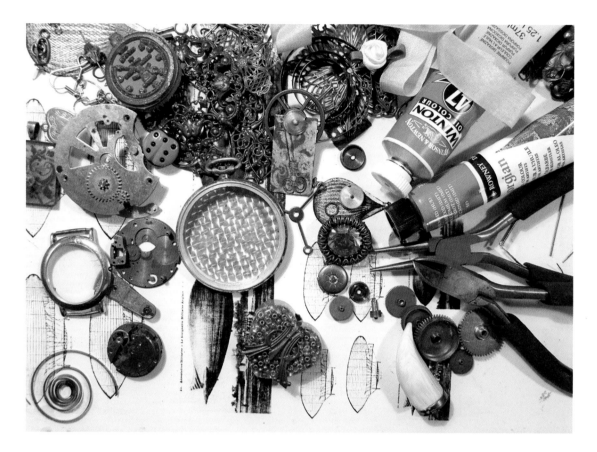

online profile, she "travels the globe on behalf of Dickens and Rivett, looking for unusual and rare artefacts of historical significance and gorgeous Steampunk jewellery. She has a large collection of very tight corsets and ridiculously tiny hats. Miss Ladybird, and her faithful family retainer Mr. Woppit, can often be found reading Poe or Stephenson (Neal of course) whilst boldly crossing continents in their hot air balloon."

She's been part of the Steampunk scene in the United Kingdom since 1997, when she started running The Company of Crimson, a role-playing campaign whose members occupied themselves with inventing Victoriana personas, holding ghost watches in castles, attending theater productions in character, and "generally enjoying ourselves" while solving "ever more extraordinary science and supernatural-based plots."

Most of Hewitt's influences come straight from the original Victorians. "I am a huge fan of art nouveau, the elegance of form and the combining of the unusual with the beautiful." Hewitt makes pieces for ladies and gentlemen, and likes seeing unusual cufflinks, cravat pins, and watch fobs actually being worn.

For her personally, Steampunk jewelry "needs Victorian-style detailing and an element of clockwork or engineering. My pieces have a feeling of elegant usefulness to them. I want them to be objects that might do something wonderful at any moment, like open the gate to Atlantis, or enable you to see Shangri-la."

ABOVE, TOP
Emily Ladybird's tools
ABOVE, BOTTOM
Jema Hewitt as Emily Ladybird

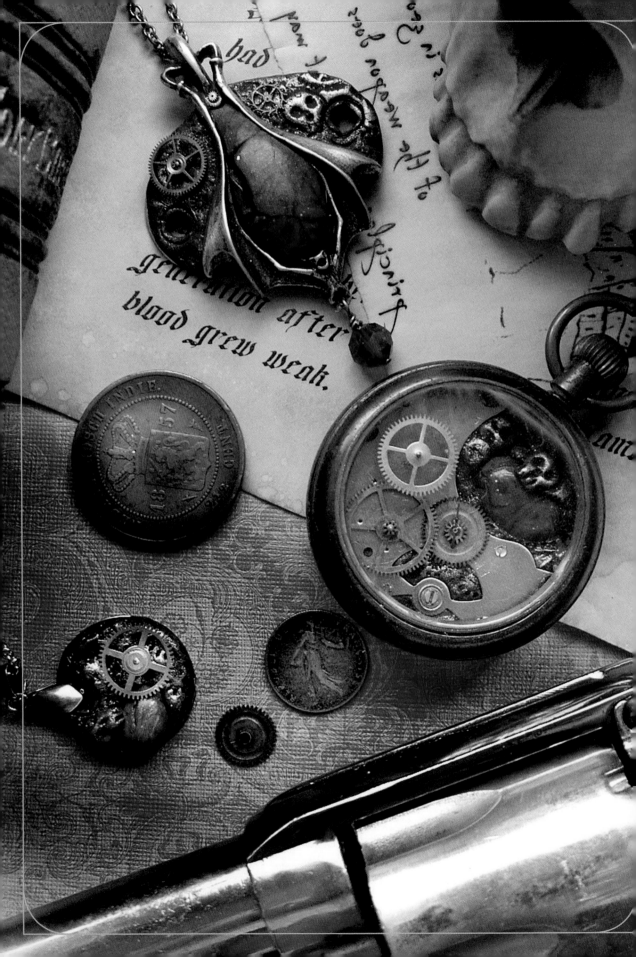

generation after
blood grew weak.

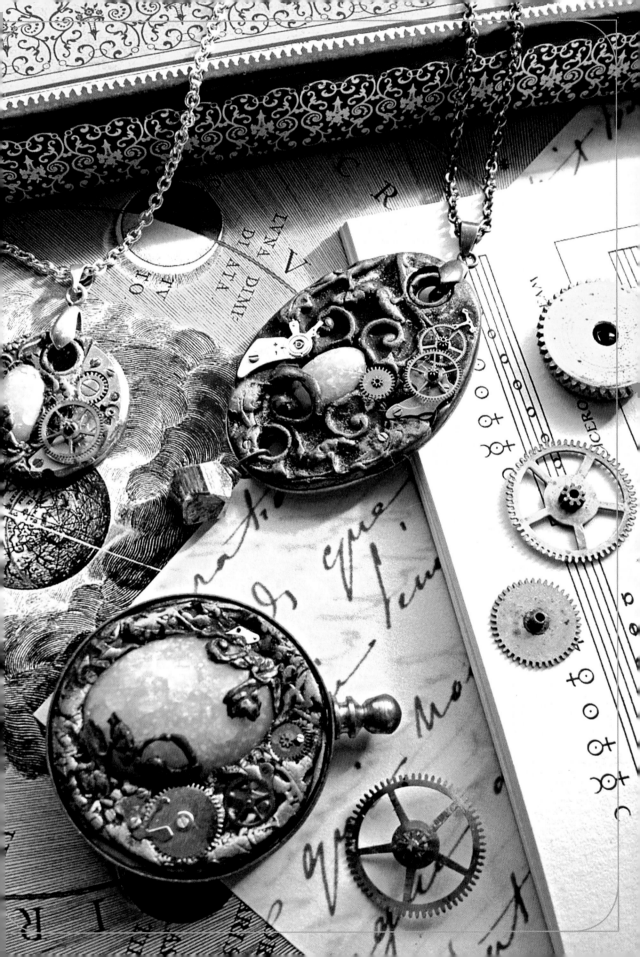

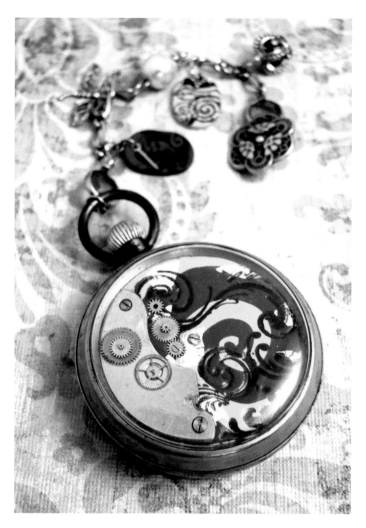

Although Hewitt doesn't believe in shunning mass-produced pieces, "the parts should be put together with style and flair, whether they are precious stones and twenty-four-carat gold or wire and vintage buttons." She finds the punk part of Steampunk in the use of recycled vintage objects.

Most of her pieces originate with a story idea. "I'll be having a Marie-Antoinette-on-the-moon moment or a vampires-on-Venus evening. I imagine who might need the piece and why."

After coming up with the conceit, Hewitt sketches "a few random ideas and shapes . . . and then I rummage through my boxes of antique parts, broken gears, and watches." Her technique involves the use of polymer clay and resins, as well as multimedia techniques and traditional smithing and jewelry construction.

When she's finished, Hewitt will expand on the origin story for each piece, and its "subsequent discovery by Emily Ladybird, who works in acquisitions at Dickens & Rivett, auctioneers." For example, her "Phantasmagoricallibration devices" come with a backstory that mixes magic and Sir Arthur Conan Doyle: "After Sir Flinders Petrie and the Company of Crimson closed the last door into the land of faerie, the devices made by the Company were delivered into the hands of several 'worthy guardians.' It is only now, after the gates have been closed for many years, that these citizens (among them Sir Arthur Conan Doyle and Mr. Jonathan Strange) have felt secure enough to explain the use of the few devices. . . . Designed by Dr. Staunton and Prof. Van Vaas, the objects were to make solid and viewable the parallel world of faerie."

PREVIOUS SPREAD, LEFT
Necrometers by Jema Hewitt
PREVIOUS SPREAD, RIGHT
Lunar Devices by Jema Hewitt (necklaces and pocketwatch in moon opals)
ABOVE
Steampunk pocketwatch by Jema Hewitt

Eight Ways to Raise
Your Steampunk Fashion Game

Of course, jewelry isn't the only accessory used by Steampunks to augment their cloth-
ing. Here's a complete list, to deck you out from head to toe. Just remember—if you
encounter a Steampunk more enamored of the "punk" than the "steam," you may be
jeered at for being a dandy.

HEADGEAR

The discerning Steampunk understands that a bare scalp may
indicate a bare brain beneath. For this reason, it's important to
consider headgear carefully. "Headgear" is a wide-ranging term
that includes fascinators, formal hats, and work hats. If you like,
you can even build a city above your brows.

GOGGLES

There's really no way to complete your sky captain ensemble
without the customized goggles worn by seasoned aviators.
Goggles come in a cornucopia of styles and shapes, so you can
find the one pair that definitively fits your distinctive optical
nerves.

FINGERLESS GLOVES

Steampunks need to be fashionable but also able to jumpstart
that greasy, rumbling perpetual motion machine that always
seems on the verge of failing. Fingerless gloves allow mobility
and practicality while adding an extra touch of "fashion garnish."

TOOLS/WEAPONS

Whether carrying them or wearing them on belts, Steampunks
need their tools. You never know when a contraptorsaurus
might be in need of a good smack across the boiler, or when
that irksome neighbor who insists on delivering his faux
Renaissance Faire spiel at the drop of a hat needs a good imagi-
nary raygunning.

CONTINUED

POCKET WATCHES

Although women indeed carry pocket watches, this is one of those few accessories more common with the gentlemen. As with goggles, pocket watches come in all shapes and sizes while retaining that one essential temporal function: to make the wearer look elegant and sophisticated, and *in the moment*.

SOCKS/STOCKINGS

Sadly, most men do not look good in stockings and therefore have no recourse but socks. For women, however, stockings are an excellent option for the housing of legs and provide additional protection against the elements, which is particularly useful in the colder climes. In areas prone to airship battles, you may want to consider metal stockings.

BOOTS/SHOES

Will your footwear be as distinctive as your clothing? This is the most important question. Just as a Steampunk's choice of headwear opens a discussion and makes a statement, so too footwear determines whether you end your fashion conversation with an exclamation point or a question mark.

SPATS

What is a shoe without a spat? It is akin to a lively argument initiated silently, without the tongue. If you lack spats, which cover the instep and ankle, you are, in Steampunk terms, practically a nudist.

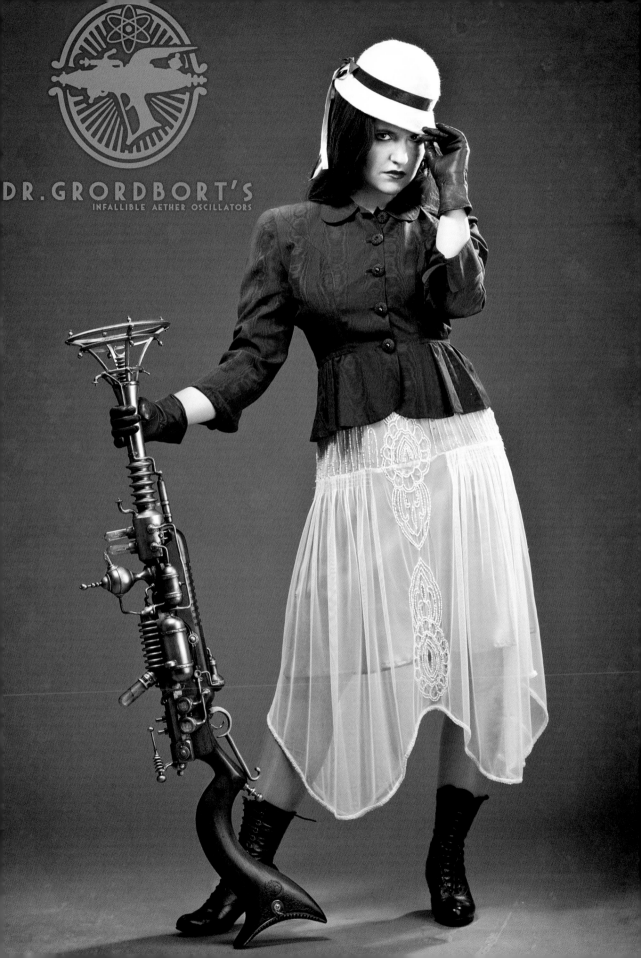

DR. GRORDBORT'S
INFALLIBLE AETHER OSCILLATORS

Steampunk Music

PREVIOUS PAGE

The Phantom Unnatural Selector, designed by Greg Broadmore, 2010

BELOW

Abney Park outside the Neverwas Haul at Maker Faire 2008: Nathaniel Johnstone (guitar/violin/mandolin), Kristina Erickson (keyboards/synths/piano), Daniel Cederman (bass), Robert Brown (vocals/dumbek/accordion), and Finn von Claret (vocals)

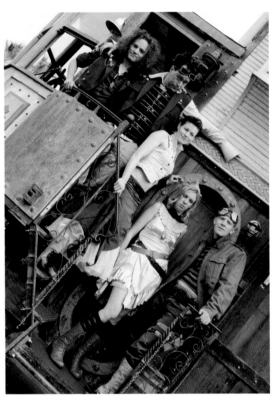

A "STEAMSONA" WITH BACKSTORY OR SOME ELEMENT OF REINVENTION is also a key ingredient for most Steampunk bands. Indeed, some bands, like the Decemberists, are not Steampunk at all, but have at times been conscripted into the subculture due to the whimsy of their claim, among others, that they "travel exclusively by Dr. Herring's Brand Dirigible Balloons." But even for core Steampunk bands, a transformation of some sort is required—the kind of metamorphosis natural in the music world, where today's punk band may reform tomorrow as electro-Goth, dark wave, or emo.

According to Evelyn Kriete, who created the first Steampunk music label, Gilded Age Records, with Vernian Process' Joshua Pfeiffer,

"Steampunk music is built on the idea that the themes, imagery, and aesthetics of the Steampunk genre can be translated into musical form. Like its literary parent, it explores the path not taken. . . . Steampunk music feels timeless and vintage, but it is not against the advantages of modern technology. It is music that would have been enjoyed in the dance halls of the 1890s, if they possessed the ability to rapidly exchange and combine forms of music from around that world that we today enjoy thanks to the advantages presented by the Internet."

However, there's still quite a bit of divergence between musical acts. Some Steampunk bands have a stated intention of creating "Steampunk music," the members inspired by the literature or lifestyle. Others existed prior to the widespread embrace of Steampunk as a genre, but later came to identify with it; they were into Steampunk "before it was cool." Yet others may not identify with Steampunk, but their music, aesthetic, or performance style clearly intersects with the typical traits of Steampunk music.

What are those traits, exactly? Although, as in many genre classifications, the definitions are vague and the boundaries fluid, here are a few: theatricality and performance, a Gothic or Victorian-inspired aesthetic, playfulness and spontaneity, grittiness and darkness, and narrative and storytelling. While playfulness and grittiness might seem like contradictory elements, their juxtaposition is actually key to the Steampunk aesthetic.

Although Steampunk music is continually evolving and the major players changing, here are ten bands Steampunk fans should sample.

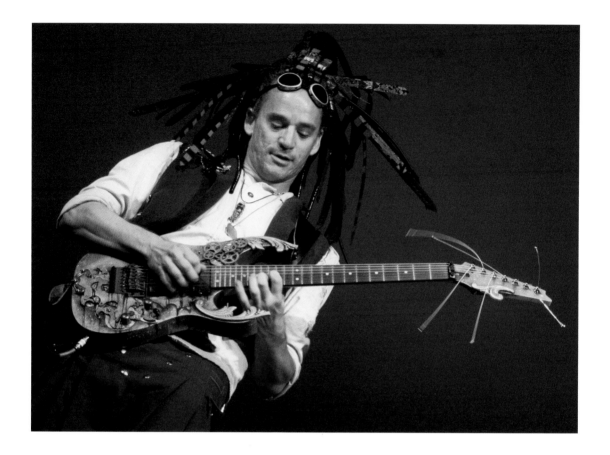

Abney Park

Self-managed, Seattle-based band Abney Park has carved out a niche as
Steampunk heavyweights. Along with their five albums, they also peddle
Steampunk merchandise: posters, stickers, flags, and fashion ranging from
scarves and kneesocks to goggles and jodhpurs. Their instruments include,
to name a few, the violin, mandolin, keyboard, flintlock bass, pocket gui-
tar, accordion, dumbek, and harmonica. The band claims to hail "from an
era that never was, but one that we wish had been. An era where airships
waged war in the skies, and corsets and cummerbunds were proper adven-
turing attire." They perform with beautiful set-piece instruments, dressed
in full costuming that features ripped tights, leather vests and corsets, kilts
and lace skirts, lace-up boots, and, of course, goggles.

ABOVE
Nathaniel Johnstone, lead
guitarist of Abney Park

ArcAttack

ArcAttack's high-tech sound features two custom-engineered Tesla coils,
each tossing out twelve-foot electrical arcs and creating a sound similar
to early synthesizers. The musical Tesla coils are grounded by the beat of
a robotic drum set. Live instrumentation comes together with drum loops

and sound samples generated by supporters of the band. The dramatic performance is enhanced by this Austin band's MC, who wears a chain-mail Faraday suit as he strolls through the sparks. They hope their high-energy music and "electrifying" performances will inspire interest in science and the arts.

The Clockwork Quartet

Incorporating characters such as The Lover, The Scientist, The Fugitive, and The Magician into their songs and performances, the Clockwork Quartet exemplifies the storytelling impulse. The band features a varied cast of musicians, performers, composers, and collaborators, and they use violins, cellos, and guitars, along with background music that includes chimes and clacking typewriter keys to create a feeling of spontaneous performance, influenced heavily by the cadences of musical theater. Singer, guitarist, and concept creator Ed Saperia also designs Steampunk Victoriana involving engines and brass in his at-home gadget workshop in London.

The Dresden Dolls

The Dresden Dolls can be counted among the most influential and widely embraced Steampunk bands. The Boston-based group features Amanda Palmer on vocals, piano, harmonica, and ukelele and Brian Viglione on

drums, percussion, guitar, bass guitar, and vocals. Their self-described "Brechtian Punk Cabaret" aesthetic is influenced by theater, with performances involving dramatic stage makeup and artistic stunts like stilt-walking and fire-breathing. The playfulness of their shows contrasts with the dark discordance of their music.

Dr. Steel

Self-described as a "creator, entertainer, and visionary," Dr. Phineas Waldolf Steel experiments with music, film, and toys, all in pursuit of making the world a better place for grown-ups through dedicated playfulness. Steel's music employs a big band sound that's simultaneously melodramatic and goofy, like the perfect soundtrack for the scheming of a nefarious but not-so-competent supervillain.

HUMANWINE

The enigmatically named HUMANWINE (Humans Underground Making Anagrams Nightly While Imperial Not-Mes Enslave) expresses "eco-anarchist politics" through the mythical narrative of an imaginary place called "Vinland." Their musical sound embodies this dark and gritty aesthetic. (For more on their music, see the interview on page 163.)

The James Gang

Motivated by their motto—"inspire until u expire"—this unique three-man band from Harlem "fuses current music with older classic sounds from the

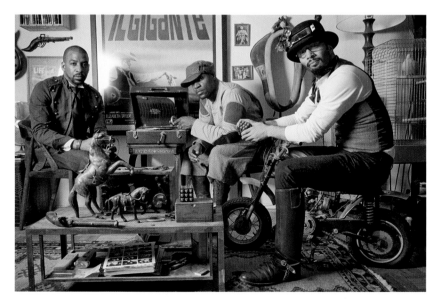

LEFT
The James Gang, Redux, as featured in the *New York Times*, May 2008

twenties to the sixties." Though their aesthetic is more 1920s than 1890s, their vaudevillian-made-hip theatricality demonstrates the same playfulness and anachronisms of many Steampunk bands. Their costuming aesthetic has an elegance reminiscent of both Prohibition-era gangsters and the Wild West. Building on the success of this visual style, troupe members Giovanni "Jellyroll" James, Deacon Boondini, and "The Great Gatsby" are opening a men's clothing store.

The Lisps

Extending Steampunk's fascination with musical theater to another level, The Lisps have written, produced, and staged a Civil War Steampunk musical called *FUTURITY* in Brooklyn. Leads César Alvarez and Sammy Tunis depict lowly Civil War soldier Julian Munro and famous metaphysician/programmer Ada Lovelace, respectively, as the pair corresponds about a hypothetical invention: a steam-powered supercomputer. They're backed by Eric Farber on drums and an ensemble cast of actors and vocalists, lending strength to a soundtrack that's folky and dramatic by turns. The set, including an eye-catching drum kit, was constructed mainly from found objects and conveys the grittiness and haphazard gadgetry of a Civil War–era workshop.

Rasputina

One of the earliest Steampunk bands, Rasputina was formed in Brooklyn in 1991 (or 1891, depending on whom you ask). Their unique blend of folk-influenced rock features two cellos played by Melora Creager and Daniel DeJesus. Creager writes the songs, while DeJesus provides vocals. They're backed by Catie D'Amica on percussion, along with a revolving group of musicians. A fascination with historical allegories is expressed in songs like "1816, The Year Without a Summer," which references Mary Shelley's *Frankenstein*, Benjamin Franklin, and the Little Ice Age.

Voltaire

Singer/songwriter/performer Voltaire, sometimes backed by a cast of musicians providing violin, cello, trumpet, clarinet, and drums, offers a sound he describes as "gypsy violins, driving rhythms, sardonic wit, and turn of the century mayhem . . . combining beautiful Old World melodies with viciously sarcastic lyrics, Wagnerian bravado with Brechtian allure. . . ." Imagine a Tim Burton–influenced Johnny Cash. Shows from this New York–based artist include theatrical elements with props and stories.

HUMANWINE: Sustainable Steampunk Music from Your Favorite Aunt

By Desirina Boskovich

Desirina Boskovich is a fiction writer and journalist who has covered Steampunk music for publications like Lightspeed. *Here she interviews Holly Brewer and M@ McNiss, two of the founders of HUMANWINE, a band embraced by Steampunks.*

Nomadic eco-anarchist band HUMANWINE is the collaborative effort of Holly Brewer and M@ McNiss, along with Nate Greeslit on percussion and Paul Dilley on upright bass, guitar, and vocals. Despite having been enthusiastically adopted by Steampunks, their music is stubbornly unclassifiable, with a revolving cast of musicians, political themes, and a gritty DIY aesthetic. Its acceptance as Steampunk raises fascinating issues about the mutation of the term while indicating that social and political progressivism is part of the bleeding edge of the subculture.

The political slant of their music includes a mythological, fantastical world called Vinland, home to their mindless Cogs enslaved in factories producing their own daily Not-Me Pill of Lies. Anarchists called YerYerOwns communicate through anagram-encoded flyers. Enjoyeurs remain satiated and intoxicated with wine pressed from the bodies of expended, retired, and decapitated Cogs. These and other creatures live in Burning Cities, enclosed by walls built from the bones of dead Cogs. The acronym HUMANWINE—Humans Underground Making Anagrams Nightly While Imperial Not-Mes Enslave—strongly suggests where the band falls on the political spectrum.

What inspired you to create the fantastical/allegorical realm of Vinland?

Holly: We'd just come back from Montreal, and I had this line stuck in my head: "Faces of the typical so sad are SAD ARE! Faceless are the typical SO SAD!" We did this mathy song, and called it "Vin d'Humaine," which is French for "human wine." It was pretty much one day, we would go off anything that made us laugh for hours and hours . . . and this is one of those times that we just went off on rants . . . coming up with the characters and the names. The world of Vinland is a lot like the United States, a lot like *1984*, a lot like any tale where there's an oppressive society that's keeping the dumb man down. . . . The fact that the IMF and the World Bank are controlling us and they're less than 1 percent of our population is the fuel of the fire. But we disguise it in song stories, so it's an easier pill to swallow than having a punk rock band yelling in your face.

Who are your musical influences?

Holly: Crass, I love Crass. They're an anarcho-punk band from England who promised they'd break up in 1984 before they got too big, and they did. I really like Dead Can Dance, I love Slayer, Sepultura. . . .

CONTINUED

I'm a big fan of certain musicals. I grew up on Julie Andrews's voice. . . .
I really like Diamanda Galás.

That's interesting, because you can definitely see the influence of musicals in
your music as well, because it's very narrative-inspired.

Holly: Yeah, and happy singing. . . . We're on a hunt against a relentless-
ly glitzy reality. Unfortunately, a lot of people, when they want to hear mu-
sic, they want to check out, because the world is so stressful, blah, blah, blah.
So as a result, people lower the bar with cabaret shit. And it becomes really
topical, and surface-level, and shallow. And it's a fine line we try to walk be-
tween involving ourselves in anything that would sound slightly Broadway
and allowing it to have a backbone; to really stand for something, besides
the right to have nipple tassels on stage. Which is fine, but it lowers the bar.

I think a lot of people think we come off as really preachy and staunch
and demanding and fucking hard core. But I guess we are. We're as straight
edge as we can be about that. We're not straight edge against drugs, but
we're really hoping to keep our message of social political music pure. Like
either be it, or don't be it. Don't pretend halfway down the line.

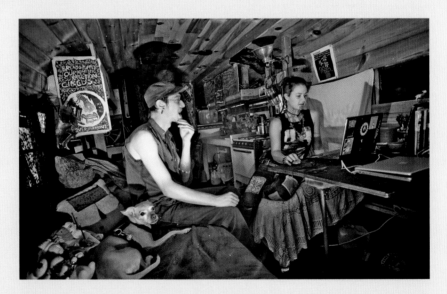

One of the most interesting things about Steampunk is how various me-
dia interact and crossbreed. Do you have books or films that have inspired
your music?

Holly: *The Saddest Music in the World* is a movie that is very inspirational
to us both. *1984*. There are movies that have inspired us visually — the color
schemes of *Moulin Rouge* and *Sin City* and *From Hell* . . . the richness of that
color almost has a music to it. *Behold a Pale Horse* is a very inspirational book.
The man who wrote it was shot in the head. It's a bunch of CIA secrets.

M@: *Democracy Now* and IndieMedia.org are influences as well. Holly
was talking about how so much of the world is polarized extremes. . . .
Those sites find a really good middle ground in terms of their recording. . . .
They tend to stick to the gray area.

What's your definition of Steampunk, and how would you say your music converses with this definition?

Holly: My definition of Steampunk? Without saying a comic book character . . . using today's technology with last century's tools. Exposed mechanics. Not hidden pipes: like a toaster that you buy at Ikea with the shield over the whole thing with a lever is the opposite of Steampunk. Steampunk would be, you made this toaster and you know how to fix it, and you can tell when something's broken. It's not hiding the mechanics and dumbing down a society. Rather, it's uplifting a society with the know-how to take care of its damn self so it's not dependent on a corporation.

That's what it is to me. That's why it's not the fashion at all. . . . I mean, if girls wanna walk around in corsets and have trouble breathing all night that's up to them, but that's not what it's about. They're cute. But to be truly Steampunk is to be prepared. You should be able to wear what you're wearing in any situation, be it desert heat sandstorm or a chilly arctic night.

So you would definitely weigh in on the side of seeing Steampunk as a political and ideological force, rather than an aesthetic.

Holly: Yes. I think the aesthetic is a happy by-product. It's not a shame, but I hope it doesn't become the focus. Because there is a deeper sociopolitical movement of independence. If you have a solar panel kit, and you have activated charcoal and you have dirty water, it doesn't matter because you can purify that water, pump it through your system with your solar panels; you don't need anybody. And to take that from it, that true independence, is very uplifting. I hope it doesn't get left behind.

M@: From our most inner self we're reluctant to say what we do, because we don't want to be trapped in anything. People love labels because they want to make sense of things . . . but that's weird for us. . . . It's very hard for us to say "we're this" or "we're that." Nothing against Steampunk, but we don't really call ourselves much of anything. . . . But I tend to feel very welcomed by people who call themselves Steampunk . . . we draw from old music and new music, so there's that. We also promote DIY ethics . . . we promote people ripping stuff apart and putting stuff back together, estranging yourself from corporate dependency. . . . The makers of the scene, the people that actually get their hands dirty, that might be another reason we've been embraced by the community, because we're DIY ourselves.

What's your level of involvement and contact with the Steampunk community?

Holly: I would say that HUMANWINE is an aunt. At the family reunion we'd be the aunt handing out copies of the Constitution when everyone wants to discuss football. We're not the mother or the father—there are mothers and fathers out there . . . We're not a cousin, because we're not a childhood perspective—we have such a clear vision that it's very hard to lead us anywhere. We'd more likely be organizing an aspect of the family reunion. Definitely the aunt who's not afraid to get her hands dirty.

Events: Taking Your "Steamsona" for a Stroll

STEAMPUNK CONVENTIONS, FAIRS, AND OTHER EVENTS GIVE FASHION designers, aficionados, and hobbyists ample opportunity to show off their work and their love for the aesthetic.

G. D. Falksen, a Steampunk expert, often serves as a consultant for such events and says, "Because the Steampunk community is such a wide-ranging entity, with members spread across the United States, the United Kingdom, and other countries, events offer a way for fans to come together in a localized area and meet one another."

Tea Parties and Civilized Sports

Typical Steampunk events can come in many forms, from rather casual outdoor gatherings, such as the Time Travel Picnic held as part of the Renaissance Faire in Tuxedo Park, New York, to very large conventions. Specialty events focus on individual creators, such as the Girl Genius Mad Scientist Ball (San Mateo, California, in April), which celebrates the Hugo Award–winning comic by Phil and Kaja Foglio. Other events, such as the New England Steampunk Festival, choose imaginative spaces for the festivities, in this case the Charles River Museum of Industry & Innovation.

Events that attract in excess of twenty thousand people make a concerted effort to include Steampunk elements. The Maker Faire, held in San Francisco in May, features a Steampunk Contraptor Lounge that spotlights Steampunk artists/makers. Atlanta's Dragoncon (September) salutes the subgenre with an Alternative History programming track, and the organizers of the con also run a three-day full-on Steampunk convention in February called Anachron. San Diego's annual Comic-Con in July, with an attendance of more than 150,000, is an important event for many Steampunk creators, especially in the comics and movie industries; it's also increasingly common to find people dressed in Steampunk styles at Comic-Con.

In London, at irregular intervals, the band Tough Love hosts White Mischief, a moveable feast of Steampunk events and parties, each with a theme based on the title of a book by Jules Verne. In Australia, events include Euchronia (Melbourne), held on New Year's Eve every other year.

However, it's worth noting that actual Steampunk conventions are a recent development, and most, while growing, are still quite small. For example, Victoria Steam Expo in May of 2010 was Canada's first Steampunk-themed arts exhibit. It took place in Victoria's historic Empress Hotel. "This oceanfront Hogwarts-style edifice, built in 1904 and bedecked with cut glass, enormous beams and oak paneling," says cofounder Jordan Stratford, was the "perfect venue for a weekend of visual and performing arts, costuming, and mad science." About three hundred people, almost all in costume, attended the inaugural event.

OPPOSITE
Poster advertising the 2010 Victoria Steam Exposition, designed by Zandra Stratford, 2010

GUEST OF HONOUR

NEBULA & HUGO NOMINEE

CHERIE PRIEST

author of

BONESHAKER

San Francisco's

UNWOMAN

BEING A CELEBRATION OF STEAMPUNK ART & CULTURE AT VICTORIA'S EMPRESS HOTEL

EXHIBITION OF THE

ARTS

in a **PLETHORA** of

MEDIA

ORIGINAL KINEMATOSCOPES

RÏESE

THE ANACHRONISM

PURVEYORS

of fine **ACCOUTREMENTS AND QUALITY GOODS**

NUMEROUS DISCOURSES & ORATIONS ON TOPICS EXTRAORDINARY!

VICTORIA STEAM EXPOSITION

{MAY 22–23, 2010}

NICK VALENTINO

author of

THOMAS RILEY

THE FABULOUS

MISS ROSIE BITTS

Steampunk Burlesque

laudanum

EVENTS & SUCH

In Falksen's opinion, a few central aspects of Steampunk gatherings give them a common identity—for example, "Victorian-style decorations, panels on fashion or technology, Steampunk music, demonstrations of antiquated technology given new life, author readings, and giveaways of relevant books and knickknacks."

Here are a few other commonalities, according to Falksen.

- Outdoor events often feature sports or activities that are associated with the nineteenth century. Croquet and boules are the most prevalent, given their comparative ease of play and level of gentility (which makes it very easy to participate in Steampunk formal wear). Events more specifically tailored to active sport activities may include cricket, tennis, and even rugby, for the very ambitious.

- Many Steampunk events feature a tea party of some sort as a way for people to enjoy a snack and socialize. In outdoor settings, tea parties tend to be fairly simple, although this is not always the case. Indoors, tea parties can be extremely elaborate.

- As is the case with most conventions, vendors are an important element of Steampunk events. Booths are operated by fashion designers, craftspeople, and artists. Steampunk bands also promote their music and give live shows. Many vendors make and sell their goods for a living, and so attending these conventions is an extremely important means of supporting Steampunk art.

- Fashion is a major aspect of the Steampunk subculture, and events are an opportunity to dress up and show off personal style. Consequently, photographers and photo shoots are a common sight at Steampunk gatherings.

- Due to the large population of well-dressed people at Steampunk events, it is common to have fashion or costume contests where attendees model their outfits. Winners are generally afforded some sort of prize in addition to the much-coveted bragging rights.

- Professional designers also put on fashion shows at Steampunk events. Designers can use the shows to attract buyers to their vending tables and promote their clothing to the larger Steampunk community.

- The centerpiece of any major Steampunk event is a grand, Victorian-style ball that takes place in the evening. This offers attendees an opportunity to wear very formal or complex outfits that might prove overly restrictive or hot during daytime activities. Balls often include live music provided by Steampunk bands.

OPPOSITE
Signpost at Maker Faire 2010
ABOVE
Jake von Slatt and Datamancer work on a Steampunk keyboard mod in the Contraptor Lounge at Maker Faire, May 4, 2008; drawn by Suzanne Rachel Forbes

The
BOILER
BAR
2 PM
LADYBUG
Demo
Build your own Mini Art Car

FIRE GARDEN
Demo
Build your own Fire Pit

CASTING IT
Demo
Low Temp Metal Casting

For Stratford, the Victorian Expo and other events are important because "the act of having a face-to-face conversation these days is almost as subversive as taking a screwdriver to your television. To that end, artists (and we're all artists here) holding the door for one another, eating together, physically handling a raygun or vacuum tube or bit of brass—this creates an immediacy, a muscular and tactile response to Steampunk as a movement. Certainly there's support, network, inspiration, flirtation at a Steampunk show. But I think the punk of Steampunk is adapting this genre to your own experience, and that includes making the artifacts of someone else's imagination part of your history. It's seeing a picture of something amazing online and knowing 'Yeah, I picked that up. It was heavy.'"

The Crew of the H.M.S. *Chronabelle*

Any Steampunk event is not just a gathering of people, but a gathering of stories. One of the purest and most endearing expressions of steamsonas to be found at a Steampunk event may be a conceit dreamed up by Lady Kodak (a.k.a. Julia Lemke), The Grand Duchess (a.k.a. Stephanie Fairbairn), Lady Almira (a.k.a. Tessa Siegel), and Captain Mouse (a.k.a. Mouse Reeve).

These intrepid four form the self-anointed crew of the H.M.S. *Chronabelle*, an airship that exists in their collective psyche, and which represents a modern meta-version of the "imaginary voyage and dream journey" stories from the 1700s that inspired Jules Verne.

The crew came together, says the Grand Duchess, while all friends at Notre Dame High School in San Jose, California, "with a similar susceptibility to the excitement of dress-up and Steampunk."

According to Lady Almira, "Captain Mouse was the one who originally introduced us to Steampunk, and we all dove in for different reasons. There was something for each of us in the subculture—literature, art, technology, fashion. When it got to the point that it was part of our daily lives, we decided we needed to form an airship crew."

Of course, the only real corroboration of their story is their clothing, which provides the illusion necessary for others to accept them at Steampunk events as the crew of an airship.

As for many Steampunk aficionados, the do-it-yourself impulse is a necessity for the crew of the H.M.S. *Chronabelle*.

The clothing has always been about "what we could do on a limited budget," Lady Almira says. "Students aren't known for their vast funds, so we generally have to make do with what we had, excluding a few choice expensive pieces, such as my corset."

The crew quickly learned the benefits of alterations and layering, although their individual styles diverge greatly—they never wanted to "institute a uniform of any kind." Lady Almira and the Grand Duchess tend to incorporate a certain kind of Victoriana into their clothing. Captain Mouse and Lady Kodak lean toward punk. Indeed, the enigmatic Captain Mouse says that "early twentieth-century military style has always appealed, as

ABOVE, LEFT
Lady Kodak by Krista
Brennan
ABOVE, RIGHT
Captain Mouse by Krista
Brennan

well as art deco and surrealism. I am always inspired by mathematics: fractals, patterns, and so on."

Other aspects of Steampunk dovetail into their creation of the H.M.S. *Chronabelle*. The outdated technology at the core of Steampunk appeals greatly to Lady Almira, even though she admits, "I'm not a scientist by any means. Captain Mouse keeps me up to snuff on technology for the most part, but I'm really into it because it's pretty. And more than that, I've always loved antiquated things. I collect rare books, I've had a vintage pocket watch collection since I was eleven, I enjoy spending time in old buildings."

Lady Kodak, meanwhile, bemoans the "efficiency" of modern technology, and the Grand Duchess loves the "DIY aspect, which is much more compatible with the urge to get your hands dirty." Captain Mouse concurs: "With a gear train, one can see exactly the action and results . . . on an intimate physical level."

Which still leaves the question of why all four decided to live on an imaginary airship.

Lady Kodak: "We live in a world of plastic and Helvetica. Being on an airship is an escape from that."

The Grand Duchess: "Adventure! The mobility and ability to explore are incredibly inviting."

Captain Mouse: "On the surface-most level, power, autonomy, and self-determination. That's really appealing, especially to people coming in like we did, as young people still in high school. . . . But obviously the appeal runs much deeper than that. It is a bit like a utopian community, but without all of the logistical problems—we can pick through Victorian and modern ideas,

take what we like and reject what we don't, and construct something new in a way that would be extraordinarily difficult in the real world. And we just don't get to have epic battles with rayguns and air kraken in everyday life."

Lady Almira: "Back when we first formed it, it was definitely an escape. . . . So the idea of having a giant, beautiful, retro-futuristic mansion that floated us to exotic places, allowed us to all live together, and let us have adventures really appealed to the group."

As for the airship itself, although accounts vary depending on the reliability of the observer, Lady Almira provides perhaps the most definitive description: "The *Chronabelle* looks a bit like a giant floating anglerfish with propellers. We never worried too much about the technical probability of it. There is a curved pole at the front with a lantern hanging off the end, like a lure. The fins can be adjusted like rudders and sails. We're a diplomatic vessel, not a battleship, so it isn't too heavily armed—just a few mounted guns. She's mostly colored in browns, greys, and brasses. Perhaps there are a couple of colors that stand out though. We're a colorful bunch."

Today, the crew members are separated, attending four different colleges, but to Lady Almira that makes no difference. "Now that we've all been scattered to the winds, it's like an imaginary meeting place. We may be stationed hundreds of miles from each other, but we'll still always be the crew of the H.M.S. *Chronabelle*."

The H.M.S. *Chronabelle* is a potent symbol for the state of the modern subculture: spread out all over the world, diverse in its interests and modes of expression, but bound together by a common love of one particular manifestation of the imaginative embodied by a single word: Steampunk.

ABOVE, LEFT
Lady Almira by Krista Brennan
ABOVE, RIGHT
The Grand Duchess by Krista Brennan
NEXT SPREAD
H. M. S. *Chronabelle*, as imagined by crewmembers Lady Almira, The Grand Duchess, Lady Kodak, and Captain Mouse, illustrated by John Coulthart

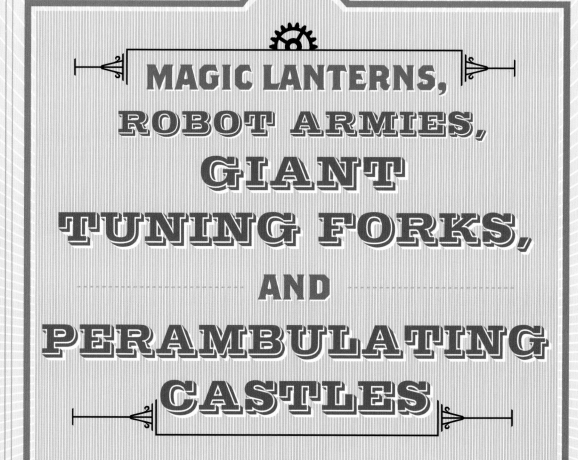

MAGIC LANTERNS, ROBOT ARMIES, GIANT TUNING FORKS, AND PERAMBULATING CASTLES

Steampunk Movies and Television

The first proto-Steampunk movie dates back almost to the beginning of film itself, and to the end of the Victorian era: Georges Méliès's *Le Voyage dans la Lune* (*A Trip to the Moon*, 1902). Based on Jules Verne's *From the Earth to the Moon* and H. G. Wells's *The First Men on the Moon*—thus, in theory, wedding the two writers' approaches—the short film may strike today's viewers as simultaneously ridiculous and oddly charming. Those who first encountered references to the movie as part of the Smashing Pumpkins' "colorized" music video for the song "Tonight, Tonight" may even find it hallucinogenic.

PREVIOUS SPREAD, LEFT
The City of Lost Children, 1995
ABOVE
20,000 Leagues Under the Sea, 1954
OPPOSITE, TOP
A Trip to the Moon, 1902
OPPOSITE, BOTTOM
Poster for *The Fabulous World of Jules Verne*, 1958

A CREW OF HYPER-ENERGETIC FOPS IN VICTORIAN GARB IS SHOT TO THE moon in a bullet-shaped capsule, to the accompaniment of horn-blowing by what appear to be anachronistic cheerleaders dressed in hot pants. The bullet-ship passes through a sky of celestial bodies, some literalized as human figures dressed in Greek robes and playing the harp. When they arrive at their destination, the fops venture underground, where they encounter a world of subterranean rivers and giant mutant mushrooms. In true colonial fashion, the explorers also come across members of a technologically inferior tribe, adept at a strange form of crablike lunging contortionism. Captured and brought before the tribe's chief, our fearless Victorians marvel at the sight of natives wielding spears with insanely large (and slightly floppy) tips and wearing what appears to be skeleton armor. After a bit of back-and-forth, one explorer rushes the chief, picks him up, and dashes him to the floor, whereupon he explodes into dust. A chase ensues, and Our Dubious Heroes beat the proverbial hasty retreat to their bullet-ship and make their way back to Earth.

No other visual representation could better exemplify the Victorian attitude toward other cultures or its interest in scientific innovation. Nor, by enlisting not just Verne but also Wells, could any film better encapsulate the dilemma facing modern Steampunk movies: the Celebrated Clockwork Firm of J. Verne & H. G. Wells, Esq., continues to cast a huge shadow, to

the point that only recently have the makers of Steampunk films become aware of other possibilities involving retro-futurism, Steampunk fiction, and the Steampunk subculture.

Indeed, up through the 1950s and 1960s, the purest manifestations of a Steampunk impulse came from adaptations of the works of Verne and, to a lesser extent, Wells, including Disney's *20,000 Leagues Under the Sea*, *The Time Machine*, and the iconic *The Fabulous World of Jules Verne*. Most of these versions had a freshness or sense of whimsy that offset what were, by modern standards, crude production values. They also helped to carry forward the influence of the two writers in the popular culture.

By comparison, latter-day Hollywood adaptations have been spotty at best, reaching new heights of unintentional camp with a truly risible remake of *The Island of Dr. Moreau* (1996) that featured a bloated Marlon Brando performing a piano duet with an unfortunate genetic misfit affectionately called "Little Gobbet" and, later, a clearly fed-up Val Kilmer doing mad scientist Brando impersonations in the midst of full-on mutant resurrection.

In television, the unique and exciting *Wild Wild West* (1965–69) was the best Steampunk

series ever to air, even if it appeared well before the development of the literature or subculture. The premise paired up secret service agents James West (Robert Conrad) and Artemus Gordon (Ross Martin) as they traveled aboard their train *The Wanderer*, foiling plots against the government and their direct boss, President Ulysses S. Grant. The two form one of the more original "odd couples" in television history—West is a gunslinger, and Gordon an eccentric inventor. Episodes also typically featured strange inventions, including sleeve guns, a cane that could send telegraphs, a stagecoach with an ejection seat, and a rod winch for raising or lowering a man up a wall. The bad guys, who included that most memorable villain, the dwarf genius Dr. Miguelito Quixote Loveless, had their own, even more exotic gadgets, like life-size steam-powered puppets, a steam-driven tank, a tsunami creator, half-man/half-robot servants, and a giant tuning fork.

The fascination with gadgets in the series, however, comes not from an appreciation for inventors so much as the spy technology served up in Ian Fleming's James Bond novels. The show's creator, Michael Garrison, had tried to bring Fleming's *Casino Royale* to the screen before producing *Wild Wild West*. Garrison turned to screenwriter Gilbert Ralston to, as Ralston put it in a deposition for his lawsuit against Warner Brothers over the 1999 movie version, "glue the idea of a Western hero and James Bond in the same series." The resulting hybrid became a sort of updated Edisonade sans the racism and with added suspense and mystery. The show also seems to have had a certain influence on Mike Mignola, whose *The Amazing Screw-On Head*

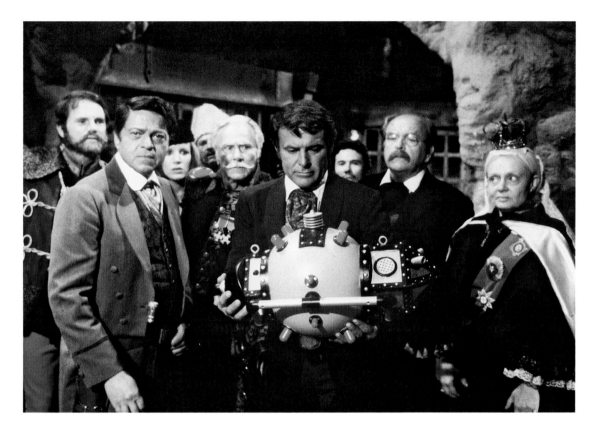

comic features the titular character performing covert missions for Abraham Lincoln much as the leads in *Wild Wild West* take secret orders from Ulysses S. Grant. Indeed, Steampunk movie buff and the author of *Geek Confidential*, Rick Klaw, believes that the series "influenced a generation of writers, including Joe R. Lansdale, Norman Partridge, and Howard Waldrop."

Despite the success of *Wild Wild West*, the show didn't spawn a golden age of Weird Westerns with Steampunk flourishes. In fact, no other show would come close to displaying such a concentrated Steampunk aesthetic, and not until the appearance of the Japanese animator, writer, and artist Hayao Miyazaki would this particular brand of retro-futurism begin to appear with regularity on the big screen.

Japanese Masters

A SIGNIFICANT PERCENTAGE OF THE SMALL NUMBER OF RECENT TRULY Steampunk films have come from Japanese filmmakers, primed perhaps by a manga comics tradition that at times has featured a fascination with various periods of European history.

Chief among these creators is Hayao Miyazaki, whose animated visions are of the highest imaginative quality and usually tied to serious

issues like humankind's negative impact on the world. These environmental concerns are connected to Miyazaki's interest in retro-futurism, even from his first full-length feature, *Nausicaä of the Valley of the Wind* (1984), where fungal jungles coexist with airship flotillas and strange robots. This interest mirrors the drive in other modes of Steampunk expression either to comment on the ill effects of the Industrial Revolution or from a desire to rework the past and thus envision a sustainable future. However, it wasn't until *Laputa: Castle in the Sky* (1986), which uses the name of a floating island in *Gulliver's Travels*, that this interest produced one of the first modern Steampunk classics.

The movie takes as its premise an alternate Earth in which an obsession with flying machines had led to its ultimate manifestation in the form of hundreds of floating cities and fortresses. An unknown disaster has destroyed all of these creations, save for one fabled city that, as legend has it, waits to be rediscovered. Airships and other machines still exist, however, and the story unfolds with complex geopolitical situations juxtaposed with romanticized sky pirates and science presented as something akin to magic.

In the book *Starting Point: 1979–1986*, Miyazaki notes that "the machines in this world are not the products of mass production, rather they still possess the inherent warmth of handcrafted things," with illumination provided by candles or gaslights, and the "bad guys'" vehicles and weapons "a collection of eccentric inventions." Miyazaki clearly shares the Steampunk fascination with the individual object, with art as opposed to mass media,

BELOW
Laputa: Castle in the Sky,
1986

and in doing so champions the role of the craftsperson as articulated by John Ruskin.

Another triumph of the movie is the way in which Miyazaki is able to give his airships such a realistic physicality. Since so much of the movie takes place in the sky, accepting the airships and floating islands is integral to the believability of the characters and the plot. Another triumph concerns the ability to be both as whimsical as *A Trip to the Moon* while grounding the story in truly adult themes.

Steampunk grace notes appeared in many of Miyazaki's films after *Laputa*, including the minor film *Porco Rosso*, but it wasn't until his adaptation of Diana Wynne Jones's *Howl's Moving Castle* in 2004—a year that featured two other Japanese films of extreme interest to Steampunk fans— that he returned with a vision central to the Steampunk aesthetic. Unlike in *Laputa*, the details of *Howl's Moving Castle* are aligned with the role of the tinker or maker in Steampunk subculture, if with a magical twist. The strong female protagonist Sophie Hatter runs afoul of the Witch of the Waste and is transformed into an old woman, whereupon she runs away and discovers the wizard Howl's castle and the demon that powers it, Calcifer. Soon Hatter has signed on to help Calcifer break his agreement with Howl in return for lifting the curse. All sorts of complications arise, as Howl is immersed in helping one side in a war, and the castle itself turns out to have mysterious hidden properties.

The central image in the movie, and its greatest charm, is the moving castle. It possesses a wonderful, almost impossible impracticality in the details of its construction. Stomping along on little chicken legs that don't seem equal to the task of balancing the seemingly unplanned series of building code violations that comprise its structure, the castle is an encrusted literalization of the homemade and the impromptu. Every so often it belches smoke out of its chimney like an old man coughing. As with the airships in *Laputa*, the physicality of the creation cannot be denied, and in true Steampunk fashion the castle, by dint of its magical properties, is actually cutting-edge technology, disguised by elements from the past.

Whereas *Howl's Moving Castle* gains power from simple repetition of the central image in different contexts, Kazuaki Kiriya's *Casshern* (2004), based on the anime series of the same name, works because of the complexity of its influences and editing. *Casshern* posits a long and devastating war in the late twenty-first century between Europa and the Eastern Federation, with most of the foreground of the story occurring after the Eastern Federation's victory and subsequent occupation of Eurasia. The only resistance arises in Eurasian Zone 7, and is tied to bioengineering genome/human tissue experiments on an obscure ethnic group.

Casshern is an outrageous and ambitious combination of camp, political intrigue, war commentary, and angsty grief, all presented within the context of ample amounts of Steampunk goodness. As often happens with a film that is sui generis, some critics thought it was a mess. However, it's an excellent example, along with Miyazaki's own *Princess Mononoke*, of moral ambiguity, shifting alliances, and the transformative power of visionary images.

NEXT SPREAD
Howl's Moving Castle, 2004

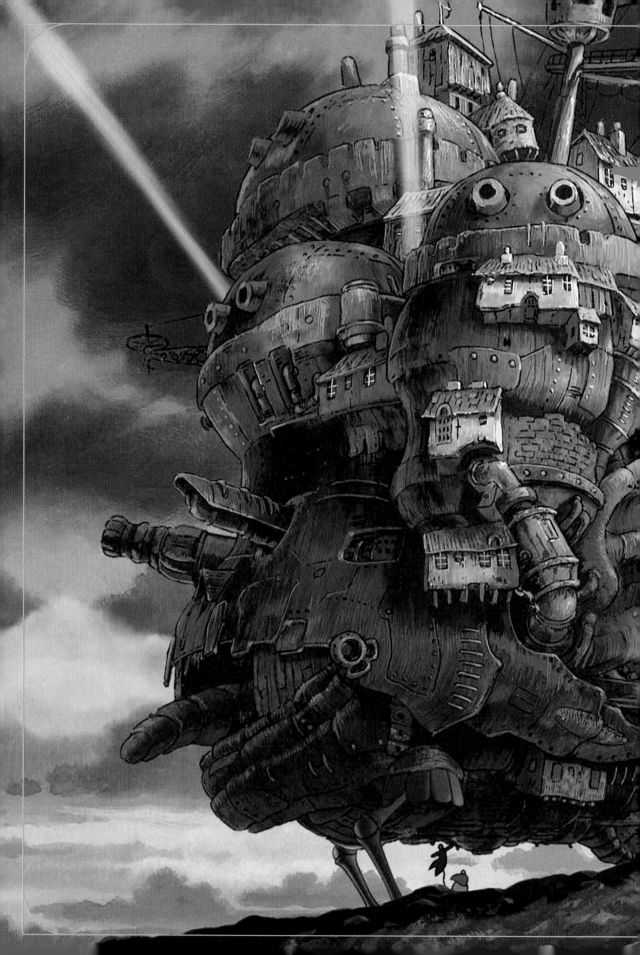

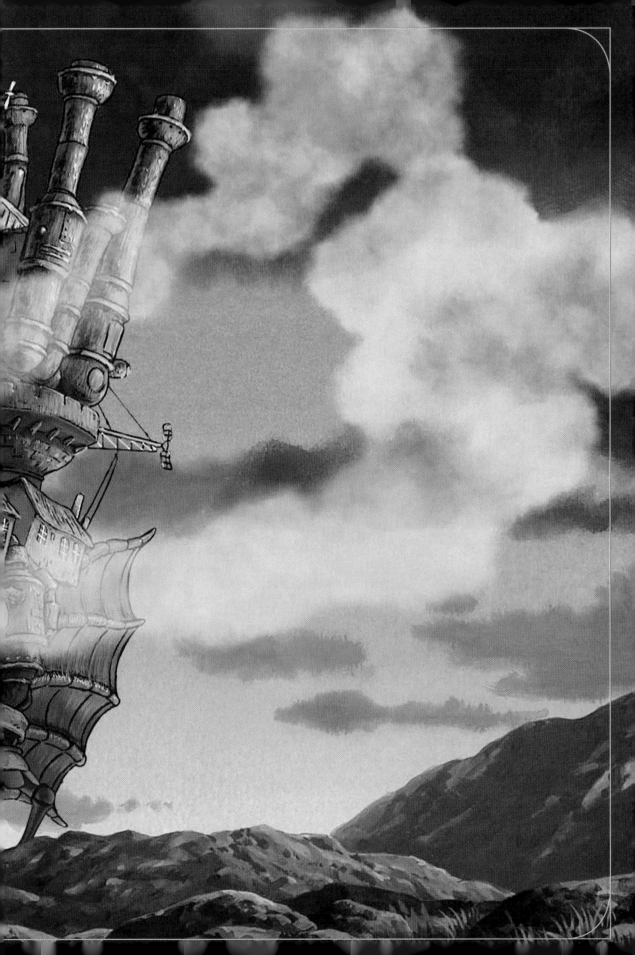

Can Airships Slouch Along? Can They Saunter?

In Angela Carter's revisionist Victoriana novel *Nights at the Circus*, Fevvers, a high-wire act if ever there was one, causes disbelief and awe in equal measure because she's billed as a flying woman. It's as if she's daring the audience to call her a fake, to accuse her of being held up by invisible wires and other tricks of the circus trade.

Steampunk cinema has its own version of this high-wire act, in that depictions of dirigibles, blimps, and zeppelins represent a kind of tipping point for the audience's threshold of disbelief. Most films don't attempt to realistically map out what a fantastical airship might look like—they're just interested in something that seems visually cool. Although there's nothing wrong with not having a blueprint for your airship, sometimes it doesn't hold up, especially because in a righteous Steampunk movie your mode of transportation is a kind of character in and of itself. Not believing in a character, even one made of canvas, wood, and metal, can doom a film.

Who gets it right? A good example is the ubiquitous Hayao Miyazaki, in movies such as *Laputa: Castle in the Sky*. Watching and re-watching that classic, viewers never consider the feasibility of his sky machines. This is because Miyazaki draws airships that are detailed, but not too baroque. They also have a weight to them, enough that the engines must drone to keep them in the air, but not so much as to become unbelievable. Not to mention, a variety of lovely whirring and clanking sounds help reassure us of the physicality of these lumbering creations.

BELOW
Im/Practical Airships by Aleks Sennwald

On the failure end of the spectrum, witness the horrible mess that is *Mutant Chronicles* (2008), which includes perhaps the least efficient airship in the history of cinema. In watching this monstro-city of heavy metal belch, burp, and fart its way into the sky, your jaw might just drop. It's as if the development team had a brief something like this: "We want something without safety rules, that burns one hundred tons of coal for every foot it travels, with its gunnery station exposed so anybody can blast it away. We also need it built so you can only track enemies through the sky by looking into a tiny hole or slit, and if something crashes into it, even something small, the entire ship blows up real good."

Which, of course, it does.

ABOVE
Casshern, 2004

The convoluted plot involves mad inventor science, mighty airships, robot armies, genetic misfits, and transcendental mysticism. But it's also grounded in the gritty personal experiences of soldiers who have committed war crimes, and this grounding combined with a strong but non-didactic message about the price of conflicts (including actual messages from Russian and Balkan writings on peace) turns the movie into an edgy success.

Considering that it was one of the first movies in which actors performed in front of blue screens with effects superimposed, *Casshern* is also an *artistic* success—more so than many later films using the same technique. What may make it unique in terms of its Steampunk pedigree is that any hint of Verne or Wells seems remote. Instead, the film appears to benefit from a knowledge of Miyazaki, and even, possibly, the proto-Steampunk fiction of Michael Moorcock as well as *The Difference Engine* in a potent blend of Eastern and Western influences.

A third Japanese film released in 2004 dealing more directly with Steampunk was *Steamboy*, directed and cowritten by Katsuhiro Otomo, creator of the iconic *Akira*. Unlike Miyazaki, who tends to recombine aspects of Japanese and European culture—especially in the way he places characters in settings that are either Asian or European with Asian flourishes—Otomo uses a recognizable alternative history England and strives to create a realistic Victorian era backdrop, complete with zeppelins and other Steampunk accoutrements.

The premise contains plenty of cautionary notes about the price of scientific inquiry, and begins with the discovery of a pure kind of water by the lazily named Dr. Lloyd Steam. This water makes steam inventions more practical. However, in the process of further experiments, a terrible

ABOVE
Steamboy, 2004

accident traps Lloyd's son in a Steam Ball of frozen gas. The military uses of the Steam Ball lead to the most amazing elements of *Steamboy*: an entire Steam Castle powered by Steam Balls, reminiscent in idea if not execution of Miyazaki's fascination with floating islands and walking houses.

The movie often feels oddly traditional compared to Miyazaki, however, and perhaps too comfortable fetishizing retro-tech. Nor is there the complexity of political situation or character wedded to visionary images found in *Casshern*. A *Washington Post* review noted the odd lack of effect: "The movie never transcended its elaborate production work to achieve an independent reality." Still, *Steamboy* does make some commentary on the militarized future it presents and is not without its poignant moments—for example, when Lloyd's injuries turn him into half-man, half-machine. The destruction wrought by the floating castle is also extensive and, for an animated feature partially intended for children, fairly realistic.

 Hollywood's Steampunk

THE NADIR OF HOLLYWOOD STEAMPUNK MIGHT JUST BE THE MOVIE version of the TV series *Wild Wild West*. Released in 1999 as a Will Smith vehicle, this boring, illogical literal and figurative train wreck proved that Hollywood is second-to-none in boiling down and straining out the most interesting aspects of a premise in order to serve up high-octane gruel. Victoriana expert Jess Nevins called it "a paint-by-numbers with no heart or soul." Hollywood botched Steampunk materials again with Tom Cruise in Spielberg's interminable and silly *War of the Worlds* remake several years later and *Mutant Chronicles*, featuring a clearly exasperated Ron Perlman.

However, although other recent forays into Steampunk by Hollywood have often been uneven, some are not without their charms for fans. Movies like *The League of Extraordinary Gentlemen* (2003), *Sky Captain and the World of Tomorrow* (2004), *The Golden Compass* (2007), *9* (2009), and *Sherlock Holmes* (2009) all invest some honest effort into conveying a consistent and interesting Steampunk aesthetic.

Critically reviled and also repudiated by Alan Moore, the cocreator of the original comic book, *The League of Extraordinary Gentlemen* tried to reflect the source material by presenting a mélange of the works of Verne, Wells, Sir Arthur Conan Doyle, Robert Louis Stevenson, and Bram Stoker. Assisted by the hoary old adventure-monger Allan Quatermain (Sean Connery), the League, which includes Captain Nemo, the Invisible Man, Mina Harker, and Dorian Gray, helps to foil a plot by a group of

mysterious German soldiers working for a master bent on world domination. The addition of Tom Sawyer to Moore's original cast—akin to inserting Pee-wee Herman into a Jane Austen adaptation—was only one of several miscues, as the script and direction all point to a need to play to the action-adventure audience, with none of the moral ambiguity and strangeness present in the graphic novel. Still, the movie is not as bad as reports would indicate; there are several moments of pleasure, including depictions of a rather splendid German zeppelin factory and the first appearance of Captain Nemo's submarine.

Sky Captain and the World of Tomorrow, meanwhile, took a different kind of pulp as inspiration: the look and feel of 1930s American cities and the zeppelin technology common to the period between World Wars I and II. It also extensively employed blue screens and is generally regarded as representing a breakthrough in that regard.

The plot features the appearance of huge hostile robots in New York City. Sky Captain Joe Sullivan (Jude Law) heads up the air legions attempting to stop them. Reporter Polly Perkins (Gwyneth Paltrow) is simultaneously investigating the disappearance of several scientists, and clues lead her to a ruined laboratory. From there, the movie becomes progressively more pulpy and unbelievable, with sojourns to Nepal and an underground land of weird dinosaurs. The Sky Captain plies his trade, Perkins finds herself in mortal danger, and the usual pulp tropes play out with the precision of

ABOVE
The League of Extraordinary Gentlemen, 2003
BELOW
Poster for *Sky Captain and the World of Tomorrow*, 2004

PREVIOUS SPREAD
9, 2009
ABOVE
Actor Dakota Blue Richards
with a bear in Steampunk
armor in *The Golden Com-
pass*, 2007

heat-seeking missiles. It's silly, but often effective, despite a murkiness re-
sulting from the blue-screen technology. The zeppelins in the movie are
nonetheless breathtaking.

Interestingly enough, director Kerry Conran cites airships, bridges,
and housing complexes created for the 1933 Chicago World's Fair and 1939
New York World's Fair as influences on the look of the movie. *Sky Captain
and the World of Tomorrow* definitely has more in common with that histori-
cal period and even William Gibson's "raygun gothic" than with typical
Victorian-inspired Steampunk. The movie points to another approach in
much the same way as Dexter Palmer's novel *The Dream of Perpetual Motion*.

Another film that could have served as a potent foundation for further
Steampunk exploration, *The Golden Compass*, is based on the Philip Pullman
novel of the same name. Pullman's His Dark Materials series contains pro-
found commentary on the clash between science and religion, housed with-
in the shell of an exciting adventure saga featuring the pugnacious Lyra
Belacqua, a fearless female protagonist. Although the Steampunk element
is secondary to the politics and intrigue—this is not a series that fetishizes
technology—the level of invention in portraying retro-futurist technology
like airships is sadly lacking. The most interesting aspect of the movie for
Steampunks, beyond the titular compass, might well be the mecha-armor
of the intelligent talking polar bears, the style of which serves the same aes-
thetic purpose as computer keyboard mods by the likes of Jake von Slatt

and Datamancer. If you want to "baroque up" a polar bear, you could do a lot worse.

More promisingly, the animated film *9* showcases several elements of the modern Steampunk subculture and the related literature that don't harken back to Verne and Wells, despite the presence of a tripodlike mechanical villain. Instead, the movie seems well aware of modern splinter factions such as Stitchpunk, which emphasizes the crafts/fashion element in the subculture, and the growing role of tinkers.

The characters themselves are made out of used parts—think of author Gail Carriger's "old metal buttons and beads of different sizes"—and occupy a landscape that Verne would say was caused by mad inventors who went too far. These "stitchpunked" people embark on a quest to rescue the future from the excesses of the past in a world that has clearly been ruined by bad uses of technology.

Like Steampunk makers, the main character creates solutions to problems in part out of other people's junk. In its commentary on a degraded environment, *9* confronts the central issue of our times, which is also a core concern of the Steampunk subculture. Or, as von Slatt says, "'We prepare for the apocalypse so that we may avoid it' is the watch-phase of the politically and environmentally aware Steampunk." The movie's resolution is more traditional, but the visuals provide a tantalizing glimpse of yet another new direction for Steampunk films.

Even more recently, the latest iteration of Sir Arthur Conan Doyle's classic creation, *Sherlock Holmes* (2009), directed by Guy Ritchie and starring Robert Downey Jr., demonstrated that new life could be breathed into a classic franchise. Downey's kinetic yet cerebral take on Holmes creates great synergy with Jude Law's excellent Dr. Watson, while Ritchie's interpretation is squalid and dirty, but also reveals the influence of other movies set in that era. There is, in a sense, a received idea of the Victorian period, hardwired into a plot about the role of science and superstition in our lives. Indeed, the Holmes on display here is a riff on the mad inventor from Verne's day, a puzzle-solver who knows his science, aided by Dr. Watson. The payoff comes when an old adversary appears, along with

perhaps the most Steampunkian doomsday device created for any recent movie. In all ways, *Sherlock Holmes* manages to sustain the level of invention promised but not fulfilled by the film version of *The League of Extraordinary Gentlemen*. It also suggests that a big Hollywood blockbuster can fulfill audience expectations of large-scale entertainment, while still providing ample space for surprises of a Steampunk variety.

Demented One-Offs

SOME OF THE BEST STEAMPUNK VISUAL WORKS HAVE COME FROM outside of Hollywood, whether in the form of feature-length films, short movies, or webisodes.

The City of Lost Children (1995), directed by Frenchmen Marc Caro and Jean-Pierre Jeunet (also responsible for the new "tinkerpunk" movie *Micmacs*) is a stunningly original film set in a dystopian future in which a mad scientist named Krank kidnaps children and steals their dreams. The process involves enough helmets, anachronistic wiring, and odd machines to keep even the most obsessed Steampunk happy. When Krank steals a circus strongman's little brother, the performer (Ron Perlman) comes to his rescue.

Krank's stronghold resembles a Steampunk oil rig, and members of a sinister cult blind themselves, replacing one eye with baroque mechanical enhancements. A living brain floats in a green aquarium fitted with an ear

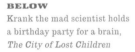

BELOW
Krank the mad scientist holds
a birthday party for a brain,
The City of Lost Children

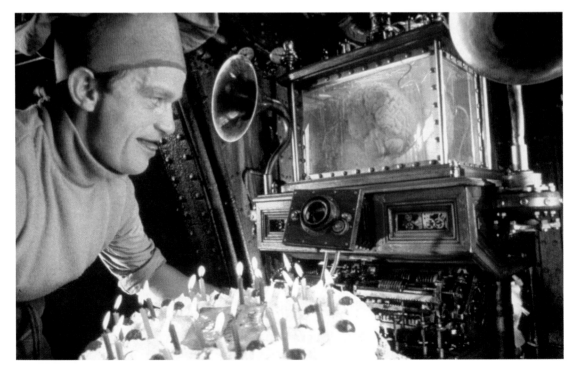

horn. An eccentric radical in diving gear hunkers down in the underwater levels of an antiquated storehouse.

The fairy tale texture of the cinematography plays against the sense of mad invention, evoking echoes of the *contes philosophiques* and related dream journeys that so inspired Poe and Verne. The romance of science (even if it's often paired with demented romance) has rarely been displayed so beautifully on the screen. Yet, despite the stunning imagery, the central relationship, between Perlman's character and a little girl he encounters along the way, is poignant, and the movie possesses a warm, beating heart. It's no wonder the *Los Angeles Times* called *The City of Lost Children* "a stunningly surreal fantasy, a fable of longing and danger, of heroic deeds and bravery, set in a brilliantly realized world of its own."

Possessed of both the lithe, quick-footed invention of *The City of Lost Children* and some of the visual sense of Georges Méliès's *Le Voyage dans la Lune*, the Oscar-nominated short film *The Mysterious Geographic Explorations of Jasper Morello: Jasper Morello and The Lost Airship* (2005) utilizes silhouettes with the appeal of shadow puppets or complex origami to achieve its unique effects.

The story follows Jasper Morello, a disgraced aerial navigator who must escape from his Plague-ridden home. Set in a world of iron dirigibles and steam-powered computers, Morello's quest

ABOVE
The League of S.T.E.A.M. (Supernatural and Troublesome Ectoplasmic Apparition Management)

takes him to a distant island aboard an abandoned dirigible in search of a cure for the plague. In twenty-six minutes, *Jasper Morello and the Lost Airship* manages to achieve a more concentrated Steampunk effect than any full-length film of the last hundred years, and does so with flair and grace.

The Lost Airship gained a whole new audience after it was posted on YouTube, and the ease with which creators can now distribute short films via the Internet has helped Steampunks like the performance group League of S.T.E.A.M. find an audience. Not only do they perform live, but they now post webisodes, usually humorous, on their video site. Recent episodes have included searches for leprechauns, encounters with ghosts, and unexpected dinners with vampires. The comedy is sometimes broad and the films are definitely DIY, but they have a charm and earnestness that reflect those aspects in the Steampunk community itself.

Always staying in character, the group has managed to combine the traditional love of role-playing, gadgets, and fashion with an extended narrative about themselves. Influences include the ubiquitous Verne and Wells, but also the creations of fellow contemporary Steampunks. It's a good example of Steampunks creating movies for their own community, perhaps fueled in part by frustration at the lack of many true Steampunk feature films.

WHILE FILMS THAT COME DIRECTLY FROM THE STEAMPUNK SUBCULTURE may be one future trend, there's also movement in the opposite direction: Steampunk once again infiltrating popular culture, this time through television. The long-running BBC show *Doctor Who* has flirted with Steampunk on occasion, but never so directly as during their 2008 Christmas special, which featured a giant automaton from 1851 who battles the good doctor from a hot-air balloon.

However, the best example may be *Warehouse 13* (Syfy channel), which features two agents in charge of tracking down odd artifacts and securing them in the titular warehouse. Saul Rubinek, who plays the caretaker of the warehouse, describes the show as "a mix of Jules Verne and *Raiders of the Lost Ark*." A villainous female H. G. Wells even makes an appearance in season two. While some of the objects they hunt are purely supernatural, others are of alien or antiquarian origins. Many of the inventions also clearly display a Steampunk aesthetic, which makes sense when you consider that *Warehouse 13* commissioned Datamancer, the Steampunk mod expert, to design for the show, thus encouraging direct influence from the subculture.

"At first they wanted me to build a full PC setup," Datamancer says, "but they eventually decided to have the LCD and other peripherals built locally so they ended up only using my keyboard on the set. It's a neat show. I wasn't sure what to expect from it, early on, but it seems to have found its own quirky niche on Syfy and is quite entertaining."

BELOW
Actor Allison Scagliotti in *Warehouse 13*, which premiered in 2009 on the Syfy channel, posing in front of Datamancer's mod

Other evidence of influence on TV comes in the form of writers and producers becoming aware of the commercial appeal of Steampunk. Recently, the hit CBS show *NCIS: Los Angeles*, a spin-off of the number-one rated *NCIS*, featured a scene set in a Steampunk bar.

Says episode writer Speed Weed, "Our executive producer, Shane Brennan, who runs *NCIS* and created the spin-off, wanted to bring a character from the original show into the Los Angeles show. We brought Abby, the forensic specialist Goth girl. She comes to L.A. for a fast-paced, scary episode. Shane asked me to write a scene where she goes to a Goth bar."

However, Weed didn't feel comfortable with Goth, so they "landed on the Steampunk aesthetic, and I instantly got it: It's lighter than true Goth, just like L.A. is lighter than D.C., where the original show is set, and just like Abby, as a character, is lighter than classic Goth. Steampunk, when Greg showed me images, just fit."

In the episode, Weed named the bar simply SteamPunk. "There's a certain beauty in something that looks old but can perform some technologically advanced task. That reflects Abby's character, actually: Morally, she could be a heroine in a Victorian novel. But she wears platform boots and a dog-collar. And she's the best person in the world at using high-tech equipment to hunt down bad guys forensically. Extras at the bar are dressed as Steampunks, but true Steampunks would probably consider it tame. In part that's because it's CBS; in part, that's because we don't want to steal focus from our characters with outrageously clad extras."

Does the casual insertion of a Steampunk aesthetic into a popular mainstream TV show serve as a fitting homage to a subgenre of science fiction that has had few moments of genuine inspiration in movies and on the small screen? Or does it signal the ultimate commercialization of Steampunk pop culture?

Steampunk expert G. D. Falksen, posting at Tor.com, wrote, "The Steampunk subculture plays an extremely small, extraneous role in the show. It is practically a nonentity." This remark presages the possible battle yet to be waged between die-hard Steampunks and a pop culture just beginning to deliberately appropriate the aesthetic.

If prior evidence is any indicator, the future holds many more mutant chronicles, but also its share of cities of lost children.

Obscure Steampunk TV Moments

By Rick Klaw

Author of The Geek Curmudgeon blog, Rick Klaw has supplied countless reviews, essays, and fiction for a variety of publications including the Austin Chronicle, The Greenwood Encyclopedia of Science Fiction and Fantasy, *and* SteamPunk Magazine. *He dreams of finding a copy of* Zeppelin Stories *(June 1929) featuring the mythical Gil Brewer story "Gorilla of the Gasbags." Here, he presents a collection of Steampunk's most obscure television moments.*

The Adventures of Brisco County, Jr., the direct thematic descendant of *Wild Wild West,* premiered on August 27, 1993, starring the cult actor Bruce Campbell of *Evil Dead* fame as the title character. Set in the 1890s, Brisco attempts to capture the members of the Bly Gang, the cutthroats responsible for his father's death. Even with clever story lines, the show lasted for only one season.

Because starring in one *Wild Wild West*–inspired, short-lived TV series is never enough, Bruce Campbell portrayed the title character for two seasons in the disappointingly inane *Jack of All Trades* (2000). Jack Stiles, a secret service agent stationed by President Thomas Jefferson on the fictional French-controlled island of Palau-Palau, defends American interests while serving as the aide to a French aristocrat. Jack employs many Steampunk weapons and gadgets.

Another Western, *Legend* (1995) starred Richard Dean Anderson as dime novel writer Ernest Pratt and John de Lancie as scientist Janos Bartok. The duo travel the country solving mysteries and making scientific discoveries. Many of Bartok's discoveries fall firmly within the realm of Steampunk. The innovative series lasted only for twelve episodes.

Loosely based on the classic 1912 novel, *Sir Arthur Conan Doyle's The Lost World* amazingly ran for three seasons (1999–2002); it contained some minor Steampunk elements, but featured second-rate special effects, bad acting, and poorly crafted story lines. The 1982 *Q.E.D.,* set in Edwardian England, lasted for only six episodes. *Voyagers!,* a time-travel adventure series with periodic Steampunk bits, managed twenty episodes over one season (1982–83). Set in the twenty-third century on a planet called New Texas, the animated series *BraveStarr* (1987–88) included many Steampunk elements, such as a futuristic London that resembled Victorian England and a time-traveling Sherlock Holmes. Steampunk materials have appeared in several episodes of the various *Doctor Who* incarnations.

Under the premise that Jules Verne actually lived the adventures that he wrote about, *The Secret Adventures of Jules Verne* (2000) delivered Steampunk action with airships, steam-powered devices, and even a

Steampunk cyborg! Playing upon the inherent meta-fictional possibilities, several episodes featured historical authors and personalities such as Samuel Clemens, Queen Victoria, Alexandre Dumas, Cardinal Richelieu (a time-travel episode), and King Louis XIII. The promising show never gelled and was canceled after one season.

Infused throughout with Steampunk paraphernalia, including a clockwork man, airships, and Victorianesque fashions, the excellent Web series *Riese* premiered on November 2, 2009. Hunted by The Sect, a powerful religious cult, the beautiful Riese wanders the countryside befriending wolves and aiding people. The show features superior designs, quality scripts, and a charismatic lead. After only ten seven- to twelve-minute episodes, *Riese* quickly emerged as one of the finest live-action Steampunk shows.

The Japanese have also embraced Steampunk television, albeit the animated variety. Based on a long-running manga, *Fullmetal Alchemist*, set in an alternate late-twentieth-century society that practices alchemy, enjoyed a fifty-one-episode run (2003–4) and a 2005 anime feature film. *Steam Detectives* (1989–90) follows the adventures of a young sleuth in a reality where the only source of energy is steam power. Set on a floating world with stylized Victorian fashions, *Last Exile* (2003) relates the story of airship pilots Claus and Lavie and their involvement in a plot about a mysterious cargo. *Samurai 7* (2004), a reimagining of Akira Kurosawa's *Seven Samurai*, recounted the classic movie in twenty-six episodes complete with the additions of a cyborg and a floating castle.

Another Steampunk show derived from the works of Jules Verne, *Nadia: The Secret of Blue Water* (1989–91), inspired a feature film sequel (1992) and a manga series. Set in 1889, the story follows circus performer Nadia, young inventor Jean Ratlique, and the famed Captain Nemo as they attempt to save the world from the Atlantean known as Gargoyle, who is bent on restoring the former underseas empire. Translated into eight different languages, the series achieved worldwide popularity. Also loosely based on Jules Verne's books, *Secret of Cerulean Sand* (2002) happens in a late-nineteenth-century England full of improbable technologies such as landships and "floating liquid."

Based on a series of popular video games, *Sakura Wars* relates an alternate 1920s in which steam is the primary source of power. Developed into numerous video games on several platforms, a manga, a television series, five original video adaptations, and a feature-length movie, since its 1996 premiere *Sakura* has evolved into a uniquely Japanese cultural phenomenon.

THE FUTURE OF STEAMPUNK

Will Clockwork Gears, Mechanical Corsets, and Dirigibles Be Enough?

"Steampunk jumped the shark way back in 2008. A) Madonna appeared in the American Airlines magazine in Steampunk garb. B) That's when I started seeing fetish/erotic Steampunk–themed club nights. That's also about the time when the voices of the people trying to define Steampunk overtook those who just wanted to describe the aesthetic. But, hell, what do I know?"

Libby Bulloff

EVER SINCE THE PUBLICATION OF THE 2008 *NEW YORK TIMES* ARTICLE that placed the spotlight firmly on Steampunk, people have speculated about when the movement would fizzle out. Had Steampunk, having finally been recognized, entered into immediate artistic decline?

When I posted a Facebook status message asking my thousands of "friends," most of them readers or creators, when Steampunk had "jumped the shark," the comments came fast and furious. Most of the answers were funny, with a healthy awareness of the reality that we often think something is past its sell-by date once too many other people know about it. But what if there were something more behind the levity?

Bulloff's remark might be the most telling given her prominence in the Steampunk subculture, but others also believed the days of clockwork gimcrack invention might be over. Bracken MacLeod wrote, "I think it ought to be 'jumped the mecha-spider' (*Wild Wild West*, 1999), since that's the first time they tried to strangle Steampunk." Absurdist writer Jess Gulbranson suggested that "In alternate timeline Czarist Russia, clockwork shark jumps you," while James Burnett took a more classic approach: "Q: How many Steampunks does it take to change a lightbulb? A: Two, one to change it and a second to glue unnecessary clock parts to it."

Other responses ranged from bewilderment—"Huh? Steampunk isn't even close to dead!"—to serious grappling with the ideas of renewal and fighting against inertia. Some wanted to express enthusiasm for one aspect of the subculture, but disdain for other parts. A few even displayed a healthy sense of self-deprecating humor.

Some friends, too, in the interest of full disclosure, dated Steampunk jumping the shark to an interview I did in 2008 for a nationally syndicated Australian Public Radio show. During the interview, the host asked me

to describe Steampunk fashion. Having not yet immersed myself in the subculture, I drew a blank and stupidly said, "You know—mechanical corsets." The host then followed up with a question I'd never been asked before: "What are you wearing?" Alas, I was wearing shorts and a T-shirt, not a mechanical corset.

But, as the previous chapters have hopefully shown, not only does the word "Steampunk" have different meanings to different people, but there is plenty of space left within current modes of thinking about the aesthetic for further growth and innovation. We may be tired of hearing about Steampunk in the media, but we're not tired of wearing it, reading it, making it, viewing it, and living it.

However, there *are* two specific areas that promise to enhance, augment, enrich, and, in some cases, serve as a signal boost to Steampunk: sustainability/greensteam and international/multicultural representation.

Green Steam. Really?

THE DO-IT-YOURSELF ASPECT OF STEAMPUNK FOUND IN FASHION AND crafting lends itself naturally to an exploration of issues like sustainability and an emphasis on green technology. Many Steampunks want to return to a time when technology was accessible to everyone, not just those with a technical background. Although some of the more complex Victorian technologies could only be found in factories and other centers of mass production, you could still conceivably fix your own watch, for example. The nostalgia for being able to repair a car dates to a more recent time, but still may be an entry point into Steampunk for many people.

However, although members of the Steampunk subculture talk about sustainability and green technology as one of their concerns, not much has been done in practical terms. The Kinetic Steam Works has experimented with low-energy steam retro-fitted vehicles, and makers like Jake von Slatt have created environmentally friendly foundries for melting recycled aluminum with waste vegetable oil, among other low-impact items like lamps and cargo bicycles, but this area remains full of untapped potential.

One other group taking the idea seriously, however, is the staff of *SteamPunk Magazine*, founded in Portland and currently run from the

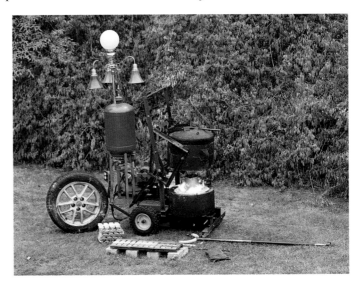

PREVIOUS SPREAD, LEFT
Excerpt from *Les Historiettes de Mr. Sandalette*, episode 1, by Vincent Bénard and Annliz Bonin, a.k.a. Futuravapeur and Anxiogene

ABOVE
Jake von Slatt's Steampunk foundry

The Future of Steampunk **203**

United Kingdom. The magazine supports such efforts by interpreting the steam element of Steampunk as a call to create a future where everyone can utilize tools to modify or repair the things around them. Thus, in a sense, Steampunk makers are reinventors who occupy a practical, forward-thinking space between the pessimistic Verne and the falsely optimistic Edisonades. They are also as close to anarchists as you will find in the Steampunk subculture.

Says magazine cofounder Margaret "Magpie" Killjoy, "Steampunk, as a subculture and as an aesthetic, is at its best when it is a way of radically readdressing the ways that we interact with technology. A way of challenging the assumptions of the industrial revolution. Which is probably more important right now, and over the next ten years, than it has ever been in human history. Top-down approaches to industry have backed our species into a corner (and outright wiped out thousands of others)."

Editor C. Allegra Hawksmoor says that the magazine came "from a very different place than a lot of Steampunk culture. When Magpie first came up with the idea . . . his whole experience of Steampunk was through a wonderful bunch of punks and anti-authoritarians who were looking at the past to build different dreams of the future. It was only later that he found out Steampunk was becoming this huge cultural phenomenon, and you know what? I think that's a good thing. When something is as aesthetic in nature as Steampunk is, it can get trapped inside its own little tropes. We're starting to see it happening now with all the goggles, the airships, and the cogs that get mindlessly stuck onto anything and everything."

Articles in *SteamPunk Magazine* have included how to create your own island despite rising seas, the basics of sewing, and how to build a "penny-farthing bicycle," not to mention a separate chapbook publication of *A SteamPunk's Guide to the Apocalypse*, which covers "water filtration, personal defense, location, looting, and many of the other skills that any good Steampunk might need in the case of catastrophe."

Magpie's hope is that Steampunk will be at the forefront of a DIY revolution. "We can present people with sustainable approaches to technology and living. We can help people realize that progress is not necessarily linear. We might have to go back in order to go forward. Perhaps fixed-wing aircraft, while militarily superior to lighter-than-air craft, are not as appropriate for our future. Perhaps what we need is more airships. Run collectively by trade syndicates instead of capitalist corporations. In order to do this, of course, we're going to have to keep the 'punk' in Steampunk."

All of which puts James Burnett's joke about two Steampunks screwing in a lightbulb (one to screw it in and one to "glue unnecessary clock parts to it") in a more serious context. One way that Steampunk can remain relevant is to de-emphasize modifications to existing technology in favor of creating working retro-machines, like the Kinetic Steam Works crew.

International/Multicultural Steam

THE INTERNET HAS BECOME AN ESSENTIAL TOOL FOR PEOPLE interested in Steampunk to learn about and participate in the subculture, no matter where they live. Websites like Brass Goggles and The Steampunk Workshop serve as a useful nexus for such activity. However, international enthusiasts have also developed their own communities, with unique interests and concerns. Gradually, the Internet is serving as a two-way conduit, allowing Steampunks in North America and Great Britain to discover efforts in other countries. From France to Brazil and all points between, there's more activity than ever with websites such as Beyond Victoriana and Silver Goggles focusing on multicultural Steampunk, regardless of origin. Longtime Steampunk stalwarts like G. D. Falksen, who has written on the subject of multicultural Steampunk for Tor.com, also recognize that the future of the genre requires diversity. "Any culture that existed in the nineteenth century can potentially be used for a Steampunk story or aesthetic style," Falksen says. "I am very pleased that people are becoming more and more aware of those possibilities."

Certain manifestations of international Steampunk go back to the source, as demonstrated by the very active French community, which has built on the influence of their beloved Verne. Some might lump continental European Steampunk in with the British or American versions, but in fact each country brings something unique to the table.

Take just the example of France. As French "image remixer" Sam Van Olffen points out, Verne isn't the only difference. "No Queen Victoria, but instead Napoleon III. No Oscar Wilde, but instead Charles Baudelaire. No Crystal Palace, but instead the Great Exhibition. On the other hand, as with any other genre, Steampunk brings its own rules. That's probably why Steampunk sadly cannot always get out of the road it has built for itself." Olffen's own art returns to iconic imagery such as Verne's elephant, but modified with his genius-level spin.

Vincent Bénard, a former set designer and props man for French television and cinema, who goes by the name "Futuravapeur," has reinvented himself as a creator who "gives a second life to antique objects by hijacking them and adding more modern elements to them, and thus saving them from trash bins or oblivion." Bénard has collaborated with Anxiogene to create the incredible adventures of a "capricious and fantastic paranormal activity detective," with all sorts of Steampunk flourishes.

Bénard believes that Steampunk is a "rich and flexible world" and that a "French touch" with regard to the subgenre is becoming harder to define because "Steampunk artists worldwide have a real influence on one another via that fabulous idea transmitter, the Internet." The French version has a "tendency to imaginative abstemiousness. Technological items are more discrete and elegant. Self-mockery, too, is a very important element."

OPPOSITE
Casque d'ingénieur impérial I, sculpture by Vincent Bénard, a.k.a. "Futuravapeur"
NEXT SPREAD
Le cirque rouillé (The rusted circus), by Sam Van Olffen

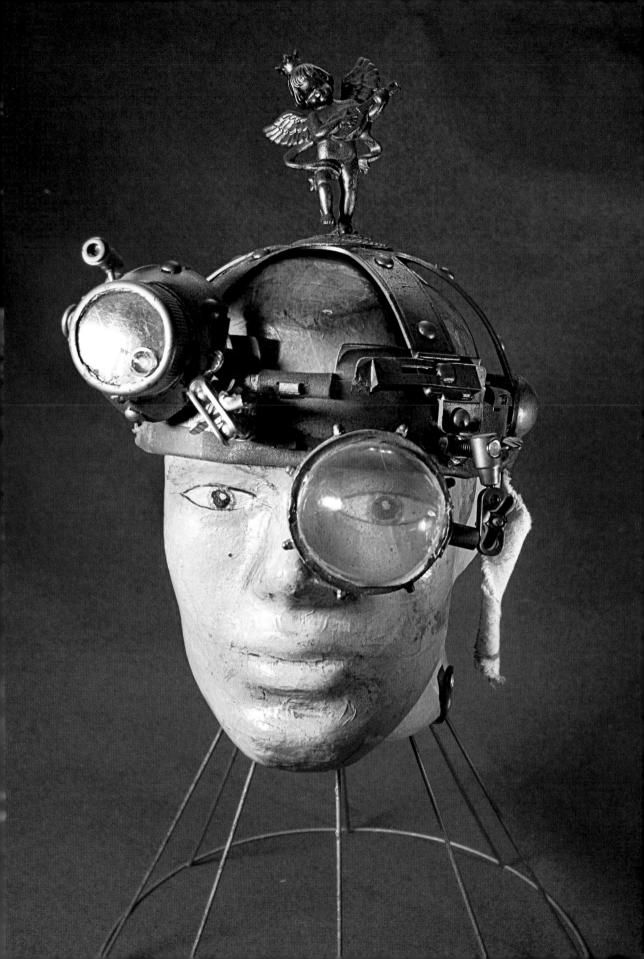

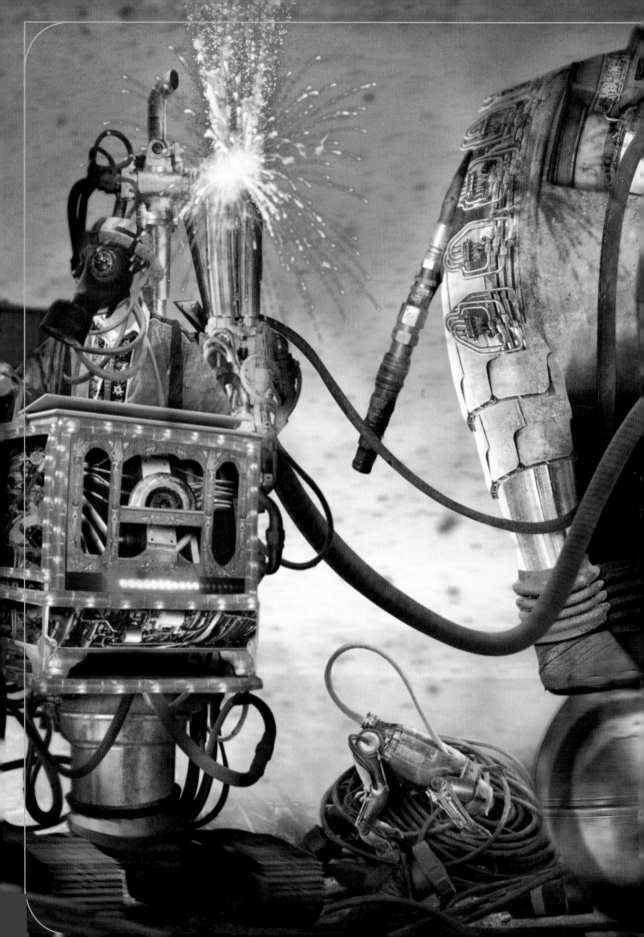

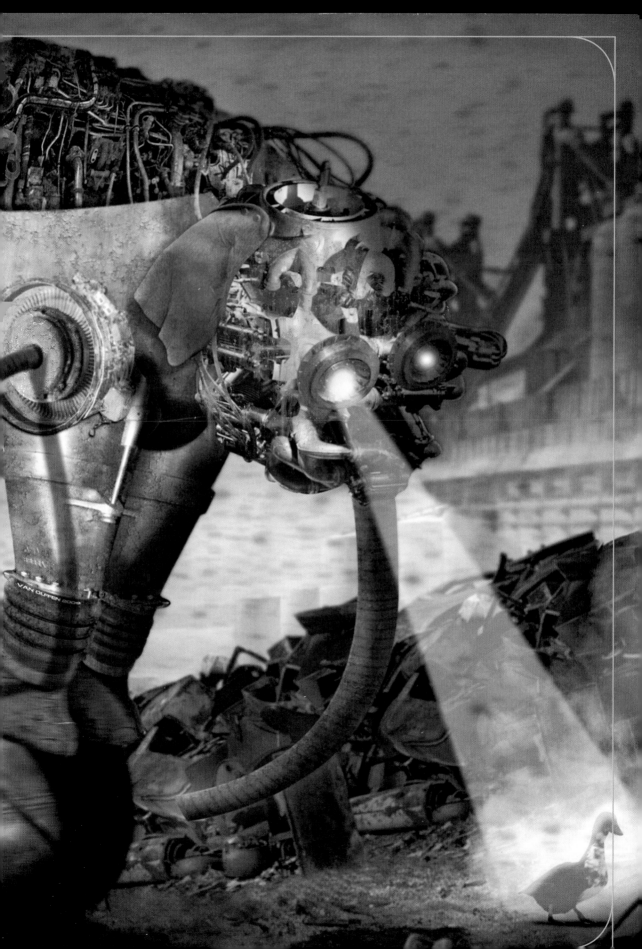

STEAMPUNK

Histórias de um Passado Extraordinário

TARJA
editorial

Still, such examples, despite differing influences, fit comfortably within Steampunk's traditional wheelhouse.

Farther afield, Brazil has suddenly emerged as a Steampunk hot spot. According to Brazilian writer, translator, and founder of the blog Post-Weird Thoughts, Fábio Fernandes, Brazilian Steampunk has been "active for a couple of years now, at least officially. Most of its members across the country didn't even know each other until 2007. They started meeting right after the foundation of the São Paolo Lodge (something akin to a Masonic Lodge, but only in name). Now there are lodges in the states of Rio de Janeiro, Rio Grande do Sul, Paraiba, and Paraná."

Even though Brazilian Steampunk is less than three years old, Fernandes says that the "community is doing a great job, with very interesting, active people doing a lot of events. Most of them so far, though, are related to Steamer fashion and lifestyle rather than literature. Some events have merged both communities . . . but they are not really that integrated. But we don't see that as a problem. Both communities get along very nicely. The writing movement is growing fast, and I daresay the next two or three years are going to see the birth of a real Brazilian Steampunk writing genre."

Fernandes believes Jacques Barcia, a leading light in the Brazilian SF/F scene, is also one of the country's best Steampunk writers. "He can conjure images of terrible beauty, infernal contraptions, and beautiful creatures such as mechanical golems in love."

Barcia agrees with Fernandes's assessment: "Brazilian Steampunk literature is growing fast, but it's still in its infancy. There are great works of fiction, great themed anthologies and conventions dedicated just to that subgenre, but many authors (and readers) don't have a clear vision of what Steampunk is, or how it has developed over the years. On the other hand, there are great examples of writers using Brazilian-flavored Victoriana, mashing up historical figures with characters from Brazilian Romantic literature for great results."

OPPOSITE
Steampunk, a Brazilian fiction anthology, 2009

Barcia's fiction doesn't "fit in the Brazilian Steampunk general aesthetic. I usually focus on Belle Époque imagery instead of Victoriana, and I'd rather place my stories in imaginary cities that just resemble (or reassemble) Brazilian cities. Also, my characters are usually the dissidents, the impoverished, the trade unionists and anarchists of the early twentieth century. I think Steampunk needs more revolutions, more strikes. After all, the turn of the last century was about factories and eighteen-hour shifts and the quest for freedom. Not just fancy steam and clockwork machines and their inventors."

In 2009, a Brazilian Steampunk anthology showcased the works of Barcia and others, and provided a flagship (airship?) of sorts for the fiction. Many of the selections rely on familiar influences like Verne and Wells, but others, like Romeu Martins's "Phantastic City," with its "steam favelas," bands of ex-slaves from Africa turned capoeira fighters, and huge buildings on the shores of Copacabana Beach, are more intrinsically Brazilian.

The issue of influence underscores the point that "international" does not always mean truly "multicultural." Through her Beyond Victoriana

An Excerpt from "Phantastic City" by Romeu Martins

Since the opening of the pioneering industry, in the estuary of Ponta da Areia, in Nictheroy—birthplace of the Baron locomotive—not a month goes by without a new factory opening its doors to work. The rhythm inside the factories is as intense as the hurly-burly in the streets, and not only during the day, but also along the nights, something that became feasible when the gaslight network replaced the old whale oil lamps. Neither luminosity nor even the imperial decree that outlawed the practice of capoeira and kung fu stopped the streets from becoming the stage for showdowns between the [rival groups]. . . .

The fog, capable of infiltrating the inhabitants' sense of touch, taste, and smell, spreads out of the maze formed by hundreds of huge stone obelisks scattered through the Capital. They are the chimneys of the industries, veritable monsters that, with their ovens, fed by the coal from Santa Catarina, give birth to fresh ovens, train tracks, whole trains, steam ship hulls. . . . It's the future materialized in metal.

Of all the prodigies engendered by technique and ingenuity in this city, none is equal to—none is even close in comparison—the colossal building that shall be finished by the end of the year, by the shore of Copacabana Beach. With a hundred floors, the Phantastic City Building is the highest structure ever designed by human hands—roughly twice the height of the Washington Monument that took decades to build in the United States capital—a work constantly delayed due to the Civil War that until a few months ago devastated the godforsaken republic. . . .

—*Translated by Fábio Fernandes*

website, Diana M. Pho, a.k.a. Ay-leen the Peacemaker, aggressively promotes examples of the multicultural in all aspects of Steampunk, while Jaymee Goh's Silver Goggles website focuses mostly on Steampunk literature in the same mode, reviewing new books and providing alternative interpretations of older ones.

Goh says that "most of the interest in [Silver Goggles] comes from individuals who are non-Anglo living in Anglo countries, because non-Anglo countries don't have that same sci-fi background where they apply the term 'Steampunk' to retro-futuristic styles."

Peacemaker established Beyond Victoriana in part to combat a sense of Steampunk idealizing Western culture without question and in part

to promote positive multicultural representations. "When talking about British culture and Steampunk, you have to consider the fact that British culture has had a great impact on the formation of modern culture and Westernization. So when you talk about British imperialist history . . . you should also acknowledge that Westernization in general has been problematic to non-Western cultures, and that the Victorian-oriented Steampunk is only an extension of an already-established pattern."

However, Peacemaker does think "Steampunks are attracted to the genre for its ambiguity as well: that innovative technology created damaging pollution, that buildings and bridges and railroads were built at the expense of poor immigrant workers, that expansion grew because of slavery and colonialism." Moreover, "Steampunks are willing to break the patterns of the past. That is what differentiates Steampunks from neo-Victorians, in my opinion."

Steampunk may well suffer further growing pains as various elements of the subculture discuss issues like cultural appropriation, multicultural representation, and ways in which Steampunk can find non-Anglo models for its expressions of "Victoriana." However, Ay-leen says the response to her advocacy has been "extremely positive, even more than I ever anticipated. . . . I started the project on a whim and now it's become a resource that a lot of people are supporting."

One artist featured on Silver Goggles, Hong Kong–born James Ng, has reimagined Steampunk from a Chinese perspective. His computer-

BELOW

Bridal Carriage by James Ng, 2009

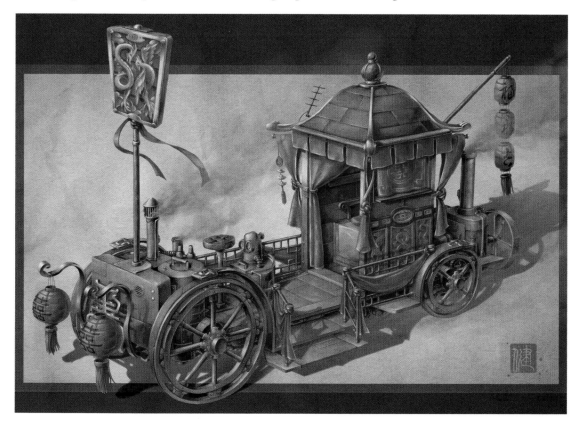

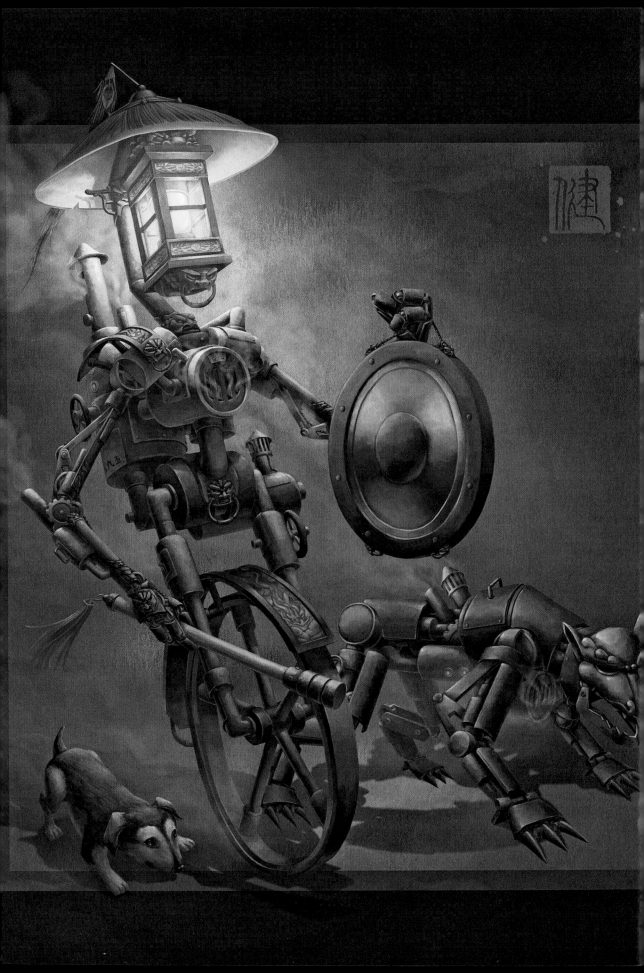

generated Imperial Airship and other images replicate the texture of oil paintings and represent an important new visual direction for Steampunk. "The work was the result of my ponders about the current state of modernization combined with my interest in Chinese history. I am very interested in the Qing Dynasty and the modernization of non-European countries. The standard of modernization is basically Westernization; as China becomes more modern, it also becomes more like the West. (Living in Hong Kong is probably why I noticed this trend, as Hong Kong is the most Westernized city in all of China.)

"[But] I began to wonder, what if China was the first to modernize and [had] gone through the Industrial Revolution during the turn of the last century? If China was the standard that other countries had to work towards, what would things look like today? Perhaps China would still be in Imperial rule? Maybe skyscrapers would look like Chinese temples? Cars would look like carriages? And maybe we would have fantastical machines that look both futuristic and historic."

Such reimaginings are still in their infancy, but coming into their own. "I want to see more empires beyond Victoriana," Goh says, "with traditionally marginalized identities towering up and above where they have been set, engaging with the self-confidence they would ordinarily be punished for. Being entrenched in history, Steampunk is well-placed to examine the hubris of the past and the present, to make way for a better future."

What would Goh's ideal Steampunk text look like? "I have a story in which I sic'd a Malayan airship crew on Captain Francis Light, who co-opted Pengang Island in the 1700s as a port for the East India Company, opening the door wide for British colonialism. My crew takes back the island in the name of the Kingdom of Kedah. If someone were to do a Steampunk project just for me, I'd like to see that story made into graphic novel form."

Certainly, the evidence suggests a future that is trending toward Goh's vision. Whereas it had been difficult for me and my wife, Ann, as editors of the anthology *Steampunk*, to find first-wave Steampunk stories written from different cultural perspectives, diverse writings were easier to come by for our *Steampunk Reloaded* anthology (2010), which covers the last decade of Steampunk fiction. For example, Shweta Narayan incorporates Indian history and legend with a tinker's perspective in "The Mechanical Aviary of Emperor Jalal-ud-din Muhammad Akbar." A new website on Muslim Steampunk, referencing astrolabes and the Islamic Golden Age, also provides hints of Steampunk's future. The site's founder, Yakoub Islam, is cur-

A Steampunk Manifesto

By Jake von Slatt

The following manifesto created by Steampunk Workshop's Jake von Slatt has frequently been read at Steampunk conventions and provides a vision of future Steampunk from a maker's perspective.

What sort of future were you promised? When I was young, they told me I'd have robotic servants to tend to my every need, cars that would drive themselves while I read the newspaper, and vacations in orbiting space hotels. When I was a bit older, they promised me ecologically friendly communities where we would all live together in geodesic domes in our white jumpsuits.

But by the time I had reached high school, they had stopped promising the future. We were all sure that we would grow up into a post-apocalyptic tomorrow where we would be roaming a desert landscape in our jury-rigged vehicles and punk rock haircuts in search of the next gallon of gasoline. When things started to look up again, our future remained dark. We'd be human flash drives with data jacked into our skulls and our destinies determined by mysterious and shadowy entities that may or may not be human, or even "alive."

Today, the only future we are promised is the one in development in the corporate R&D labs of the world. We are shown glimpses of the next generation of cell phones, laptops, or MP3 players. Magazines that used to attempt to show us how we would be living in fifty or one hundred years, now only speculate over the new surround-sound standard for your home theater or whether next year's luxury sedan will have Bluetooth as standard equipment.

What do you do when you are promised no future beyond the next Steve Jobs keynote address or summer blockbuster movie? What do you do when your present consists of going to work, paying the bills, and trying to make ends meet? Our society would have you put your head down, work a little longer, try a little harder, and maybe order that 50-inch HDTV from Amazon.com.

"If you want something done right, do it yourself." Haven't heard that much lately have you? Except perhaps from people who want to sell you home improvement supplies. But everything else is labeled "no user-serviceable parts," including your future.

Is it any wonder, then, that some of us have decided to take a step sideways? A step out of the corporate time stream and into one we have made for ourselves? A step into a world of adventure and romance where we each seek out our own futures on our own terms without having to wait for it to go on sale? A step sideways into a past that never was and a future that *still could be*?

OPPOSITE
Jake von Slatt and his
Wimshurst machine

CONTINUED

There is no doubt that the near future holds great challenges for us. Many believe that Peak Oil has arrived and the rising price of petroleum will soon vastly reshape the lives and habits of most of the people of Earth. In addition, evolving economies in China and India have already fundamentally altered the manufacturing and labor landscapes.

In that context, ironically enough, the nineteenth century holds important lessons for us in dealing with disruptive technologies, as well as giving us readymade technical solutions that were once discarded as inefficient. For instance, steam power has an advantage in its multi-fuel capability. In a world where several different forms of biomass-derived fuel may be available in greater or lesser quantities due to the growing season or other variables, steam power may yet play a role.

"We prepare for the apocalypse so that we may avoid it" is the watchphrase of the politically and environmentally aware Steampunk. Buying habits, for example, were very different in the nineteenth century. If you needed a piece of furniture, an appliance, or a tool, you would have to save for it, and the item you then purchased would often stay with you for the rest of your life.

Steampunks eschew the consumerism of popular culture. They purposely pare their lives down, choosing to own a few very fine things rather than closets of mass-produced goods. They will often seek out vintage or even antique examples of such technology as sewing machines and then purchase these for their daily use in the belief that only machines of a past era have the durability to outlive their owners.

Steampunks want to buy something once and then pass it on to our children. Even better, we want to *make* something once, something that we will use every day for the rest of our lives. Something that will remind us each time we use it that we have skill and ability. Something that no one else in the world has.

BELOW
The Neverwas Haul being pulled by Kinetic Steam Works's *Hortense*

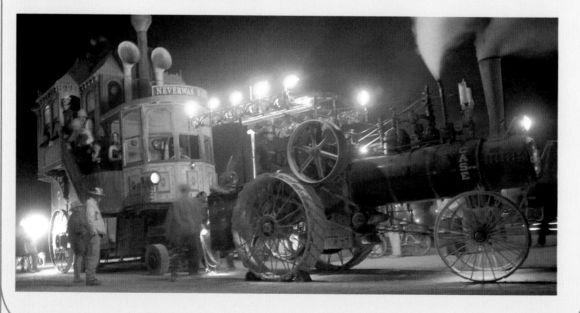

rently working on a novel set in 1148, just prior to the reign of Saladin.

The world is wide open for Steampunk fiction. Ancient Egyptians had sliding doors that may have been steam-powered, while the Khmer civilization popularized by the ruins of Angkor Wat had sophisticated water distribution systems that may well have had steam-power applications. Released from the tyranny of the nineteenth century, Steampunk might well enter a true renaissance on the printed page.

◘　◘　◘　◘　◘

The truth is, no one knows what Steampunk will look like in the future—there's even a kind of irony in suggesting a future for a subculture that gains so much of its power from reimagining the past. With any luck, though, sustainability will become a hot-button Steampunk issue, and international/multicultural Steampunk will become integrated in a way that enhances all aspects of the subculture.

Jake von Slatt believes the mutable aspect of the aesthetic will continue to be its strength: "I've come to view Steampunk, the combination of a Victorian aesthetic and a punk rock attitude, as a sort of cultural mule. A mule is a hybrid creature that is strong and robust but can't reproduce. Steampunk is like that in that it has been popping up in various forms for generations, but doesn't really have a continuous presence. What we call Steampunk today will likely run its course, but as long as there are horses and donkeys, there will continue to be mules."

Occasional Cyberpunk author Marc Laidlaw, who has written Steampunk stories, playfully suggests another possible future: "Sterling and Gibson retract *The Difference Engine*. Tim Powers launches a virus that removes the word 'steam' from all digital media. Jim Blaylock sues to shut down Steampunk conventions and removes all gears from clocks. K. W. Jeter enters a black hole and the universe starts again."

Perhaps the most startling reinvention of Steampunk might be *as* the future. According to a BBC report, within the next decade airships will become the fuel-efficient, preferred method of moving people and products across the continents.

Maybe one day we'll all be Steampunks.

JEFF VANDERMEER'S fiction has been published in over twenty countries. His books, including the best-selling *City of Saints & Madmen* and *Finch*, have recently made the year's best lists of the *Wall Street Journal*, the *Washington Post*, and the *San Francisco Chronicle*. VanderMeer's surreal, often fantastical fiction, has won two World Fantasy Awards and an NEA-funded Florida Individual Writers' Fellowship and Travel Grant, along with several awards in translation. He regularly reviews books for the *New York Times Book Review*, *Los Angeles Times Book Review*, and the *Washington Post*, while his short fiction has appeared in *Conjunctions*, *Black Clock*, and many others. With his wife, Ann, the Hugo Award–winning editor of *Weird Tales*, he has edited such iconic anthologies as *Steampunk*, *Steampunk Reloaded*, *The New Weird*, and *The Thackery T. Lambshead Pocket Guide to Eccentric & Discredited Diseases*. His fiction has received praise from the likes of Lev Grossman, Peter Straub, and Junot Diaz, who wrote of his latest collection, *The Third Bear*, "Cunningly crafted stories full of wonder and intelligence, proving again why VanderMeer is so essential." VanderMeer is the assistant director for the unique teen SF/Fantasy writing camp Shared Worlds, based at Wofford College, and has also taught workshops or given lectures at conventions, conferences, and universities around the world. He lives in Tallahassee, Florida, and all four of his cats have yet to reveal any Steampunk tendencies.

S. J. CHAMBERS'S fiction and nonfiction has appeared in a variety of publications, including *Fantasy*, the *Baltimore Sun*'s Read Street blog, *Yankee Pot Roast*, Tor.com (where she first aired her Steampunk Poe ideas), and Ann and Jeff VanderMeer's forthcoming anthology *Thackery T. Lambshead's Cabinet of Curiosities*. She is the articles senior editor at *Strange Horizons*, a devout Poepathist, a member of the Poe Studies Association, and a regular reviewer for *Bookslut*. She lives in Tallahassee, Florida, and on the Web at www.sjchambers.org. This is her first book, which was entirely composed via the Popov Lightenin-o-gramatic 6000 aboard the recommissioned H.M.S. *Victoria*.

Acknowledgments

First and foremost, thanks to our editor, Caitlin Kenney, whose edits, suggestions, and attention to detail made this a much better book. Special thanks also to acquiring editors Maxine Kaplan and David Cashion. Thanks to everyone who provided supplementary text or ideas for this book, including our go-to consultant Jess Nevins, Libby Bulloff, Jake von Slatt, Evelyn Kriete, G. D. Falksen, Morgan Guery, Gio Clairval, Ann VanderMeer, and John Coulthart. Additional thanks to Ay-leen the Peacemaker and her website Beyond Victoriana, along with resources like the *SteamPunk Magazine* site. Finally, thanks to everyone who contributed to this book; you were all so kind and gracious in working with us.

Certain ideas and text in the introduction were suggested by Jake von Slatt and used with his permission. Although this book is a collaboration, the ideas and approach used in chapter one came from S. J. Chambers, as did the thoughts on Ruskin and the arts and crafts movement in chapter three. The text on various Steampunk bands originated with Desirina Boskovich. Most of the ideas on Steampunk events set out in chapter four, especially the list, came from G. D. Falksen and are used with his permission.

When we first began this book, we had intended to include a "Steampunk index" that cataloged all vendors, makers, artists, and international groups within the Steampunk community. The response was so overwhelming that we were unable to fit this information into the book, and will place it on the companion website for ease of updating. This index, as well as more information on Steampunk, resides at: www.steampunkbible.com.

Photo Credits

GENERAL CREDITS

Chris Allen: 148 (bottom); Tom Banwell/tombanwell.com: 34; Vincent Bénard: 207; Annliz Bonin: 200; Krista Brennan: 172, 173, 220; Greg Broadmore/Weta Workshop: 73, 75, 157, back cover (left); Libby Bulloff: 11, 63, 133, 134, 138–141, 146, 147, 155, 156, 158–160, 168, 170; Kyle Cassidy: 61; John Coulthart: 9, 20, 52–55, 96, 174–75; Andrew Cowley: 56; Molly Crabapple/DC Comics: 80, 81 (top); Molly Crabapple/*SteamPunk Magazine:* 204; Art Donovan/Donovan Design: 121 (top, design only), 123, 124; Jeremy Faludi/FaludiDesign.com: 90, 93–95; Anna Fischer: 135; Phil and Kaja Foglio: 78, 79; Suzanne Rachel Forbes: 169; Molly Michelle Friedrich: 122, 124 (bottom right); Paul Guinan/Anina Bennett: 43; NK Guy: 102, 103; Vladimir Gvozdez: 12, 112, 113 (with Giuseppe), 114–15; Beth Gwinn: 48; *The New York Times*/Redux: 161; Jema Hewitt: 151–54; Kevin Honglin: 88; Dan Jones: 215 (art); Kazu Kibuishi: 71; Bruce Jansen: 59; Julie Klima: 195; Kris Kuksi: 97; Yann Langeard/Le Chatrou Electrique: 18, 118–19, 121 (bottom); Matthew M. Laskowski: 150; Nadya Lev and Kit Stølen: 132; Mike Libby/Insect Lab: 116; Library of Congress Prints

and Photographs Division: 19, 21–28; Gabino Mabalay: 130, 144–45, 148 (top); Lex Machina: 133, 143; Joey Marsocci/DrGrymmLaboratories.net: 123 (top left); Ian Miller: 57; Mike Mignola: 76, 77 (Hellboy™, Amazing Screw-On Head™ © 2010 Mike Mignola); Ann Monn: 14, 215 (design); Stéphan Muntaner: 44, 45, 117, 120; Richard Nagy: 107, 108; James Ng: endpapers, 213, 214, back cover (right); Jesse Nobles: 136, 137; Kevin O'Neill/Top Shelf: 81 (bottom), 82, 83; Sydney Padua: 72; Penguin UK: 99; J. K. Potter: front cover (bottom), 2, 46, 49 (bottom), 50, 51; J. Daniel Sawyer: 142; Ramona Szczerba: 89; Bryan Talbot: 69, 70, 84, 85; Jon Sarriuggarte & Kyrsten Mate: 10, 170; Aleks Sennwald/sennvald.com: 186, 199; Judith Stephens: 149; Matt Teuten: 164; Sam Van Olffen: 121 (top, art only), 208, 209; Jake von Slatt: 13, 104–106, 125–129, 203, 217; Zandra Stratford: 167; Keith Thompson: 68; Steven Unwin/Weta Workshop: 74; William Wadman: 87; Shane Washburn: 100; Zach Wasserman: 6; Troye Welch: 109, 110, 111, 218; Wikipedia Commons (public domain): 31; Nick Winterhalter: 15, 101; Mark Ziesing: 49 (top).

BOOK COVER CREDITS

The following book covers used by kind permission of the publishers: *Pinion* (Tor Books; artist Stephan Martiniere, designer Irene Gallo): 86; *Boneshaker* (Tor Books; artist Jon Foster, designer Jamie Stafford-Hill): 62; *The Alchemy of Stone* (Prime Books; artist David Defigueredo, designer Stephen H. Segal): 63; *The Immorality Engine* (Snowbooks, Ltd.; artist and designer Emma Snow): 65; *Changeless* (Orbit; artist Derek Caballero, designer Lauren Panepinto): 64; *The Dream of Perpetual Motion* (St. Martin's Press, artist isifa image service, designer Ervin Serrano): 87; *The Gaslight Dogs* cover used by permission of Orbit Books (artist Sam Weber, designer Lauren Panepinto): 88; *Leviathan* cover and interior illustration reprinted with the permission of Simon Pulse, an imprint of Simon & Schuster Children's Publishing Division from *Leviathan* by Scott Westerfeld, illustrated by Keith Thompson. Jacket design and illustration by Sammy Yuen Jr. Mechanical wing illustration by Keith Thompson. Mechanical wing illustration copyright © 2009 Scott Westerfeld: 67, 68.

MOVIE/TV CREDITS

The following images were provided by The Kobal Collection acting on behalf of the copyright holders: *20,000 Leagues Under the Sea* (Walt Disney): 178; *9* (Focus Features): 190, 191; *Casshern* (Shochiku Co./Tatsunoko Prods.): 187; *The City of Lost Children* (Claudie Ossard/Constellation): 176, 194; *The Fabulous World of Jules Verne* (CSF/Filmove): 179; *The Golden Compass* (New Line Cinema): 192; *Howl's Moving Castle* (Tohokushinsha Film Corp/NTV/Tokuma Shoten): 184, 185; *Castle in the Sky: Laputa* (Studio Ghibli/Tokuma Shoten): 182; *The League of Extraordinary Gentleman* (20th Century Fox): 189; *Sherlock Holmes* (Silver Pictures): 193; *Sky Captain and the World of Tomorrow* (Paramount): 189; *Steamboy* (Studio 4 Degrees/Sunrise): 188; *The Time Machine* (MGM): 180; *A Trip to the Moon* (Melies), 179; *Warehouse 13* (SyFy Channel/Bosse, Philippe): 196, 197; *The Wild Wild West* (The Kobal Collection): 181.

Index